PLASMA TECHNOLOGY IN THE PRESERVATION AND CLEANING OF CULTURAL HERITAGE OBJECTS

T0176369

PLASMA TECHNOLOGY IN THE PRESERVATION AND CLEANING OF CULTURAL HERITAGE OBJECTS

Radko Tiňo, Katarína Vizárová, František Krčma, Milena Reháková, Viera Jančovičová, and Zdenka Kozáková

CRC Press
Taylor & Francis Group
Boca Raton London New York

CRC Press is an imprint of the
Taylor & Francis Group, an **informa** business

First edition published 2021
by CRC Press
6000 Broken Sound Parkway NW, Suite 300, Boca Raton, FL 33487-2742

and by CRC Press
2 Park Square, Milton Park, Abingdon, Oxon, OX14 4RN

© 2021 Taylor & Francis Group, LLC

CRC Press is an imprint of Taylor & Francis Group, LLC

Library of Congress Cataloging-in-Publication Data
Names: Tiňo, Radko. l Vizárová, Katarína. l Reháková, Milena, author. l Jančovičová, Viera, author.
Title: Plasma technology in the preservation and cleaning of cultural heritage objects / Radko Tiňo, Katarína Vizárová, Milena Reháková, Viera Jančovičová.
Description: First edition. l Boca Raton : CRC Press, [2021] l Includes bibliographical references and index.
Identifiers: LCCN 2020048404 l ISBN 9780367229153 (hardback) l ISBN 9780367699802 (paperback) l ISBN 9780429277610 (ebook)
Subjects: LCSH: Cultural property--Protection. l Cultural property--Cleaning. l Plasma (Ionized gases) l Historic preservation.
Classification: LCC CC135 .P59 2021 l DDC 363.6/9--dc23 LC record available at https://lccn.loc.gov/2020048404

ISBN: 978-0-367-22915-3 (hbk)
ISBN: 978-0-367-69980-2 (pbk)
ISBN: 978-0-429-27761-0 (ebk)

Typeset in Times New Roman
by MPS Limited, Dehradun

Contents

Contributors ..ix

Chapter 1 Introduction.. 1

Chapter 2 Cleaning in Preservation of
Cultural Heritage ... 3

 2.1 Principles of Cleaning ... 5
 2.2 Cleaning Methods.. 5
 2.2.1 Solvent Cleaning 6
 2.2.2 Aqueous (Wet) Cleaning........................... 7
 2.2.3 Surfactant Cleaning 7
 2.2.4 Chemical Cleaning 8
 2.2.5 Gel Cleaning.. 8
 2.2.6 New Cleaning Methods.............................. 9

Chapter 3 Plasma Technologies in Preservation of Cultural Heritage 11

 3.1 Low-Pressure Operating Plasma Systems
for Metallic Objects Surface Treatment............................... 12
 3.1.1 Vacuum and Gas Handling System.......................... 12
 3.1.2 Power Supply ... 14
 3.1.3 Plasma Process Monitoring.......................... 18
 3.2 Atmospheric Pressure Operating Plasma Systems
for Metallic Objects Surface Treatment...............................23
 3.3 Laser-Based Plasma Systems for Metallic
Objects Surface Treatment ...25
 3.4 Application of Plasmas with Liquids.....................................27
 3.5 Atmospheric Pressure Low-Temperature
Plasma Systems for Objects Made from Natural
and Synthetic Polymers ...31
 3.5.1 DBD...31
 3.5.2 ADRE ...33
 3.5.3 Plasma Pen ...33
 3.5.4 Other Systems...35

Chapter 4 Cleaning Processes in Plasma..43

 4.1 Sterilization/Decontamination ...45
 4.2 Ablation...48

 4.3 Activation...48
 4.4 Deposition ..49
 4.5 Cross-Linking...49

Chapter 5 Plasma Cleaning of Inorganic Objects and Materials.....................53

 5.1 Removal of Corrosion Product Layers from Metals............53

Chapter 6 Plasma Cleaning of Organic Objects and Materials.......................59

 6.1 Cleaning of Paper...59
 6.2 Cleaning of Wood ..62
 6.3 Cleaning of Photographs ...69
 6.3.1 Introduction...69
 6.3.2 Cleaning of Daguerreotypes..................................70
 6.3.3 Microbial Decontamination of Albumen
 and Gelatin Photography.......................................72
 6.3.4 The Influence of Plasma Treatment on
 Properties of Photography.....................................74
 6.4 Cleaning of Textiles ..75
 6.5 Cleaning of Paintings ...78

Chapter 7 Overview of Relevant Research Projects ..85

Chapter 8 Current Own Case Studies...89

 8.1 CS1: Microbiological Decontamination of
 Paper Substrate Using Low-Temperature
 ADRE Plasma...89
 8.2 CS2: Cleaning of Color Layer on Paper Substrate92
 8.3 CS3: Decontamination of Gelatin Photography95
 8.4 CS4: Image Recovery in Cyanotype...................................97
 8.5 CS5: Cleaning Historical Textile with Metal
 Threads by Plasma...99
 8.6 CS6: Low-Pressure Removal of Model
 Corrosion Layers from Iron ...104
 8.6.1 Preparation of Iron Model Samples.......................105
 8.6.2 Experimental Setup and Conditions110
 8.6.3 Samples Corroded in Hydrochloric Acid
 Corroded Treatment in the Continuous Regime112
 8.6.4 Hydrochloric Acid Corroded Samples Treatment
 in the Pulsed Regime ...116
 8.6.5 Treatment of Samples Corroded in Nitric Acid.....120
 8.6.6 Treatment of Samples Corroded in
 Sulfuric Acid ...123
 8.6.7 Application of Bias Voltage124

8.6.8 Treatment in Hydrogen-Argon Gaseous Mixtures. 126

8.6.9 Concluding Remarks .. 130

8.7 CS7: Treatment of Bronze Chisel by
Low-Pressure Hydrogen–Argon Plasma 131

8.8 CS8: Surface Cleaning of Ancient Glass by
Plasma Generated in Water Solution 134

Index ... 147

Contributors

Dr. Radko Tiňo is an Associate Professor at the Slovak University of Technology in Bratislava. He focuses his research on the properties and modifications of materials composed of natural polymers, mainly wood, paper, composites and parchment. He is also active in the research and development of new mass conservation technologies for the preservation of cultural heritage. Since 2003, he has been actively researching the effects of low-temperature non-equilibrium plasmas on the surfaces of lignocellulosic materials in international projects (Durawood, SusPlArt) and domestic projects (PlasmArt, Mespekri and others). He is a member of the advisory board of experts of the Slovak Commission for UNESCO and a member of the steering committee of the Working Party of Chemistry in Cultural Heritage within the European Chemical Society.

Dr. Katarína Vizárová is an Associate Professor at the Slovak University of Technology in Bratislava in the field of natural polymers and materials. Her research focuses on the identification, degradation and stabilization processes of organic materials and heritage objects. She has led and been part of several international and domestic research projects focused on mass conservation technologies for the preservation of heritage objects and materials.

Dr. František Krčma is an Associate Professor at Brno University of Technology in the field of physical chemistry. His research focuses on low-temperature non-equilibrium plasmas in gases and liquids and their applications in material, environmental and biomedical applications. He was a chair of COST Action TD1208 Electrical discharges in liquids for future applications and currently he is vice-chair of COST Action CA19110 Plasma applications for smart and sustainable agriculture.

Dr. Milena Reháková is an Associate Professor at Slovak University of Technology in Bratislava in the field of macromolecular chemistry. Her research focuses on the spectral identification, characterization, stabilization and cleaning processes of the color layer and writing means on traditional supports.

Dr. Viera Jančovičová is an Associate Professor at the Slovak University of Technology in Bratislava, where she focuses on the study of photochemical processes and reactions. Her research also includes historical photographs, the study of their light and thermal stability, the degradation processes associated with their aging and their protection.

Dr. Zdenka Kozáková is an Associate Professor at Brno University of Technology in Brno, Czech Republic in the field of physical chemistry. Her research focuses on diagnostics, chemical analyses and applications of non-thermal plasmas generated in gases and liquids.

1 Introduction

The aim of the efforts of all professionals involved in the protection of tangible cultural heritage values is to prolong the existence of heritage objects in a time far beyond their natural lifetime. To this, Townsend's thesis (Townsend 2006) must be added in good physical condition. At the same time, according to ethical principles, the conservation intervention should bring minimal changes to the originality of the object or artwork.

Cleaning can be considered as a key operation in the process of conservation. The removal of impurities and deposits of various origins and chemical compositions from the surfaces of various types of objects is a case-specific process. Impurities, whether mechanical, biological or chemical, reduce aesthetic values, hinder the functionality of objects and, above all, contribute to accelerating the degradation of materials and the aging of heritage objects. For individual types of materials and contaminants, cleaning methods are established and used in practice.

However, the current state indicates the need for research and development of new, efficient, environmentally acceptable conservation methods and technologies and at the same time friendly to the treated object and human health. In this endeavor, communication, and cooperation of researchers with experts from practice, popularization, and implementation of new solutions are necessary steps. New methods and technologies, based on the use of knowledge about the effects of low-temperature plasma on various inorganic and organic materials, seem promising. They provide environmentally friendly and human-like solutions (elimination of the replacement of organic, often toxic substances), and also address the persistent disparity between the rate of degradation and degradation of heritage sites and protection capacity. It should be noted that each conservation intervention brings a change in the properties of the original object. Therefore, when researching and implementing new methods and technologies for cleaning (and not only cleaning), it is important to ensure the safety of conservation technologies for cultural heritage. Part of the work must not be only the setting of conditions that effectively remove unwanted substances from the material, but also the verification of possible adverse effects on the treated material, even in the long term regarding prolonging the lifetime of historical artifacts.

REFERENCE

Townsend, J.H., 2006. What is Conservation Science? Macromolecules in Cultural Heritage, Macromolecular Symposia, 238, 1–10. DOI: 10.1002/masy.200650601.

2 Cleaning in Preservation of Cultural Heritage

The world's cultural heritage is formed by a complex of intangible legacy, whose carrier creates its material base. Tangible cultural heritage is represented by movable and immovable objects characterized by absolute variability and heterogeneity of materials, which, in dependence on their durability, are subject to aging and degradation over time. The first class includes the art and archive pieces made of a wide variety of combined inorganic and organic material bases, such as wood, paper, textile, leather, metals, glass, ceramics and other inorganic materials, plastic materials, binders, oils and waxes, etc. Many heritage objects are part of heterogeneous systems containing interrelated and influencing components; for example, works of art that are composed of layers differing in composition, books, textile-based objects, historical furniture that contains various kinds of materials. Generally, they are different in shape; spacious 3D objects; 2D objects such as archival documents, paintings, graphical works and photography; and small 3D objects such as statues, museum artifacts, books and others (Tiňo, Vizárová, and Krčma, 2019). These characteristics are important in selecting materials, methods and technologies for preservation, while the type and degree of deterioration have not yet been taken into account.

During aging, there is gradual degradation and damage to objects of cultural heritage. One of the most important reasons being their contamination, caused by mechanical, biological and chemical pollutants. These come from so-called external factors of aging and degradation of materials such as dust, sulfur and nitrogen oxides, volatile organic compounds (VOC) in air, light irradiation, microbiological elements, corrosive substances, temperature and relative humidity, human factor and others. Contamination reduces aesthetic, informational or other values of an object, and/or accelerates the process of deterioration (Rivers and Umney, 2003). The literature refers to a series of definitions of pollutants (Perry, 2000; Phenix and Burnstock, 1992), which can take different forms and origins. Ultimately, contaminants create a surface deposit, which can be defined as an accumulated layer of surface impurities of different origins (mechanical, biological and even chemical) on the surface of the object; specifically, dust, insects, fungi, greasy and chemical substances derived from impurities such as oxidation products resulting from the reaction with oxygen, ozone, oxides of sulfur and nitrogen, or that arise as products of oxidation or degradation of the material. The dust can contain contaminants, poisonous residues from previous pretreatments or pollutants from the surrounding atmosphere. Microscopic droplets of oily substances combined with dust and dirt

will create a film on the surface (assist the adhesion of particulate matter to the surface). Inorganic materials are covered with oxidation, corrosive layers, salts, and incrusts with various chemical compositions. These deposits are difficult to remove in many cases without deterioration of the original substrate or paint layer. In some cases, especially in the case of colored and varnished layers, the original surface layer is degraded and disturbed (cracked) and simultaneously a deposit of impurities is formed.

One of the most important degradation factors of cultural heritage objects consisting of organic materials is microbiological contamination. Fungi play a considerable role in the deterioration. Due to their enormous enzymatic activity and their ability to grow at low aw values (aw value – water activity – the relative product equilibrium humidity, the freely available water for microorganisms to grow), fungi can inhabit and decay paper, parchment, leather, textiles, paintings, binders, glue and other materials used for heritage objects (Gutarowska, 2016; Sterflinger, 2010). Fungal growth on objects often causes serious aesthetical damage due to colony formation and fungal pigments (Sterflinger, de Hoog, and Haase, 1999). Fibrous fungi have destructive activity, damage, and gradually lead to loss of material. These factors contribute significantly to reducing the lifetime of art pieces and archives and they adversely affect people in contact with contaminated materials.

Depending on the type of materials and historical objects, in addition to general characteristics, contamination is characterized by specific contexts. Table 2.1 summarizes the characteristics of pollution for individual types of materials, respectively cultural heritage objects. This is related to the surface properties of the materials (from smooth surfaces through porous natural materials to a

TABLE 2.1
Kinds of pollution and deterioration for individual types of materials and objects of cultural heritage

Material/object	Kind of pollution/deterioration
Stone	Encrustation (degraded layer as a sulphation process)
Metal	Oxidation, corrosion layers, metal salts, incrusts
Wall paint	Sulfate (nitrate, chloride) salting out, flaking and detachment of paint layer
Polychromie Paint layer	Oxidation, degraded varnish layer (crackling), grime deposit
Paper, parchment	Adhesives (wax and resin), stains, grime deposit (particulate and/or greasy)*
Textiles, canvas	Adhesives, stains, particulate grime deposit
Wood	Adhesives, grime deposit, (particulate and/or greasy)

* Phenix and Burnstock (1992) define a surface dirt/grime deposit as a combination of particulate material (inorganic material and elemental carbon/carbon black in various chemical compositions, surface characteristics, sizes, shapes and hardness) and greasy or oily material (composed of hydrocarbons and fats, may contain free acids).

multicomponent color layer), adhesion of the soil deposit to the surface and their polarity (hydrophobicity or hydrophilicity, respectively), the ability of the impurities to penetrate the structure of the material (stains from liquids on textiles or paper) and, last but not least, the function that the objects during their lifetime fulfilled.

All these aspects directly affect the selection of methods and technologies for the removal of contamination/cleaning.

2.1 PRINCIPLES OF CLEANING

Cleaning represents a major activity for conservators and is conducted on practically every type of cultural heritage object. Conservation practice is characterized by the diversity of different cleaning approaches, as the authors of the Coming Clean study (Golfomitsou et al., 2017) show. Although the impact of a cleaning treatment can vary widely, it is always an irreversible intervention. In general, cleaning is a procedure that allows removing surface layers or small contaminant particles deposited over different kinds of substrates. In conservation science, there are several interpretations of cleaning as the uniting conservation operation. Most often, it is the withdrawing of polluting particles – dirt that has been deposited or introduced on the surface. Sometimes, the term cleaning also means removing the original layers that were part of the object, which over time have changed significantly, affecting the appearance of the surface. Examples include degradation – yellowing, darkening, opacification or cracking of the surface layer on the paints.

The choice of the method depends on the type of contamination and material composition of the object. Therefore, an important part of the conservation process is material research of the object as a whole. The material investigation is undertaken to determine the chemical characteristics of the substrate (fibers, dyes, pigments, binding media, metals, etc.). The technology of materials and condition of the object is assessed and evaluated, too. Composition of soiling, their polarity, degree of (chemical) interaction with the surface and adhesion forces are other factors that the conservator has to consider.

Cleaning is an irreversible process. Assessing the possible advantages and disadvantages of any cleaning treatment is an important task in conservation. The probable effect of cleaning on the physical and chemical condition of the original material should always be assessed before any cleaning treatment is undertaken. This can include testing for stability (color change and chemical resistance) of the materials present (Tímár-Balázsy and Eastop, 2005).

2.2 CLEANING METHODS

In conservation practice, many cleaning methods are used, which can be divided into basic groups based on the method of contamination removal. There are several classifications in the literature, but generally are:

- mechanical cleaning (dusting, dry cleaning methods)
- solvent cleaning

- aqueous/wet cleaning
- surfactants cleaning
- cleaning by chemical reaction
- cleaning by emulsions
- gel cleaning
- others (laser cleaning, plasma treatment, nanocomposites materials/nanosponges, biocleaning and other)

From the historical cleaning procedures (seventeenth–nineteenth centuries), we can mention the methods of mechanical dry surface cleaning by brushes, fabrics, rubbers, sponges, ash or sharp metal objects. Various natural and chemically prepared substances, often of a very aggressive nature (e.g. lime water, beer, wine, alcohol, urine, olive oil, lemon juice, soapy water), were used for wet cleaning.

2.2.1 SOLVENT CLEANING

The nineteenth and twentieth centuries bring the possibilities of using a wide range of solvents and, concerning their properties, their targeted selection. Besides cleaning, solvents play a significant role in conservation and dissolving undesirable layers and conservation materials.

The term 'solvent cleaning' is used to describe the removal of soiling by organic solvents. Solvent cleaning is considered for the removal of soiling as soiling by tars, bituminous materials, waxes, fatty/oily dirt and synthetic adhesives. Solvent cleaning does not require an elevated temperature. Mechanical action is often necessary to aid the dirt removal. The requirement for its implementation is that the material of the treated object should not be sensitive to organic solvent, does not swell in it or does not degrade otherwise (dissolving and bleeding). Solvent cleaning is ineffective or should not be carried out if the dirt is water-soluble (clay, earth materials and salts, sugars, starches, vegetable gums, proteins of highly polar character). All organic solvents (except the highly halogenated ones) are flammable. Most solvents give off highly volatile vapors, which explains why naked flames, electric switches and other sources of sparks must be avoided when solvents are used. All organic solvents are toxic, too.

Various factors influence the choice of the organic solvent or mixture of solvents (Banik and Krist, 1986; Torraca, 1990; Horie, 1987; Baij et al., 2020):

- polarity – solvent molecules are held together by van der Waals, dipole and hydrogen bonds of various strengths and proportions, depending on the polarity of the solvent (predominance of hydrogen bonds – solvents of strong polarity, predominance of dipole bonds – solvents of medium polarity, predominance of van der Waals forces – solvents of limited or no polarity)
- fractional solubility parameters and position of solvents on the triangle diagram of solvents (Teas´ diagram)
- identifying of soiling and determining the soiling solubility
- penetration and retention of the solvent

- evaporation of solvents from the treated material
- health and safety conditions.

2.2.2 AQUEOUS (WET) CLEANING

The most important polar solvent is water. Cleaning with water mentioned as aqueous or wet cleaning is particularly suitable for removing water-soluble impurities. Water serves both as a solvent and as a medium for the cleaning processes. Water is an effective solvent for many types of dirt – inorganic soiling, such as ionic salts, and polar organic soils, such as sugars and some types of polysaccharides and proteins. The efficiency of pure water concerning the impurity removed can be increased or decreased by the addition of cations/anions that affect the ionic strength and pH of the system. Wet cleaning is, therefore, normally undertaken using water that has been filtered and purified in some way (distilled, deionized and demineralized). Water is readily available, relatively cheap and safe.

The limitations of wet cleaning are as follows:

- water can have a considerable effect on some materials cleaned: deformation, swelling, wrinkling, dissolving, dimensional changes (textiles), color changes (dyes)
- water can penetrate through the cracks and capillaries of aged material into the internal structures causing swelling of the colloidal materials (paints, wooden objects); it can create a tension that is equal to its long-term exposure to atmospheric moisture
- water causes corrosion of metallic materials.

2.2.3 SURFACTANTS CLEANING

Effective modification of wet cleaning is cleaning with the surface-active agents present (known as surfactants, wetting agents, detergents or washing agents). Surfactants even at low concentrations significantly change the energy ratios at the phase interface and, due to specific interactions with the molecules of the dispersion medium, significantly affect the surface and interfacial tension. They stabilize dispersion systems, and affect technological processes and physicochemical properties of materials, for example, they can also wet and disperse substances in water that are insoluble in water (greases and oils). Surfactant molecules are amphiphilic – they contain polar (hydrophilic) and non-polar (hydrophobic) groups. Effective surfactant concentrations are determined by their critical micelle concentration (CMC, the concentration at which micelles in solution begin to form) and depend on physicochemical conditions (temperature and pH). A typical and ancient example of surfactants in cleaning is the use of soaps (Marseille soap and Venetian soap). Currently, the most commonly used surfactants in preservation are the commercially available nonionic surfactants (TritonXL-80N, TritonX-100, Synperonic N, Igepal a Vulpex) (Tímár-Balázsy and Eastop, 2005). The risk of using these compounds is their low biodegradability.

Microemulsions can also be included among the effective water-based cleaning systems. They can remove hydrophobic dirt using only small amounts of organic solvents (in water). They are mainly used for removing old varnishes from the surface of paintings (Wolbers, 2003).

2.2.4 CLEANING BY CHEMICAL REACTION

Solvent and wet cleaning use physical processes to remove dirt from the surface. However, much soiling cannot be removed by physical processes alone. In such cases, a chemical reaction must be used to change the dirt to be readily removable (e.g. water-soluble product). Examples are the use of:

- acids and alkalis (metal corrosion products; fats, oils, resins, waxes hydrolyzed by acids or alkalis – saponification; hydrolysable dyes);
- oxidizing and reducing agents (e.g. bleaching);
- sequestering (chelating) agents, often combined with surfactants (fatty dirt, some types of dyes).

The risk assessment of chemical methods is the possibility of damage and/or loss the cleaned material. Their selection and use require deep chemical knowledge of chemical reactions, the composition of dirt and the composition of treated objects.

A special group of chemical reactions are enzymatic reactions/reactions catalyzed by enzymes. Enzymes in cleaning can break down dirt composed of large molecules into smaller (soluble) particles (old adhesives, fats and resins). Specific types of enzymes are selected according to the type of dirt – hydrogenase, lipase, protease, glycosidase, etc. Although the presence of water is essential for enzyme activity, the temperature of action and pH plays an important role. The reaction can be extremely fast. Saliva is a very effective enzymatic agent. It contains a combination of active (ptyaline, lipase and phosphatase) and emulsifying components, which give them penetration and dissolution properties. They are used, for example, to remove difficult removable layers of greasy dust. Nowadays, mainly synthetic saliva is used for hygienic reasons.

2.2.5 GEL CLEANING

Almost all of the mentioned cleaning systems, including enzymatic ones, can be applied to the surface of the treated material not only directly, in the form of a solution or emulsion, but also using a gel. Gels are carriers of active cleaning agents of aqueous, organic or combined nature. They are cross-linked natural or synthetic polymers inert to the material of the cleaned object (Angelova et al., 2011; Baglioni et al., 2014). After swelling in the cleaning solution/blend, they are transparent and easy to use. They are applied to the surface and kept in contact for a limited time. Compared to traditional cleaning methods, they are gentler on the surface layer, reduce the risk of unwanted penetration into the structure of the material and do not leave any residues on the surface (Stulik et al., 2004).

2.2.6 NEW CLEANING METHODS

New knowledge in various scientific disciplines (material science, colloid science, nanoscience, applied physics and other), advances in technology and inter-disciplinary cooperation enable new approaches to the elimination of pollutants in cultural heritage objects. The benefits should be alternatives that will eliminate the shortcomings of conventional cleaning methods. In recent years, innovative systems are developed based on nanoscience concepts such as nanostructure fluids (oil-in-water microemulsions, micellar solutions), which are characterized by high cleaning efficiency of hydrophobic deposits with small amounts of organic solvents and limited penetration into the substrate. They are effective in the removal of poly-meric coatings from different types of surfaces (Domingues et al., 2013; Baglioni, 2013; Baglioni, 2019). The physical gels (cellulose derivatives, polysaccharide-based gels and others) used in conventional conservation practice can be replaced with nanocellulose sponges, which effectively removes soiling from the hydrophilic substrate (Zidan, 2017) and chemical gels; highly retentive chemical 'sponges' can provide different chemical–mechanical properties.

A special group consists of physical cleaning methods, based on the use of various radiation sources for soil removal. This includes laser cleaning techniques that have undergone a long period of development and at present allow ablation/selective deterioration such as removal of stone, metals, pigments and organic substances (paper, parchment and other), which require different choices of laser wavelength and pulse width (Salimbeni, 2006; Zanini, 2018). The advantages of these techniques are the selectivity and the non-contact method of the cleaning process, whereas the disadvantage is the risk of damage while working with organic materials (Ferrari, 2011) and changes in color by pigment irradiation.

In recent years, research outputs have appeared that use plasma for deconta-mination of cultural heritage objects. Plasma cleaning ensures the removal of impurities and contaminants from the surface through the use of an energetic plasma created from the gaseous species. This technology offers several benefits: non-contact, multifunctional processing, with surface treatment of the order of nano-level. In the environment of plasma discharge, several mechanisms of surface modification are applied (depending on the gas and parameters), from which for cleaning purposes ablation, activation, crosslinking and sterilization are used.

REFERENCES

Angelova, L.V., Terech, P., Natali, I., Carretti, E., Weiss, R.G., 2011. Cosolvent gel-like materials form partially hydrolyzed poly(vinyl acetate)s and borax. Langmuir 27 (18), 11671–11682.

Baglioni, P., Alterini, M., Chelazzi, D., Giorgi, R., Poggi, G., Feb. 2013. Colloid and materials science for the conservation of cultural heritage: Cleaning, consolidation, and deacidification. Langmuir 29 (17), DOI: 10.1021/la304456n.

Baglioni, P., Berti, D., Bonini, M., Caretti, E., Dei, L., Fratini, E., Giorgi, R., 2014. Micelle, microemulsions, and gels for the conservation of cultural heritage. Adv. Colloid Interface Sci. 205, 361–371.

Baglioni, M., Alterini, M., Chelazzi, D., Giorgi, R., Baglioni, P., 2019. Removing polymeric coatings with nanostructured fluids: Influence of substrate, nature of the film, and application methodology, Front. Mater. DOI: 10.3389/fmats.2019.00311.

Baij, L., Hermans, J., Ormsby, B., Noble, P., Iedema, P., Keune, K., 2020. A review of solvent action on oil paint. Herit. Sci. 8 (43). https://doi.org/10.1186/s40494-020-00388-x.

Banik, G., Krist, G. (Eds.), 1986. Losungsmittels in der Restaurierung, Verlag der Apfel. 3., erw. und verb. Aufl. Wien. ISBN 3-85450-001-7.

Domingues, J., Bonelli, N., Giorgi, R., Fratini, E., Baglioni, P., 2013. Innovative method for the cleaning of water-sensitive artefacts: Synthesis and application of highly retentive chemical hydrogels. Int. J. Conserv. Sci. 4 (SI), 715–722.

Ferrari, A., 2011. The Each Project - Cultural Heritage - Second Report January 2011. https://books.google.sk/books?isbn¼8890563923 (10-11-2017).

Golfomitsou, S., et al., 2017. Coming Clean. Heritage, Conservation, and Cleaning. A Study on Cleaning. http://www.comingcleanucl.com/.

Gutarowska, B., et al., 2016. A Modern Approach to Biodeterioration Assessment and the Disinfection of Historical Book Collections. Institute of Fermentation Technology and Microbiology. The Lodz University of Technology, Lodz, Poland. ISBN 8363929018, 9788363929015.

Horie, C.V., 1987. Materials for Conservation, Butterworth, Oxford, pp. 58–62. eBook ISBN: 9781483182773.

Perry, R.A., 2000. Retouching damaged modern art, in Filling and Retouching, Conference Preprints, Association of British Picture Restorers, pp. 19–22.

Phenix, A., Burnstock, A., 1992. The removal of surface dirt on paintings with chelating agents. The Conserv. 16, 28–38.

Rivers, S., Umney, N., 2003. Conservation of Furniture, Routledge. ISBN 0 7506 09583.

Salimbeni, R., 2006. Laser techniques for the conservation of artworks. Archeometriai Műhely 1, 34–40.

Sterflinger, K., 2010. Fungi: Their role in deterioration of cultural heritage. Fungal Biol. Revi. 24 (1–2), 47e55. https://doi.org/10.1016/j.fbr.2010.03.003.

Sterflinger, K., de Hoog, G.S., Haase, G., 1999. Phylogeny and ecology of meristematic ascomycetes. Stud. Mycol. 43, 5e22.

Stulik, D., Miller, D., Khanjian. H. Khandekar, N., Wolbers, R., Carlson, J., Petersen, W.C.H., 2004. Solvent Gels for the Cleaning of Works of Art: The Residue Question, The Getty Conservation Institute.

Tímár-Balázsy, A., Eastop, D., 2005. Chemical Principles of Textile Conservation, *Part 2* Cleaning, Series in Conservation and Museology, Elsevier Butterworth-Heinemann, pp. 157–265. ISBN-13: 978-0750626200.

Tiňo, R., Vizárová, K., Krčma, F., 2019. Nanotechnologies and Nanomaterials for Diagnostic, Conservation and Restoration of Cultural Heritage, In: Lazzara G., Fakhrullin, R. (Eds.), *Chapter 11*: Plasma Surface Cleaning of Cultural Heritage Objects, Elsevier, Los Angeles, pp. 239–275. eBook ISBN: 9780128139110, Paperback ISBN: 9780128139103.

Torraca, G., 1990. Solubility and Solvents for Conservation Problems, 4th edition. ICCROM, Rome, Italy. ICCROM technical notes. ISBN: 9290770929.

Wolbers, R., 2003. *Cleaning Painted Surfaces Aqueous Methods*, Archetype Publications Ltd., London, pp. 102–107.

Zanini, A., Trafeli, V., Bartoli, L., May 16–18, 2018. The laser as a tool for the cleaning of Cultural Heritage. IOP Conference Series: Materials Science and Engineering, Vol. 364, Florence Heri-Tech - The Future of Heritage Science and Technologies Florence, Italy.

Zidan, Y., El-Shafei, A., Noshy, W., Salim, E., 92907709292017. A comparative study to evaluate conventional and nonconventional cleaning treatments of cellulosic paper supports. Medit. Archaeol. Archaeometry 17 (3), 337–353. DOI: 10.5281/zenodo.1005538.

3 Plasma Technologies in Preservation of Cultural Heritage

Plasma cleaning systems can be used for a variety of surface cleaning purposes before processing. In industrial practice, it is already efficiently used for removing surface oxidation and clearing mineral residue from surfaces. It is also used for preparing surfaces of plastics and elastomers, as well as for cleaning ceramics. It is also used for cleaning the surface of glass as well as metal surfaces. Using efficient plasma cleaning systems eliminates the need for using chemical solvents. One major benefit of using plasma cleaning is that the entire process is, or can be, operator friendly and environmentally friendly.

Plasma can be characterized as an at least partially ionized gas and is a complex mixture of different components, such as charged particles (electrons and ions) and neutral species (atoms and molecules), in addition to radicals, UV photons and irradiated heat. In general, plasma can be classified according to its temperature in thermal and nonthermal plasmas. A thermal plasma is an almost completely ionized gas, whereby the temperatures of the charges and neutral species are approximately equal, with temperatures typically reaching at least 15,000 K (Eliasson and Kogelschatz, 1991). In comparison to thermal plasma, nonthermal ones are only partially ionized, indicating that the number of neutral species is much higher than the number of charged species, whereby the temperature of the different particles is not equal. The temperature of electrons is still in the range of several thousand Kelvin, but the temperature of the neutral species and ions can be close to ambient temperature. Thus, nonthermal plasmas are also termed cold plasmas.

For the generation of cold plasma, energy needs to be supplied to a gas, where electric energy sources have been shown to be the most convenient. The lifetime of the particles inside the plasma is quite small due to energy loss by collision processes, and therefore energy must be supplied continuously for plasma applications. The generation of cold plasma can be achieved under atmospheric pressure and/or lower pressure conditions (Hertwig et al., 2018).

A plasma treatment is usually, but not always, performed in a chamber or enclosure that's evacuated (Vacuum plasma). The air within the chamber or enclosure is pumped out prior to letting the gas in. The gas then flows in the enclosure at low pressure. This is done before any energy (electrical power) is applied. It is imperative to know that plasma treatment performed at a low temperature can easily

process materials that are heat-sensitive. There are also multiple plasma systems operating in ambient air at atmospheric pressure (atmospheric plasma).

These types of plasma are sometimes referred to as 'cold plasma'.

In general, there are a number of plasma definitions, according to various disciplines with which it is connected. The simplest ones tell us that sufficient additional energy to gas creates a plasma. In the case of cold plasma, suitable for the modification of natural polymers, the basis of the process remains on the excitation of gas at reduced pressure or atmospheric pressure by radiofrequency (RF) energy. A review of multiple cold-plasma reactors that are not covered by this chapter describes the technical aspects of most low-temperature plasma systems (Hnatiuc et al., 2012).

By producing high-frequency electric discharges, plasma generates ionized gas that can modify the surface properties of the material it is in contact with. Plasma treatment is a versatile and powerful technique commonly used in many industries for materials such as plastics, textiles, glass, and metals.

3.1 LOW-PRESSURE OPERATING PLASMA SYSTEMS FOR METALLIC OBJECTS SURFACE TREATMENT

The low-pressure hydrogen-based plasmas operating in the flowing regime where the reaction products are continuously pumped out of the system were studied broadly (Daniels 1979; Daniels 1981; Patscheider and Veprek, 1986; Veprek et al., 1985, 1988; Rašková et al., 2002). The diffusion length of active particles is not too short at low pressure (typically, a pressure of hundred Pascals is used). Therefore, active particles are able to penetrate into the pores or holes in the surface and, thus, nearly the whole surface can be treated.

3.1.1 VACUUM AND GAS HANDLING SYSTEM

As it was described above, special systems are needed to complete the low-pressure plasma treatment of metallic objects. The general scheme of such systems is shown in Figure 3.1. The core of the experimental device is a vacuum chamber with a pumping system and a proper gas handling system.

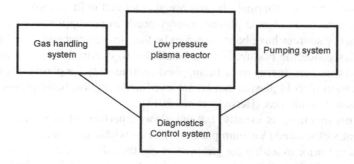

FIGURE 3.1 General concept of the low-pressure plasma system for the surface treatment of archaeological objects.

The vacuum chamber can be made of stainless steel in case of an internal electrode system (see Section 3.1.2 and Figure 3.3) or it can be made of Pyrex or Quartz glass if external electrodes are used. The chamber size can be from 20 cm in its diameter with the height from 50 cm up to a couple of meters in case of a stainless steel reactor. For the glass reactor, a diameter starting at 10 cm and its length from 40 cm up to meters is applicable. Both kinds of reactors must be easily open for the manipulation of the treated samples and be equipped with non-conductive sample holders (ideal material is glass). An exception is if samples are simply placed on the bottom electrode in case of the stainless steel reactor chamber. The fused silica optical window is necessary for the plasma process monitoring in case of the stainless steel reactor. High vacuum pressure is not needed for the process; thus, silicon rubber gaskets are sufficient for the reactor sealing. The glass reactor should have flanges isolated from the rest of the device (i.e. mounted at the floating potential) to avoid their role as grounded electrodes. The detailed scheme of the vacuum and gas handling system is given in Figure 3.2.

The pumping system needs a simple mechanic pump like a two-stage rotary oil pump or at least a two-stage membrane pump; the use of a scroll pump is possible but it is more expensive. The base pressure of the pump should be in the order of about 1 Pa to ensure proper pumping before the process. The pumping speed depends on the volume of the plasma reactor, so it is better to consult this parameter directly with vacuum technologies suppliers. In general, the pump with a speed of about 4 m^3/hour is sufficient for small systems. A mechanical filter at the pump input should be installed to avoid the intake of small grains falling off from the treated samples during manipulation with them because they can mechanically damage the pump. The strongly corroding hydrochloric acid and other less corrosive species are generated by the plasma process (Chapter 5), thus it is necessary to avoid their introduction to the pump, although the membrane pump can be constructed in a chemical version which would be less sensitive to their effects.

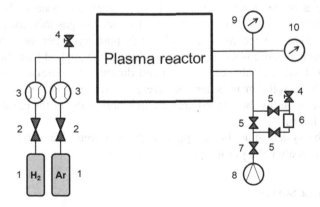

FIGURE 3.2 Scheme of the vacuum and gas handling system. 1 – High-pressure cylinder; 2 – on/off valve; 3 – mass flow controller; 4 – airing valve; 5 – on/off valve; 6 – cold trap with a reactive absorber of HCl; 7 – regulating valve; 8 – vacuum pump; 9 – operating pressure gauge; 10 – atmospheric pressure indicator/gauge.

Exhaust gas must be led into the outer open space, not to the laboratory because of hydrogen presence and to avoid potential higher hydrogen concentration in the closed volume (hydrogen is explosive in the air in concentrations between 3% and 97%). A simple cooled trap (liquid nitrogen cooling is not necessary, simple water cooling is sufficient) filled with material easily corroded by hydrochloric acid with a large surface (like aluminum shavings) is a good solution. The operational pressure is in the order of hundreds of Pascal. To be able to set the pressure and also for a good pump start, it is useful (but not necessary) to add some regulating valve at the pump input. The gauge operating in the range of about plus-minus 2 orders around the operating pressure must be installed close to the reactor chamber. The additional simple gauge showing pressure up to atmospheric values is useful but not necessary.

Plasma is generated in the gaseous mixture containing mainly hydrogen because this element is the most important in the plasma chemical reactions with the corrosion products (Chapter 5). The initial studies (Veprek et al., 1988) also used much more complicated gaseous mixtures containing methane, argon and nitrogen. Later studies (Fojtíková et al., 2015b, 2015c; Sázavská et al., 2012) used hydrogen–argon mixtures only. If the hydrogen–argon gaseous mixture is used, the surface bombardment by atomic argon (both neutral and ionic) species contributes to the surface processes by ablation because of 40 times higher mass of argon ions than hydrogen atoms. The negative effect is in the significantly higher heating of the treated object, especially in the atomic scale (Note that the surface bombardment is by inert gas atoms. They lose not only their kinetic energy, but also some part or even all excitation energy. All this energy becomes heat because argon is non-reactive). This very local (only a few surrounding atoms at the surface are affected) overheating can lead to the selective melting of the surface material. This was observed when tin atoms from the copper matrix were removed from the bronze surface after the plasma treatment although the bulk material temperature was about 100 °C below the tin melting point (Fojtíková et al., 2015a, for example, see Figure 3.10).

To ensure a proper gaseous mixture flow through the system, the mass flow controllers are the best solution. To be able to vary the gas mixture composition, two separate lines are recommended, although pure hydrogen or a pre-prepared hydrogen–argon mixture is used. The gases should be supplied from high-pressure gas cylinders. Hydrogen also can be prepared directly at the device from water by electrolysis. This solution is better for safety reasons but in this case, hydrogen contains some humidity that can complicate the monitoring of the plasma treatment process (see later).

Finally, the system must be equipped with an ambient air valve to be able to open the system after the plasma process completing.

3.1.2 POWER SUPPLY

The most frequent systems use RF power supplies (operating at a frequency of 13.54 MHz or 27.2 MHz). The use of direct current (DC) systems is possible in principle but cathode material sputtering is an issue that can contaminate the treated object. Moreover, DC systems are not commonly used for large volume plasmas.

Systems based on the microwave discharge (typically 2.54 GHz) are also not convenient because metallic objects are at least partially conductive and they can disturb the electromagnetic field in the reactor. Moreover, objects will significantly heat up in this kind of discharge.

Figure 3.3 shows two general concepts for the creation of low-pressure capacitively coupled RF discharge (Lieberman and Lichtenberg, 2005; Raizer et al., 2019; Roth 1995).

An advantage of the common system used for plasma deposition is that these systems are broadly used in various technologies, so they can be easily purchased in various sizes of the reactor chamber up to several m^3. Additionally, treated objects can be simply placed on the bottom electrode and it is possible to change bias voltage on it (see later). A disadvantage is that objects are not treated simultaneously from the bottom side, so two treatments are necessary for the whole surface treatment. Also, there is a danger of possible object contamination from the electrode material. The other systems (see Figure 3.3-right) are combinations of the capacitively coupled RF discharge with the dielectric barrier discharge (DBD). The electrodes are placed out of the Pyrex or quartz reactor tube, so there is no possible contamination of the treated object by the electrode material. A disadvantage of these systems is in their cylindrical shape and relatively limited size (up to about 2 m in length and 1 m in diameter). Also, it is impossible to apply any bias on the treated objects, so it is impossible to regulate the ion flux interacting with the treated object surface. An additional electromagnetic shielding (Faraday catch) must be installed around the plasma reactor due to the significant electromagnetic radiation into the surroundings. On the contrary, the system construction is simpler. In both systems, objects can be positioned in the reactor volume using different non-conductive holders and thus the whole surface treatment can be done within one

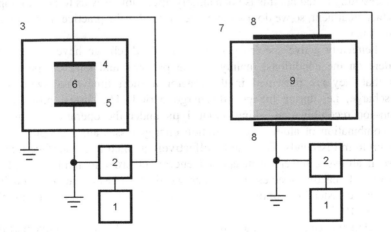

FIGURE 3.3 Schemes of the low-pressure capacitively coupled RF discharge. Left – a common system used for plasma depositions; right – electrodeless system. 1 – RF generator; 2 – matching network; 3 – stainless steel vacuum chamber; 4, 5 – inner electrodes; 6 – plasma; 7 – glass reactor; 8 – outer electrodes; 9 – electrodeless plasma.

step of the process if no bias is applied. Besides the power supply, it is necessary to ensure a proper energy transfer from the power supply to the plasma. The situation is similar to in case of the classical radio or TV tuning. Plasma is partially reflecting power because it is a conductive matter with its own capacitance and inductance. The additional device called a matching network containing tunable capacitors and inductors must be installed between the RF power supply and the plasma electrode system. The tuning can be realized manually or automatically. The automatic tuning can bring some problems in the case of plasma operating in the pulsed regime (see at the end of this section).

The presence of ionic species in plasma allows regulation of the ionic flux interacting with the surface by the additionally applied DC voltage. Such procedure is widely applied in the plasma-assisted/enhanced deposition techniques (PACVD/PECVD) or in plasma etching (Lieberman and Lichtenberg, 2005; Roth 1995). The negative bias voltage applied to the treated object increases the positive ions flux. The problem of cultural heritage objects typically is their very complicated shape and a bad conductive surface. The direct application of bias voltage into the object body is impossible because of possible partial object damage.

The application of bias voltage is simply possible in the case of common plasma systems with internal electrodes (see Figure 3.4). In this case, the object can be placed on the bottom electrode that is biased (commonly directly from the RF power supply), and thus, ions are accelerated from plasma also to the object surface but only from one side (as it was pointed above). The bias application is much more complicated in the case of glass reactors. It is possible only if the biased thin metallic mesh that covers the treated object is used. This is not too well-suited and, thus, the bias voltage application is convenient only for objects with smooth and less complicated surfaces (like coins). The problem is also in the biasing of the mesh because of the additional high-voltage feedthrough necessity. This possibility was successfully tested but this is not a simply applicable way as to how to improve the surface treatment, so we do not recommend this for the practice. For details, see Chapter 8.6.5.

All chemically active species generated in the discharge have some lifetime dependent on the conditions, mainly on the pressure and kind of species. This means that they are presented in the reactor a short time after switching off the discharge, i.e. during the post-discharge period. The fastest process is the electron–ion recombination taking about 1 μs under the operational conditions. The recombination of atoms and excitation energy losses are a couple of orders slower up to milliseconds. This can be effectively applied to the surface treatment because it allows a lower mean applied energy in order to maintain high concentrations of reactive species. In another word, the plasma can be used in the pulsed regime instead of continuous (see Figure 3.5, Lieberman and Lichtenberg, 2005; Roth, 1995).

Parameters that can be varied are the maximal power during the active part of the discharge, the duty cycle (i.e. relative time of discharge in %) and the duty cycle frequency. Higher maximal power evokes higher concentrations of active particles but also elevates the temperature because higher mean energy is supplied into the plasma; duty cycles of 20–40% seem to be optimal (Sázavská et al., 2012, see also

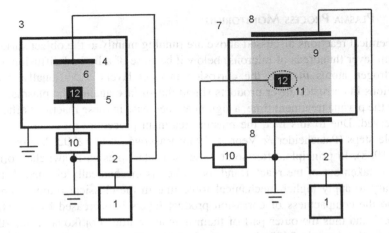

FIGURE 3.4 Schemes of the low-pressure capacitively coupled RF discharge with the application of bias voltage. Left – a common system used for plasma depositions; right – electrodeless system. 1 – RF generator; 2 – matching network; 3 – stainless steel vacuum chamber; 4, 5 – inner electrodes; 6 – plasma; 7 – glass reactor; 8 – outer electrodes; 9 – electrodeless plasma; 10 – bias voltage supply; 11 – metallic mesh surrounding the treated object; 12 – treated object.

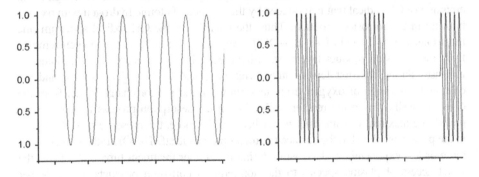

FIGURE 3.5 Continuous (left) and the pulsed (right) regime of the RF discharge.

Chapter 8.6). The duty cycle frequency is optimal in the order of 100 Hz to 1 kHz at pressures of hundreds Pa with respect to the active species lifetimes. The use of the pulsed regime can induce problems with the optimal setting by the automatic matching network. Commonly, it starts to be unstable, and thus, it is impossible to automatically set the optimal energy transfer from the power supply to the plasma. This problem can be easily solved if the matching network is set at the given plasma conditions in the continuous regime and after that, the automatic network regime is turned off.

3.1.3 PLASMA PROCESS MONITORING

The chemical reactions discussed above are running mainly at the object surface or in a thin layer (hundreds of microns) below it because of a limited diffusion ability of hydrogen atoms through the corrosion product layers. Additionally, the incrustations in corrosion layer products shield the surface against the plasma. Thus, during the plasma treatment time, a significant decrease in these reactions efficiency is observed. Due to this fact, the plasma treatment procedure must be applied in multiple steps (Patscheider & Veprek, 1986; Rašková et al., 2002; Veprek et al., 1985, 1988). In principle, after some time (see later) plasma is switched off, the object is taken out of the reactor and its surface is mechanically cleaned. It is not necessary to apply higher mechanical force like in the classical removal process because the compactness of corrosion product layers is decreased by the plasma treatment and thus the outer part of them is much brittle (Fojtíková et al., 2015b, 2015c; Rašková et al., 2002; Krčma et al., 2014). Typically, the application of a dental brush, pulp, or a simple dish sponge is fully sufficient. After that, the next plasma cycle can be carried out (Rašková et al., 2002).

A question is how to decide when the plasma process treatment starts to be non-efficient. Visual observation of the treated surface of the object does not ensure proper information; moreover, each object is different by its shape and color. Among the hydrogen plasma treatment reaction products, there are species that can be easily detectable. When we look at the spectrum emitted during the plasma treatment (see Figure 3.6), besides atomic and molecular hydrogen radiation, there is a significant emission of OH radical that is produced by the reaction of atomic hydrogen with oxygen built up in the corrosion products. Thus, the intensity of the OH radical spectrum (the most intense is 0-0 band of A $^2\Sigma \rightarrow$ X $^2\Pi$ transition) well reflects the oxygen removal from the corrosion product layers (see Figure 3.7). It is well visible that the intensity increases during the first few minutes. This is related to the object heating and accelerated desorption of oxygen from all surfaces in the reactor chamber (i.e. from the object as well as from the reactor walls). When the desorption process is nearly completed, the maximal OH intensity is reached. Furthermore, the presence of OH radicals in the plasma is related to the surface treatment process itself. The OH radical intensity is more or less exponentially decreasing during the further treatment time that reflects the worst access of plasma species to the non-reduced corrosion products in the deeper layers. It was proposed in the study of Rašková et al. (2002) that the process should be stopped when the OH radical intensity falls down to about 10% of its maximal value.

The optical emission spectra are additive, so all particles from the plasma emit photons simultaneously. Therefore, radiation of nitrogen second positive system (C $^3\Pi_u \rightarrow$ B $^3\Pi_g$), mainly the band 1-0 at 317 nm (Pearce and Gaydon, 1976) is also visible in the spectrum (see Figure 3.8) and it is overlapping with an OH radical band. Thus, for the process monitoring, only the interval between 306 and 312 nm is suitable where this overlap is fully negligible. Because of some background radiation (see Figure 3.8), the intensity of OH must be corrected to it. The good choice for the estimation of background emission intensity is the spectral interval of 304–305 nm where no other emissions are presented. The presence of nitrogen is not surprising, especially at the beginning of the process because molecular nitrogen

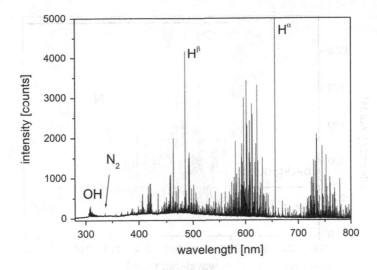

FIGURE 3.6 Example of the full optical emission spectrum of plasma during the plasma treatment of an iron model sample in the continuous regime at 300 W.

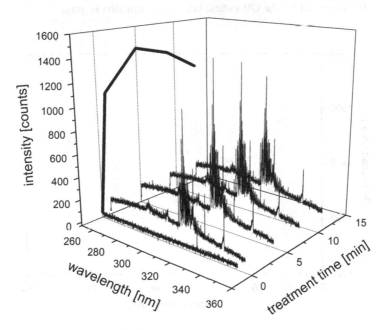

FIGURE 3.7 OH radical spectrum during the plasma treatment of the iron sample (the maximal OH intensity is depicted in *xy* plane).

is adsorbed on all surfaces. It is also visible in Figure 3.9 that its intensity simply falls down during the treatment time. The presence of the molecular nitrogen spectrum can also indicate some air leakage into the reactor chamber.

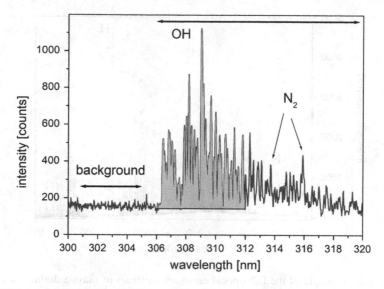

FIGURE 3.8 Detail of OH radical spectrum during the plasma treatment of the iron sample with marked background and overlap with nitrogen second positive system (C $^3\Pi_u$ → B $^3\Pi_g$), 1-0 band. The area used for the OH radical intensity calculation is gray.

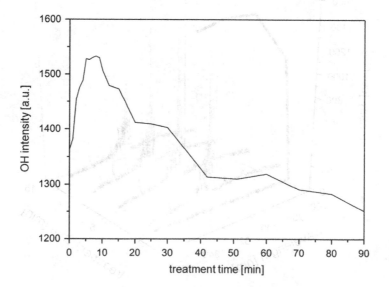

FIGURE 3.9 Example of integral OH radical intensity during the plasma treatment of the iron model sample.

An additional point is that it is possible to see some atomic lines such as Pb (322.05 and 324.02 nm), Zn (330.26 and 334.50 nm) or Sn (300.91, 303.41, 317.50 and 326.23 nm, see Figure 3.10; Kramida et al., 2020) in the same wavelength

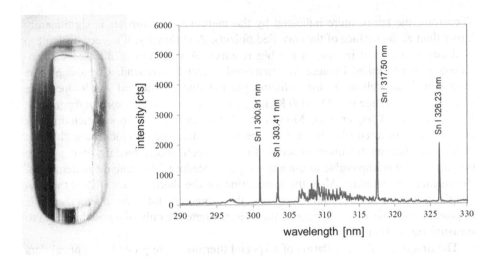

FIGURE 3.10 Presence of tin spectral lines in the plasma treatment of bronze sample (right) and presence of tin mirror deposits around the treated sample (right, the sample was removed before taking the photo).

interval as OH that originates from the object material. This indicates that the treated object is locally overheated and the process must be stopped immediately because some compounds of the object are evaporating and the object starts to get damaged.

Thus, it is clear that the optical emission spectrometry provides very important information about the process itself as well as information about the potential damage of the treated object. It is not necessary to use a big spectrometer with high resolution. It is fully sufficient to use a spectrometer covering the spectral interval of 300–330 nm. Of course, better resolution in the order of 0.1 nm is beneficial. There are more small compact spectrometers offered by producers fulfilling this requirement, thus it is no problem to implement them into the technology.

As it was pointed above, there is quite a high probability for selective evaporation of some metals at temperatures significantly (more than 100 °C) below the melting point. Besides this, the temperature of the treated object is also critical for very stable metals such as iron because it can induce changes in its metallographic composition. All metals have different crystallographic phases depending on their manufacturing (Lavakumar, 2017) that give us important historical information about object manufacturing procedures and can also help in the object origin identification (Scott, 1991). These changes are observed at temperatures deeply below the melting point.

The direct temperature measurement of the object surface is impossible because of the RF electromagnetic field presence (Zajíčková, 1997). The mercury thermometer was used in the initial works (Patscheider and Veprek, 1986; Veprek et al., 1985, 1988) but such devices are currently prohibited. Furthermore, it could not reflect the real temperature of the treated object because its surface is clean and thus no chemical reaction besides the surface recombination is running on it.

Therefore, the temperature indicated by the mercury thermometer is significantly lower than at the surface of the corroded objects. Additionally, it is very difficult to read any value on it in case of the big reactors. Application of infrared thermometers is very limited because the measured object is surrounded by the plasma reactor wall as well as by the radiating plasma that has neutral gas temperature typically in the range of 500–1000 K (i.e. much higher than the object temperature; for details, see Chapter 8.6). Moreover, object surface conditions including its emissivity in infrared (that is used for the temperature measurement) are changed during the plasma treatment process. Finally, each object has its own surface properties so it is impossible to use any simple procedure for online measurement of the surface temperature. Also, the application of the thermometer (like a thermocouple probe or a platinum resistance thermometer) into the object body is impossible because of the damage to the object. There are only two possible ways to measure object temperature.

The first one is the installation of a special thermocouple probe with optical data transfer on the object surface. For its installation, a thin glass wire should be used to allow maximal access of plasma to the treated surface. The second one is the application of the same probe into an auxiliary new object made of the same material of similar shape and size because object temperature is dependent on the material, its thermal capacitance and the shape (Řádková et al., 2015). We can suppose in this case that object temperature is not so much higher than the measured one because corrosion product layers, especially with incrustation, are less thermally conductive than the bulk metal.

It is possible to optimize and partially automatize the plasma treatment process based on the measured object temperature during the process and combining this information with the observation by the optical emission spectrometry. The supplied power into the plasma can be modified in two ways. The first one is an absolute value of the power in case of the continuous mode. In principle, higher power can be applied at the beginning of plasma treatment and the power will be attenuated when the temperature is reaching some pre-set limit depending on the treated object material. A change of the duty cycle can be applied for the same purpose in case of the pulsed regime operation (examples and details see in Chapter 8.6).

As it was written before, the low-pressure systems allow the simultaneous plasma treatment of more objects. Based on the detailed process and equipment discussions, a set of rules must be established for this application. All simultaneously treated objects should be made of the same metal, similar size and ideally also similar shape because object heating is dependent on all these characteristics. The maximal object temperature during the treatment must be kept about 100 K lower than the lowest melting point of any metal in the alloy to avoid the selected metal evaporation. The same limit should also be applied with respect to the metallic phases (Krčma et al., 2016).

The application of the low-pressure pure hydrogen plasma on the selected compounds typically presented in the corrosion layers was studied in detail by Schmidt-Ott in Zurich (Schmidt-Ott and Boissonnas, 2002; Schmidt-Ott, 2004).

The pilot experiments in the surface treatment of metallic objects have been also carried out using a cascading arc plasma source developed in Eindhoven (Graaf et al., 1993, 1995). This application was done at a lower pressure in the plasma outgoing from the cascading arc source. The treatment was not done in the active discharge but at the post-discharge conditions at a much lower temperature and at a low concentration of ions. The advantage of this device is a high concentration of neutral active species because the discharge itself is formed at a much higher pressure and the possibility to treat the bigger area is contrary to jets (see the next chapter). The disadvantage is that the plasma treatment is possible from one side only, thus it is necessary to manipulate the object to complete the full surface treatment. And such operation is not so simple under the low-pressure conditions.

3.2 ATMOSPHERIC PRESSURE OPERATING PLASMA SYSTEMS FOR METALLIC OBJECTS SURFACE TREATMENT

The application of various discharges operating at atmospheric pressure for the corrosion removal from the metallic objects is less studied up to now. These discharges, commonly, ensure the local treatment only. Although the concentrations of the active particles are much higher than in the low-pressure systems, the treatment procedures are much slower and need a lot of manpower. Thus, these systems can be recommended for special purposes only and not for the emergency treatment of big objects or object assemblies.

The majority of these systems is based on various plasma jets operating at atmospheric pressure (Lieberman and Lichtenberg, 2005; Roth, 1995). The common systems are based on the DBD and they are supplied by audio-frequency (operation frequency is in tens kHz) or RF (typically 13.56 or 27.2 MHz) high voltage. Recently, a microwave system was also developed. These plasma sources are broadly studied during the last decade mainly because of their applicability in the plasma medicine field, i.e. they represent a very soft tool applicable to the cultural heritage objects treatment too. The surface temperature is only slightly elevated, typically not exceeding 50 °C and, thus, the thermal damage of the treated objects is impossible.

In the case of audio or RF jets, the plasma is generated in capillaries of inner diameter up to 2 mm in helium or argon with additional reactive gasses at atmospheric pressure. There are two general concepts. The first one uses one electrode inside the capillary and the second one outside (see Figure 3.11-left) and the second one uses both electrodes as external (see Figure 3.11-right).

The plasma is created in the flow of argon or helium (this is because of lower temperature important mainly for the treatment of the biological object) or their mixtures. Typical mass flows are in the order of 100 ml/min up to several liters per minute, so the velocity of the gas particles is in the order of meters or tens meters per second. Another gas such as hydrogen can be added into the gaseous mixture before the discharge or after that as it is depicted in Figure 3.11-right. This additional gas input can be simply perpendicular or radial (in this case vortex flow is formed). The surface of the treated object is affected by the plasma downstream

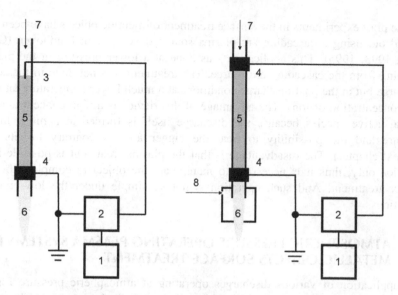

FIGURE 3.11 Scheme of audio or RF dielectric barrier plasma jets. 1 – audio/radio frequency power supply, 2 – matching network (for RF, only), 3 – tip high-voltage electrode, 4 – outer ring electrode, 5 – active discharge, 6 – post-discharge (discharge downflow), 7 – main gas flow, 8 – auxiliary gas flow.

from the jet only, and thus no ions are involved in the surface reactions (lifetime of ions is in the order of microseconds only, so they are neutralized by electrons before arriving at the surface). The gas flow also forms a protecting atmosphere around the treated surface spot (see Figure 3.12). The reaction mechanisms are the same as they are described in Chapter 5. This application is possible by the surface scanning mainly for the smooth surfaces, the treatment of complex objects is carried out manually only, and its effectiveness is dependent on the shape of object. The penetration of plasma into the object holes is limited because of rather high gas flow. In some cases, the formation of spark discharge between the plasma jet and the surface is also possible. It is difficult to ensure the treatment soft enough because the object surface starts to play the role of the electrode and it can be overheated and/or even sputtered. The problem should be the application of hydrogen-containing plasma in the closed laboratory because of hydrogen–oxygen mixture explosiveness. Thus, this kind of device must be operated only in the proper functional hood.

The practical applicability of two different plasma jet systems operating in the argon–hydrogen (35%) gaseous mixture under the open-air conditions was demonstrated on the surface treatment of the nineteenth-century daguerreotype (Boselli et al., 2017). It was shown that the corrosion reduction was successful without any measurable damage to the original object. Another electrodeless plasma jet developed especially for the cultural heritage objects treatment was described in Patelli et al. (2018). Firstly, the daguerreotype surface was treated in the argon–oxygen plasma for the removal of the former conservation by epoxide. Subsequently, the

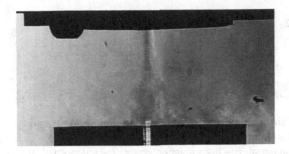

FIGURE 3.12 Plasma jet gas flow visualization by Schlieren imaging. Microwave torch (Benova et al., 2016) with quartz capillary (i.d 3 mm, o.d. 8 mm) at argon flow of 4 Slm and 10 W, the distance between the end of capillary and substrate is 30 mm.

argon–hydrogen (0.008%) plasma was used for the metallic reduction. Applicable temperature below 40 °C was observed during the treatment. The detailed study of Ag_2S and Cu_2S corrosion products by the helium–hydrogen atmospheric plasma jet system was also presented in another recent study (Grieten et al., 2017). Also, in this case, it was shown that the plasma jet system can be applied for this purpose.

A significant advantage of this kind of plasma jets is its small size and simple operation. Thus, these plasma systems can also be applied out of the laboratory conditions; they can be used for the selected open-air applications such as the treatment of stained parts of the stained windows. The comparison of the plasma jets with other methods applied for the surface cleaning, mainly of daguerreotypes, was described recently (Grieten et al., 2017; Schalm et al., 2018).

In the case of planar metallic samples, the volume DBD can also be applied again using the hydrogen or hydrogen–argon gaseous mixture at atmospheric pressure (Lieberman & Lichtenberg, 2005; Roth, 1995). The problem should be in a typically higher energy density resulting in higher object heating. Also, in this case, the security regulations must be taken into account because of a high explosion risk due to the hydrogen-based gaseous mixture. Currently, there is no evidence about the application of this discharge for the removal of corrosion products.

3.3 LASER-BASED PLASMA SYSTEMS FOR METALLIC OBJECTS SURFACE TREATMENT

The last group of the gaseous atmospheric pressure operating plasma devices contains systems using laser-based plasmas. A couple of laser-based techniques are widely used in the analytical chemistry, namely, Laser-Induced Bulk Spectroscopy (Singh & Thakur, 2007; Cremers & Radziemski, 2013; Musazzi & Perini, 2014; Noll, 2012), Laser Ablation Mass Spectrometry (Sylvester 2008; Hirata 2012; Vašinová et al., 2014) or Matrix-Assisted Laser Desorption/Ionization Time Of Flight spectrometry (Hosseini & Martinez-Chapa, 2016). The general principle of the laser action on the surface is the same for all of them. In its principle, that is also shown in Figure 3.13, a short laser pulse (typically Nd-YAG laser at 1024 nm wavelength) evaporates material at the surface area of a few microns in the diameter

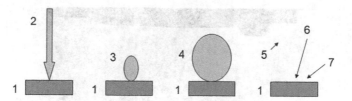

FIGURE 3.13 Scheme of the laser ablation-based corrosion removal. 1 – treated object, 2 – laser beam, 3 – plasma plume, 4 – plume of evaporated material, 5 – (nano)particles formed from the ablated material, 6 – laser ablation crater, 7 – redeposited material (crater wall).

and tens of nanometers in the depth (Miller & Haglund, 1991; Phipps 2007). The treatment of some area can be realized by scanning along the surface. The problem of a broad application of this technique is that the surface is locally overheated (to be able to evaporate its material) and, thus, both local thermal stress and local metal phase changes can be observed. Also, not all material is evaporated. Some part of it is redeposited around the laser spot and forms so-called crater walls. Thus, more scans are needed for full removal. An additional disadvantage is that there is no access to the holes in the objects and it is very complicated to treat uniformly any object with a complicated structure. An important advantage of the laser ablation is a possibility to get the long distance between the laser source and the treated surface (Gronlund et al., 2006; Salle et al., 2007). Currently, small laser evaporating systems are also available in the market and thus the surface treatment of not easily accessible objects in the outdoor can be possible.

A couple of studies were made with respect to the laser ablation applied for the surface cleaning of metallic historical objects. The first study in this field was in 1998 (Turovets et al., 1998). They treated the daguerreotype surface by the laser beams. The important note is that it is also possible to treat locally colored daguerreotypes without any color changes, gilded and un-gilded plates, and remove tarnish without object immersion into solvents and chemicals. Another set of experiments with the laser ablation treatment of daguerreotypes was carried out by the group around Valerie Golovlev (Golovlev et al., 2000, 2001, 2003). These studies were focused on the analysis and removal of thin tarnish from the surface of colored daguerreotypes. The best parameters of laser wavelength, power and pulse duration have been determined.

Another study was using Ti:Sapphire 150 fs laser pulses focused to a beam diameter of 60 μm and normally incident to the daguerreotype (Abere et al., 2011). It was found that the corrosion layer has a lower material removal threshold than silver, allowing for removal of corrosion with minimal removal of vital information contained in the silver substrate. Thus, this technique was evaluated as more effective for the removal of corrosion products such as silver oxide and silver sulfide than chemical cleaning. Moreover, chemical cleaning is hard to control and often leads to the damaging to the underlying silver, which consequently can significantly damage the image.

The artificially prepared chlorine-containing corrosion products of copper, brass and steel were treated by three different lasers with selected repetition frequencies

(Atanassova et al., 2019). The cleaning was performed at dry as well as in wet conditions. The detailed study of the black encrustation removal of silver sulfide by the KrF excimer laser was presented recently (Raza et al., 2019). Applied laser energy per pulse and the number of pulses were varied as the process parameters. The 5–10 μm thick layers of the silver sulfide were possible to remove without affecting the silver substrate. The Q-switched Nd:YAG laser at 1064 nm was performed on two different types of corroded coins excavated from under the Red Sea water (Abdel-Kareem et al., 2016).

3.4 APPLICATION OF PLASMAS WITH LIQUIDS

The application of all kinds of plasmas leads to the elevation of the temperature of the treated object. Thus, systems that will ensure a direct cooling of the treated object can be very beneficial. During the last decade, broad research of electrical discharges interacting with various liquids was carried out with respect to the fields such as water decontamination (Gözmen et al., 2009; Kozáková et al., 2019; Perkins, 1999; Rauf and Ashraf, 2009; Tosik 2005), synthesis and surface treatment of nanoparticles (Chiang et al., 2020; Fedlheim and Foss, 2001; Kozáková et al., 2019; Liguori et al., 2018; Sharma et al., 2017), medicine (Jayasena et al., 2017; Lee et al., 2017; Lu et al., 2016; Sosnin et al., 2004; Stoffels et al., 2002; Zhang et al., 2015), agriculture (Bradu et al., 2020; Judee et al., 2018; Puac et al., 2018; Rezaei et al., 2019), etc. The most widely used liquid is water and its solutions. However, some experiments with pure organic or ionic liquids have been successfully completed too (Bruggeman et al., 2016; Locke et al., 2006; Malik et al., 2001). Applicability of the plasma–liquid systems for the conservation and/or restoration purposes thus opens a new perspective way. The interaction of plasma with water environment forms OH radicals that are strongly oxidative, so the applicability of these systems is limited generally to non-oxidizing materials, i.e. artifacts made of glass and ceramics. The use of organic liquids is limited mainly by the formation of carbon nanostructures and also a potential hazard due to the formation of byproducts that can be harmful and/or environmentally unfriendly.

Application of the discharge with liquids for the surface treatment of ancient glass and ceramic objects allows a simultaneous removal of corrosion product layers with the removal of organic pollutants deposited on their surface. Products of the plasma–surface interaction can be simply dissolved into the bulk liquid or can be removed by the liquid flow. The layers deposited on the ancient glass and ceramic surface contain mainly compounds from the surrounding environment with species, mainly alkali metal compounds, originating from the object core. Based on the discharge configuration and its supply, the plasma–liquid–surface interactions can significantly differ.

Interactions between plasma and the surface in the liquid environment are very complex (Bruggeman et al., 2016). In the case of water, the main generated chemically active species are H, O, and OH. Thus, this treatment combines both oxidation (via reactions with O and OH particles) and reduction (via reactions with atomic hydrogen) together. Additionally, the water environment commonly contains (or can contain after a defined addition) ions of alkali metals that can diffuse

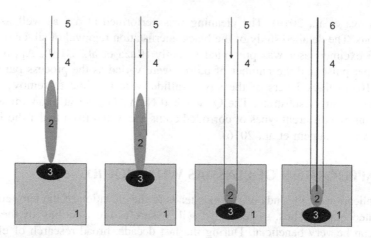

FIGURE 3.14 Plasma–liquid system concepts convenient for ancient object treatment. 1 – liquid, 2 – plasma, 3 – treated object, 4 – capillary, 5 – gas flow, 6 – high voltage wire (see later).

back into the surface layers of the bulk material from which they were removed during the corrosion process.

The plasma–liquid system can be formed in a huge number of plasma–liquid and electrode configurations (Vanraes et al., 2016). In principle, we can distinguish three main concepts (see Figure 3.14). Plasma can be simply generated in the gaseous phase above the liquid (i.e. in some of the plasma systems described in Chapter 3.2) with all advantages/disadvantages presented there and later here. The second possibility is the plasma generation using jets immersed into the liquid, i.e. systems with plasma in artificial gaseous bubbles in the liquid. The last possibility is the generation of electrical discharges directly in the liquid without the addition of any gas.

The creation of electrical discharges inside the liquid phase needs an electric field focusing at some tip because the breakdown voltage is about 1 MV/cm (i.e. about 30 times higher than in the case of discharges in the gaseous phase at atmospheric pressure). Thus, the most typical configuration is a point to plane, i.e. one tiny tip connected to the high voltage and the second planar electrode placed anywhere in the liquid of low conductivity. The applied voltage at such conditions is commonly around or exceeding 20 kV. Due to this fact, the power cable is very thick and it is not possible to manipulate it simply. Therefore, it is difficult to realize the surface treatment of objects except for planar ones. The recently patented (Krčma, 2015, 2019) and published (Krčma et al., 2016, 2018) configuration based on the pinhole discharge is more versatile (see Figure 3.15).

The principle of this discharge is in the microbubble formation by the liquid evaporation at the surface (Asimakoulas et al., 2020) or close to the pin electrode by the passing current. Therefore, the discharge itself is ignited in the bubble formed by the evaporated liquid, and thus applied voltage of about 1–2 kV is sufficient. This allows a simpler power supply as well as thin cables, so the electrode system

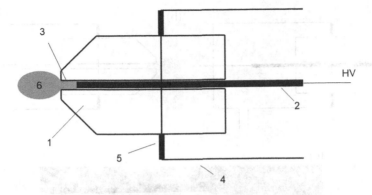

FIGURE 3.15 Scheme of the electrode system based on pinhole discharge. 1 – Dielectric body, 2 – wire tungsten electrode, 3 – space with enhanced current density, 4 – glass holder, 5 – silicon glue, 6 – plasma in a bubble of evaporated liquid.

FIGURE 3.16 Practical realization of the pinhole-based electrodes for the surface cleaning of ancient objects. Electrode with alumina ceramic head (top), fully quartz made electrode (middle), tiny quartz made electrode for the treatment in holes (bottom). The diameter of the glass part is 10 mm in all cases.

can have the shape of a pen (see Figure 3.16). According to our own experience, the best configuration is to make the whole system from the quartz glass. A special thin long-form is suitable for the surface treatment in the deep holes; unfortunately, this construction is too tiny and can be easily broken.

This system was also modified using the pin electrode with the additional flow of gas (through the metallic electrode or around it, see Figure 3.17; Krčma et al., 2016). This configuration allows the introduction of various gases into the discharge in the liquid and thus the chemistry of the cleaning process can be modified.

Both systems can be supplied by DC, audio frequency (AF, tens kHz), or RF (RF, 13.54 or 27.2 MHz) operating power supplies. The application of DC produces big bubbles in the liquid that generate very strong shock waves (Krčma et al., 2018),

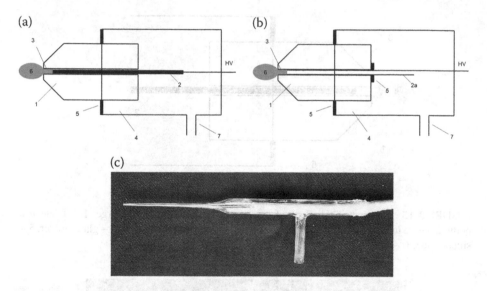

FIGURE 3.17 Pinhole-based discharge with the additional gas flow. 1 – Dielectric body, 2 – wire tungsten electrode, 2a – needle tungsten electrode, 3 – space with enhanced current density, 4 – glass holder, 5 – silicon glue, 6 – plasma in gaseous bubble, 7 – gas flow input.

and, thus, this supplying system is not recommended for the surface treatment of fragile ancient objects. The RF supplying needs some matching network and, thus, such powering is more expensive. Based on this, the best powering is by AF power supplies. Soft shock waves are generated also at these conditions but their intensity is similar to the ultrasound commonly used for the cleaning, so it is not damaging the treated objects. The main active species generated by plasma are OH radical and atomic hydrogen and oxygen. If the discharge is generated in the presence of additional gas (most commonly ambient air), many nitric and nitrous species are generated too (Bruggeman et al., 2016), as described above. The discharge also generates photons in the ultraviolet or vacuum ultraviolet spectral regions that can play a significant role mainly in the decomposition of organics.

Another under-the-liquid operating system is the multielectrode configuration described in Hlochová et al. (2016) and Tiňo et al. (2018). That system is designed for the medical applications, so it ensures soft treatment by the discharge operating again at kHz voltage.

The plasma–liquid systems allow the local treatment, with the affected area of a few millimeters in diameter. Surface treatment of larger areas needs a scanning over the surface that is not so simple in the case of three-dimensional objects. Accessibility to the deep holes in the surface of the treated object is limited but possible. An advantage of the plasma–liquid systems is in the lower thermal stress of the treated objects because of the water cooling environment. The material removed from the surface is dissolved into the liquid, and, thus, it is not shielding the treated surface.

An example of the treatment using the pinhole-based discharge generated directly in the liquid is given in Chapter 8.8. An example of the multielectrode system application was presented in Hlochová et al. (2016), Krčma et al. (2014), and Tiňo et al. (2018). Water solutions of sodium or potassium salts are applied but salts of other elements can also be used. The application of fluoride and chloride salts is not recommended because of the strong corrosive ability of atomic fluorine and chlorine and a high risk of damage to the treated object. The discharges generated directly in liquids can be also applied in the plain air but a relatively high liquid volume is necessary.

The objects covered with the thin water film can be treated by any plasma jet system as was described in the precedent parts. In contrary to the discharges generated directly in the liquid, the application of the plasma jets does not need a liquid with any conductivity, and, thus, distilled water can be used too. This enhances dissolving the surface pollution; on the contrary, this limits the re-diffusion of alkali ions into the surface layers of the treated object. These systems can be also easily applied to big objects or in plain air conditions.

A specific situation is if the laser-induced plasma is used in the combination with liquid. The laser beam passes through the liquid more or less without any interaction, so all energy is deposited at the surface of the treated object. In contrary to the laser ablation discussed previously, there is only a negligible formation of the crater wall around the laser spot at the surface because the ablated material effectively forms nanoparticles that are spread immediately into the bulk liquid. The problem is that these nanoparticles decrease the liquid transparency and thus, a higher liquid flow is needed. An additional effect of the laser ablation under the liquid is the formation of gaseous phase bubbles in the liquid that cavitates. Therefore, ultrasound acoustic waves are also produced and a combined treatment effect is observed. The laser-based system can be also applied at outdoor conditions.

3.5 LOW-TEMPERATURE PLASMA SYSTEMS OPERATING AT ATMOSPHERIC PRESSURE FOR OBJECTS MADE FROM NATURAL AND SYNTHETIC POLYMERS

Heat-sensitive organic materials made of natural and synthetic polymers, such as wood, paper, plastics, parchment, leather and their mixtures, cannot be exposed to plasma with a temperature of the order of several hundred degrees °C. Therefore, it is necessary to focus on plasma-generating systems at temperatures close to room temperature, or temperatures that do not cause thermal damage to these materials, for their processing.

3.5.1 DIELECTRIC BARRIER DISCHARGE

Owing to its wide employment in the printing industry for activating the surface of polymer foils, and known positive effect on paper, volume DBD or industrial 'corona', was the first system to be tested for activating the wood surfaces (Podgorski et al., 2000; Sakata et al., 1993). In a typical arrangement of volume DBD, the treated material is fed into the discharge gap formed by two plane parallel

or co-axial cylindrical electrodes, at least one of which is covered by appropriate dielectric insulation (Raheľ and Tiňo, 2016). At sufficiently high electric field strength (approx. 40 kV/cm for dry air; Wagner et al., 2003) between the insulated electrodes, created by alternating voltage power supply, an electrical breakdown of gas occurs, which manifests itself as numerous short-lasting (~10 ns) fine luminous microfilaments (0.1–0.2 mm in diameter) bridging the entire inter-electrode gap (see Figure 3.18). When microfilament hits the dielectric surface of the electrode (or material to be treated), it continues to propagate along this dielectric surface and forms a characteristic circular footprint. The footprint defines the interaction region of direct plasma exposure to the treated materiál (Raheľ and Tiňo, 2016). Electrically, the volume DBD can be described as two serially connected capacitors representing the discharge air gap and the dielectric insulation, respectively, and spark gap switch connected in parallel to the grounding electrode. For the treatment of heat-sensitive materials (which most polymers are), it is critically important to control and minimize the heat load generated by the interacting plasma. The total energy released by a single microfilament is in the order of units of µJ (Akishev et al., 2011). For thin lignocellulosic materials, such as wood veneers, sheets of paper, or paperboards, the volume DBD can be used without any substantial accommodation (Sakata et al., 1993). The problem arises when attempting to treat thick materials of more than 10 mm. Here the thick material represents the lowest capacitance and takes most of the external voltage at the expense of a narrow discharge gap. As wood is a lossy medium, with specific resistivity that is highly sensitive to the moisture content, the high voltage drop across the thick piece of wood results in power dissipation via internal joule heating. In addition to that, it reduces the quality of the LC resonance circuit formed by the DBD reactor and driving high-voltage transformer (Raheľ and Tiňo, 2016).

A particular efficiency toward wood surface activation exhibits a coplanar configuration known as diffuse coplanar surface barrier discharge (DCSBD) (Odrášková et al., 2008; Lux et al., 2013). A characteristic feature of DCSBD is the electrode width and inter-electrode spacing in the order of units of millimeters, which is more than 10 times higher than in the case of coplanar systems for the ozone production (Gibalov and Pietsch, 2012). Plasma in a sufficiently narrow gap takes the form of uniform (diffuse) strips above the powering electrodes underneath

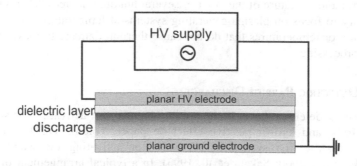

FIGURE 3.18 Schematics of a general configuration of volume DBD plasma system.

the dielectric surface. For woods, the natural structural roughness of their surface is mostly sufficient to provide sufficient space, however, the exposed piece must be flat as the thickness of the plasma discharge layer is 0.4–0.8 mm. Such a solution is not suitable for objects with complex surface geometry or for 3D objects.

3.5.2 ATMOSPHERIC DISCHARGE WITH RUNAWAY ELECTRONS (ADRE)

When a sub ns voltage pulse of more than 100 kV is applied between the plane–parallel electrodes, a significant part of electrons may reach energy high enough to enter so-called runaway régime (Babich et al., 1990). Runaway electrons (RE) exhibit a dramatically reduced rate of inelastic collisions (energy losses) even at atmospheric pressures. Consequently, RE electrons can travel several centimeters from the place of its origin and gain extremely high energy from electric field acceleration. In the reactor configuration described by Maltsev (2006), named ADRE, pulses of 350 kV/1.5 ns were able to fill the discharge gap of several centimeters with visually uniform plasma and REs of up to 300 keV energy. The application of the ADRE generator on thick wood material is shown in Figure 3.19. From a practical point of view, the ADRE system generates highly energetical corona type volumetric discharge at ambient temperature that is suitable for planar two-dimensional objects, as well as for reliefs with a height of several centimeters (see Figures 3.20–3.22).

3.5.3 PLASMA PEN

Plasma pen is constructed as a system containing 'piezoelectric direct discharge plasma'. In general, it is a nonthermal plasma generated at the high side of a piezoelectric transformer (PT). This generation variant is particularly suited for highly efficient and compact devices where a separate high-voltage power supply is not desired. The technology is based on a piezoelectric component (hardened PZT ceramic – Pb Zr Ti), which enables very efficient plasma generation at cold atmospheric pressure and combines voltage transformation and plasma generation in a single component. The component made of this component – a multilayer PT – is

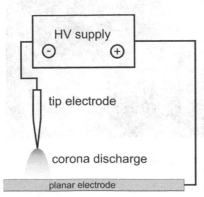

FIGURE 3.19 Schematics of the general configuration of corona ADRE plasma system.

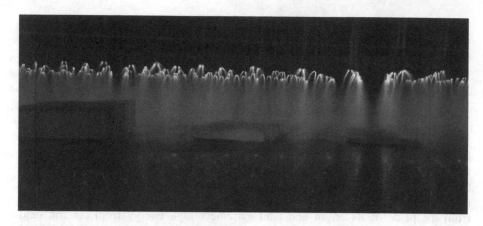

FIGURE 3.20 ADRE plasma in action – exposure of wood with various thicknesses to discharge plasma.

FIGURE 3.21 Schematics of piezoelectric transformer PZT.

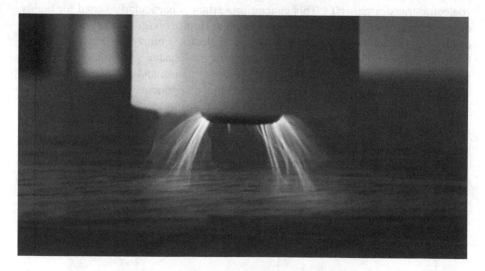

FIGURE 3.22 Piezoelectric plasma pen activating surface of the wood.

housed in a PTFE (Teflon) tube. The output (active area) side of the transformer has a monolithic structure and this area is 16.8 mm^2 large. The inlet side has a multi-layer structure with internal copper electrodes. Because the temperature at the transformer output is less than 50 °C, heat-sensitive materials can also be processed by plasma. The supply voltage is about 12 V/2 A, the output voltage is up to 20 kV, the maximum input power is 10 W, the operational frequency is ~50 kHz and the temperature of discharge is < 50 °C.

3.5.4 OTHER RELEVANT LOW-TEMPERATURE PLASMA SYSTEMS

3.5.4.1 Nonthermal Plasma Jets (NTPJ)

Similarly to Section 3.5.2, plasma jets can be used also for heat-sensitive materials. The application of NTPJ treatment is not constrained by material thickness. Typically, an abnormal glow or arc plasma is generated inside a hollow tube, and an intense flow of working gas is used to transport reactive species in the form of luminous plume toward the treated material. The essential step here is that hot ionized gas that leaves the space of intense ionization is cooled down by mixing with ambient air. This cooling allows control of thermal load delivered to treated material. In general, at fixed power input, it is much easier to create long luminous plumes in rare gases than in molecular ones (i.e. air, N_2, O_2, CO_2, etc.; Raheľ and Tiňo, 2016). Plasma jets operating in the air must be energized by substantially higher power inputs and cooling must be provided by a substantially higher gas flow rate comparing to rare gases. Plasma jets can be employed to activate complex 3-D objects, including wood (Busnel et al., 2010; Potočňáková et al., 2013). The area of a treated surface offered by most of the plasma jet systems is limited to a few square millimeters due to the small size of the exhaust plume (Laroussi and Akan, 2007).

3.5.4.2 Atmospheric Pressure Glow Discharge (APGD)

APGD is analogous in its mode of generation and some key characteristics to low-pressure glow discharge plasma described earlier (Roth et al., 1993; Yializis et al., 1999). The APGD is generated by the application of relatively low (~200 V) voltages across opposing symmetrical planar or curved electrodes, separated by millimeters at high frequency or even very high frequencies (2–60 MHz), which is much higher than the other plasma types. The electrodes are not covered by dielectric but are bare metal. This feature enables significantly higher power densities (up to 500 W/cm^3). The application of a voltage between metal plates would generally result in the generation of a highly undesirable, very high-current density, and hot plasma arc. However, by control of the interelectrode gap and the frequency of the driving voltage and, above all, by the use of helium as ~99% of the generation gas, arching is prevented and a large volume, nonthermal plasma is generated, which is both dense and a rich source of the chemical species needed to carry out the surface modification (Kutz, 2016).

REFERENCES

Abdel-Kareem, O., Al-Zahrani, A., Khedr, A., Harith, M.A., 2016. Evaluating the use of laser in analysis and cleaning of the Islamic marine archaeological coin excavated from the Red Sea. Int. J. Conserv. Sci. 7, 511–522.

Abere, M.J., Murphy, R.D., Jackson, B., Mourou, G., Menu, M., Mansfield, J., Yalisove, S.M., 2011. Ultrafast laser cleaning of Daguerreotypes, MRS OnLine Proceedings Library Archive 1319 (Symposium WW – Materials Issues in Art and Archaeology IX) mrsf10-1319-ww04-03.

Akishev, Y., Aponin, G., Balakirev, A., Grushin, M., Karalnik, V., Petryakov, A., Trushkin, N., 2011. 'Memory' and sustention of microdischarges in a steady-state DBD: Volume plasma or surface charge? Plasma Sources Sci. Technol. 20 (2), 024005.

Asimakoulas, L., Graham, W.G., Krčma, F., Dostál, L., Stalder, K.R., Field, T.A., 2020. Fast framing imaging and modelling of vapour formation and discharge initiation in electrolyte solutions. Plasma Sources Sci. Technol. 29, 035013.

Atanassova, V., Penkova, O., Kostadinov, I., Karatodorov, S., Avdeev, G.V., 2019. Laser removal of chlorine from historical metallic objects, Proceedings Volume 11047, 20th International Conference and School on Quantum Electronics: Laser Physics and Applications, 110470C.

Babich, L.P., Loĭko, T.V., Tsukerman, V.A., 1990. High-voltage nanosecond discharge in a dense gas at a high overvoltage with runaway electrons. Sov. Phys. Usp. 33, p. 521. DOI:10.1070/PU1990v033n07ABEH002606.

Benova, E., Atanasova, M., Bogdanov, T., Marinova, P., Krčma, F., Mazánková, V., Dostál, L., 2016. Microwave plasma torch at a water surface. Plasma Med. 6, 59–65.

Boselli, M., Chiavari, C., Colombo, V., Gherardi, M., Martini, C., Rotundo, F., 2017. Atmospheric pressure non-equilibrium plasma cleaning of 19th century Daguerreotypes. Plasma Process. Polym. 14, e1600027.

Bradu, C., Kutasi, K., Magureanu, M., Puac, N., Zivkovic, S., 2020. Reactive nitrogen species in plasma-activated water: Generation, chemistry and application in agriculture. J. Phys. D – Appl. Phys. 53, 223001.

Bruggeman, P.J., Kushner, M.J., Locke, B.R., Gardeniers, J.G.E., Graham, W.G., Graves, D.B., Hofman-Caris, R.C.H.M., Maric, D., Reid, J.P., Ceriani, E., Fernandez Rivas, D., Foster, J.E., Garrick, S.C., Gorbanev, Y., Hamaguchi, S., Iza, F., Jablonowski, H., Klímová, E., Kolb, J., Krčma, F., Lukeš, P., Machala, Z., Marinov, I., Mariotti, D., Mededovic Thagard, S., Minakata, D., Neyts, E., Pawlat, J., Petrovic, Z.Lj., Pflieger, R., Reuter, S., Schram, D.C., Schroter, S., Shiraiwa, M., Tarabová, B., Tsai, P.A., Verlet, J.R.R., von Woedtke, T., Wilson, K.R., Yasui, K., Zvereva, G., 2016. Plasma-liquid interactions: A review and roadmap. Plasma Sources Sci. Technol. 25, 053002.

Busnel, F., Blanchard, V., Prégent, J., Stafford, L., Riedl, B., Blanchet, P., Sarkissian, A., 2010. Modification of sugar maple (Acer saccharum) and black spruce (Picea mariana) wood surfaces in a dielectric barrier discharge (DBD) at atmospheric pressure. J. Adhes. Sci. Technol. 24 (8), 1401–1413.

Chiang, W.H., Mariotti, D., Sankaran, R.M., Eden, J.G., Ostrikov, K., 2020. Microplasmas for advanced materials and devices. Adv. Mater. 32, 1905508.

Cremers, D.A., Radziemski, L.J., 2013. Handbook of Laser-Induced Breakdown Spectroscopy, Second Ed. John Wiley & Sons, Ltd., ISBN:9781119971122.

Daniels, V., 1981. Plasma reduction of silver tarnish on Daguerreotypes. Stud. Conserv. 26, 45–49.

Daniels, V.D., Holland, L., Pascoe, M.W., 1979. Gas plasma reactions for the conservation of antiquities. Stud. Conserv. 24, 85–92.

Eliasson, B., Kogelschatz, U., 1991. Nonequilibrium volumeplasma chemical-processing. IEEE Trans. Plasma Sci. 19, 1063–1077.

Fedlheim, D.L., Foss, C., 2001. Metal Nanoparticles: Synthesis, Characterization, and Applications, CRC Press. ISBN: 978-08-24-706043

Fojtíková, P., Řádková, L., Janová, D., Krčma, F., 2015a. Application of low-temperature low-pressure hydrogen plasma: Treatment of artificially prepared corrosion layers. Open Chem.13, 362–368.

Fojtíková, P., Řádková, L., Janová, D., Krčma, F., 2015b. Removal of corrosion layers using the reducing effect of low-temperature low-pressure H_2-Ar plasma, in Proceedings of 7^{th} Symposium on Advanced Plasma Science and its Applications for Nitrides and Nanomaterials & 8^{th} International Conference on Plasma Nano Technology and Science. Nagoya, A4-P-06-01.

Fojtíková, P., Řádková, L., Janová, D., Krčma, F., 2015c. Application of Argon-Hydrogen plasma as a tool for the corrosion layers removal, in Proceedings of EUROCORR 2015, Graz, 18.

Gibalov, V.I., Pietsch, G.J., 2012. Dynamics of dielectric barrier discharges in different arrangements. Plasma Sources Sci. Technol. 21 (2), 024010.

Golovlev, V.V., Gresalfi, M.J., Miller, J.C., Romer, G., Messier, P., 2000. Laser characterization and cleaning of 19th century Daguerreotypes. J. Cult. Herit. 1, S139–S144.

Golovlev, V.V., Miller, J.C., Romer, G., Messier, P., 2001. Laser analysis and restoration of 19th century Daguerreotypes. AIP Conf. Proc. 584, 208–212.

Golovlev, V.V., Gresalfi, M.J., Miller, J.C., Anglos, D., Melesanaki, K., Zafiropulos, V., Romer, G., Messier, P., 2003. Laser characterization and cleaning of 19th century Daguerreotypes II. J. Cult. Herit. 4, 134S–139S.

Gözmen, B., Kayana, B., Gizir, A.M., Hesenov, A., 2009. Oxidative degradations of reactive blue 4 dye by different advanced oxidation methods. J. Hazar. Mater. 168, 129.

Graaf, M.J., de Severens, M.J., van de Sande, M.J.F., van de Sanden, M.C.M., Schram, D.C., Meijers, H.J.M., Kars, H., 1993. Hydrogen atom cleaning of archeological artefacts. J. Nucl. Mater. 200, 380–382.

Graaf, M.J., de Severens, R.J., van Ijzendoorn, L.J., Munnik, F., Meijers, H.J.M., Kars, H., van de Sande, M.J.F., van de Sanden, M.C.M., Schram, D.C., 1995. Cleaning of Iron archaeological artefacts by cascaded arc plasma treatment. Surf. Coat. Technol. 74–75, 351–354.

Grieten, E., Schalm, O., Tack, P., Bauters, S., Storme, P., Gauquelin, N., Caen, J., Patelli, A., Vincze, L., Schryvers, D., 2017. Reclaiming the image of Daguerreotypes: Characterization of the corroded surface before and after atmospheric plasma treatment. J. Cult. Herit. 28, 56–64.

Gronlund, R., Lundqvist, M., Svanberg, S., 2006. Remote imaging laser-induced breakdown spectroscopy and laser-induced fluorescence spectroscopy using nanosecond pulses from a mobile lidar systém. App. Spectr. 60, 859.

Hirata, T., 2012. Advances in laser ablation–multi-collector inductively coupled plasma mass spectrometry, In: Vanhaecke, F., Degryse, P. (Eds.), Isotopic Analysis: Fundamentals and Applications Using ICP-MS, WILEY-VCH Verlag GmbH & Co. KGaA, ISBN: 978-3-527-32896-3.

Hlochová, L., Graham, W.G., Janová, D., Krčma, F., 2016. Treatment of the glass archaeological artefacts by underwater discharge, in International Symposium on High-Pressure Low-Temperature Plasma Chemistry (HAKONE XV) with joint COST TD1208 workshop Non-Equilibrium Plasmas with Liquids for Water and Surface Treatments: Book of Contributed Papers. Brno, Masaryk University, 392-395.

Hnatiuc, E., Astanei, D., Ursache, M., Hnatiuc, B., Brisset, J.-L., 2012. A review over the cold plasma reactorsand their applications. International Conference and Exposition on Electrical and PowerEngineering (EPE 2012), 25e27 October, Iasi, Romania.

Hosseini, S., Martinez-Chapa, S.O., 2016, Fundamentals of MALDI-ToF-MS Analysis:

Applications in Bio-diagnosis, Tissue Engineering and Drug Delivery, Springer Verlag, Singapore, ISBN: 978-981-10-2356-9.

Jayasena, D., Kim, H.J., Cheorun, J., 2017, Dielectric barrier discharge: Meat treatment. In: Shohet, J.L. (Ed.), First ed., Encyclopedia of Plasma Technology, CRC Press, 10.1081/ E-EPLT-120053642.

Judee, F., Simon, S., Bailly, C., Dufour, T., 2018. Plasma-activation of tap water using DBD for agronomy applications: Identification and quantification of long lifetime chemical species and production/consumption mechanisms. Water Res. 133, 47.

Kozáková, Z., Klimova, E.J., Obradovic, B.M., Dojcinovic, B.P., Krčma, F., Kuraica, MM., Olejnickova, Z., Sykora, R., Vavrova, M., 2018. Comparison of liquid and liquid-gas phase plasma reactors fordiscoloration of azo dyes: Analysis of degradation products. Plasma Process Polym. 15, 1700178.

Kozáková, Z., Krčma, F., Čechová, L., Simić, S., Doskočil, L., 2019. Generation of silver nanoparticles by the pin-hole DC plasma source with and without gas bubbling. Plasma Phys. Technol. 6, 180.

Kramida, A., Ralchenko, Yu., Reader, J., and NIST ASD Team, 2020. NIST atomic spectra database (ver. 5.7.1), [Online]. Available: https://physics.nist.gov/asd [2020, April 12]. National Institute of Standards and Technology, Gaithersburg, MD. DOI: https://doi. org/10.18434/T4W30F.

Krčma, F., 2015. Jet system for plasma generation in liquids. Czech Republic patent CZ 305304 B6, 2015 Jun 10.

Krčma, F., Řádková, L., Grossmannová, H., Miková, P., Černý, M., 2016. Methodics of the corrosion layers products removal from metallic objects surface by low-pressure plasma, Certified Methodics – in Czech.

Krčma, F., 2016. Jet system for the plasma generation in gaseous bubbles in liquids, Protected Construction, CZ 30097.

Krčma, F., 2019. Jet System for Plasma Generation in Liquids. EU patent, EP 3122161B1, 2019 Oct 23.

Krčma, F. et al., 2014. Application of low-temperature plasmas for restoration/conservation of archaeological objects. J. Phys.: Conf. Ser. 565, 012012.

Krčma, F., Tsonev, I., Smejkalová, K., Truchlá, D., Kozáková, Z., Zhekova, M., Marinova, P., Bogdanov, T., Benova, E., 2018a. Microwave micro torch generated in argon based mixtures for biomedical applications. J. Phys. D – Appl. Phys. 51, 414001.

Krčma, F., Kozáková, Z., Mazánková, V., Horák, J., Dostál, L., Obradovic, B., Nikiforov, A., Belmonte, T., 2018b. Characterization of novel pin-hole based plasma source for generation of discharge in liquids supplied by DC non-pulsing voltage. Plasma Sources Sci. Technol. 27, 065001.

Kutz, M., 2016. Atmospheric-pressure glow discharge, In: Kutz, M., (Ed.), Second Ed., Applied Plastics Engineering Handbook: Processing, Materials, and Applications (Plastics Design Library), pp. 449–450. ISBN-13: 978 – 0323390408.

Laroussi, M., Akan, T., 2007. Arc-free atmospheric pressure cold plasma jets: A review. Plasma Process. Polym., 4 (9), 777–788.

Lavakumar, A., 2017. Physical metallurgy of ferrous alloys, in Concepts in Physical Metallurgy. Morgan & Claypool Publishers, SBN: 978-1-6817-4472-8.

Lee, T., Puligundla, P., Mok, C., 2017. Corona discharge plasma jet inactivates food-borne pathogens adsorbed onto packaging material surfaces. Packag. Technol. Sci: An Int. J. 30, 681.

Lieberman, M.A., Lichtenberg, A.J., 2005. Principles of Plasma Discharges and Materials Processing, John Wiley & Sons, ISBN 0-471-72001.

Liguori, A., Gallingani, T., Padmanaban, D.B., Laurita, R., Velusamy, T., Jain, G., Macias-Montero, M., Mariotti, D., Gherardi, M., 2018. Synthesis of copper-based nanostructures

in liquid environments by means of a non-equilibrium atmospheric pressure nanopulsed plasma jet. Plasma Chem. Plasma Process. 38, 1209.

Locke, B.R., Sato, M., Šunka, P., Hoffmann, M.R., Chang, J.S., 2006. Electrohydraulic discharge and nonthermal plasma for water treatment. Ind. Eng. Chem. Res. 45, 882–905.

Lu, P., Cullen, P.J., Ostrikov, K., 2016. Chapter 4 - Atmospheric pressure nonthermal plasma sources. In: Misra, N.N., Schluter, O., Cullen, P.J. (Eds.), Cold Plasma in Food and Agriculture: Fundamentals and Applications, Elsevier Inc., pp. 83–116, ISBN. 978-0-12-801365-6.

Lux, C., Szalay, Z., Beikircher, W., Kováčik, D., Pulker, H.K., 2013. Investigation of the plasma effects on wood after activation by diffuse coplanar surface barrier discharge. Eur. J. Wood Wood Prod. 71 (5), 539–549.

Malik, M.A., Ghaffar, A., Malik, S.A., 2001. Water purification by electrical discharges. Plasma Sources Sci. Technol. 10, 82–91.

Maltsev, A.N., 2006. Dense gas discharge with runaway electrons as a new plasma source for surface modification and treatment. IEEE Trans. Plasma Sci. 34 (4I), pp. 1166–1174.

Miller, J.C., Haglund, R.F. Jr. 1991. Laser Ablation: Mechanisms and Applications, Springer-Verlag Berlin Heidelberg, ISBN: 978-1-4757-6982-1.

Musazzi, S., Perini, U., 2014. Laser-Induced Breakdown Spectroscopy, Theory and Applications, Springer-Verlag, Berlin, ISBN: 978-3-642-45084-6.

Noll, R., 2012. Laser-Induced Breakdown Spectroscopy, Fundamentals and Applications, Springer-Verlag, Berlin, ISBN: 978-3-642-20667-2.

Odrášková, M., Ráheľ, J., Zahoranová, A., Tiňo, R., Černák, M., 2008. Plasma activation of wood surface by diffuse copla- nar surface barrier discharge. Plasma Chem. Plasma P. 28 (2), 203–211.

Patelli, A., Verga, E., Nodari, L., Petrillo, S.M., Delva, A., Ugo, P., Scopece, P., 2018. A customised atmospheric pressure plasma jet for conservation requirements, Florence Heri-Tech – The Future of Heritage Science and Technologies, in IOP Conference Series-Materials Science and Engineering 364, UNSP 012079.

Patscheider, J., Veprek, S., 1986. Application of low-pressure hydrogen plasma to the conservation of ancient iron artifacts. Plasma Chem. Plasma Process. 6, 29–37.

Pearce, R.W.B., Gaydon, A.G., 1976. The Identification of Molecular Spectra, Springer, Netherlands, ISBN: 978-94-009-5760-2.

Perkins, W.S., 1999. Oxidative decolorization of dyes in aqueous medium. Textile Chem. Colorist Am. Dyestuff 1, 33.

Phipps, C., 2007. Laser Ablation and its Applications, Springer-Verlag US, New York, ISBN: 978-0-387-30452-6.

Podgorski, L., Chevet, B., Onic, L., Merlin, A., 2000. Modification of wood wettability by plasma and corona treatments. Int. J. Adhe. Adhes. 20 (2), 103–111.

Potočňákova, L., Hnilica, J., Kudrle, V., 2013. Increase of wettability of soft- and hardwoods using microwave plasma. Int. J. Adhe. Adhes. 45, 125–131

Puac, N., Gherardi, M., Shiratani, M., 2018. Plasma agriculture: A rapidly emerging field. Plasma Process. Polymers 15, e1700174.

Řádková, L., Fojtíková, P., Kozáková, Z., Krčma, F., Sázavská, V., Kujawa, A., 2015. Sample temperature during corrosion removal by low-pressure low-temperature hydrogen RF plasma. Rom. Rep. Phys. 67, 586–599.

Raheľ, J., Tiňo, R., 2016. Wood surfaces: Plasma activation, First ed. Encyclopedia of Plasma Technology, CRC Press, Boca Raton, pp. 1541–1551, ISBN 978-1-4665-0059-4. https://doi.org/10.1081/E-EPLT-120049575.

Raizer, Yu. P., Shneider, M.N., Yatsenko, N.A., 2019. Radio-Frequency Capacitive Discharges, CRC Press, ISBN 9780367401863.

Rašková, Z., Krčma, F., Klíma, M., Kousal, J., 2002. Characterization of plasmachemical treatment of archaeological artifacts. Czechoslovak J. Phys. 52(E), 927–932.

Rauf, M.A., Ashraf, S.S., 2009. Radiation induced degradation of dyes-An overview. J. Hazard. Mater. 166, 6.

Raza, M.S., Das, S.S., Tudu, P., Saha, P., 2019. Excimer laser cleaning of black sulphur encrustation from silver surface. Opt. Laser Technol. 113, 95–103.

Rezaei, F., Vanraes, P., Nikiforov, A., Morent, R., De Geyter, N., 2019. Applications of plasma-liquid systems: A review. Materials 12, 2751.

Roth, J.R., 1995. Industrial Plasma Engineering, Vols. 1 & 2, CRC Press, ISBN 9780750303170 & 9780750305457.

Roth, J.R., Tsai, P., Liu, C., Wadsworth, L.C. 1993. Method and apparatus for glow discharge plasma treatment of polymer materials at atmospheric pressure. US Patent No. 5456972; May 28, 1993.

Sakata, I., Morita, M., Tsuruta, N., Morita, K. 1993. Activation of wood surface by corona treatment to improve adhesive bonding. J. Appl. Polym. Sci. 49 (7), 1251–1258.

Salle, B., Mauchien, P., Maurice, S., 2007. Laser-induced breakdown spectroscopy in open-path configuration for the analysis of distant objects. Spectrochim. Acta B – Atomic Spectroscopy 62, 739–768.

Sázavská, V., Krčma, F., Řádková, L., Fojtíková, P., 2012. Heating of metal archaeological artefacts during low-pressure plasma treatment, in Proceedings of EUROCORR 2012. Istanbul, pp. 1224–1228.

Schalm, O., Storme, P., Gambirasi, A., Favaro, M., Patelli, A., 2018. How effective are reducing plasma afterglows at atmospheric pressure in removing sulphide layers: Application on tarnished silver, sterling silver and copper, Surf. Interface Anal. 50, 32–42.

Schmidt-Ott, K., 2004. Plasma-reduction: Its potential for use in the conservation of metals. Proceedings of Metal, pp. 235–246.

Schmidt-Ott, K., Boissonnas, V., 2002. Low-pressure hydrogen plasma: An assessment of its applications on archaeological iron. Stud. Conserv. 22, 81–87.

Scott, D.A., 1991. Metallography and Microstructure of Ancient and Historic Metals, Getty Conservation Institute in association with Archetype Books, ISBN 0-89236-195-6.

Sharma, G., Kumar, D., Kumar, A., Al-Muhtaseb, A.H., Pathania, D., Naushad, M., Mola, G.T., 2017. Revolution from monometallic to trimetallic nanoparticle composites, various synthesis methods and their applications: A review. Mater. Sci. Eng. C: Mater. Biol. Appl. 71, 1216.

Singh, J., Thakur, S., 2007. Laser-Induced Breakdown Spectroscopy, 1st ed., Elsevier Science, ISBN: 9780444517340.

Sosnin, E.A., Stoffels, E., Erofeev, M.V., Kieft I.E., Kunts, S.E., 2004. The effects of UV irradiation and gas plasma treatment on living mammalian cells and bacteria: A comparative approach. IEEE Trans. Plasma Sci. 32, 1544.

Stoffels, E., Flikweert, A.J., Stoffels, W.W., Kroesen, G.M.W., 2002. Plasma needle: a non-destructive atmospheric plasma source for fine surface treatment of (bio)materials. Plasma Sources Sci. Technol. 11, 383.

Sylvester, P., 2008. Laser Ablation–ICP–MS in the Earth Sciences: Current Practices and Outstanding Issues, Vol. 40, Mineralogical Association of Canada, Quebec City, QC, ISBN: 9-0-921294-49-8.

Tiňo, R., Vizárová, K., Krčma, F., 2018. Plasma surface cleaning of cultural heritage objects, in Nanotechnologies and Nanomaterials for Diagnostic, Conservation and Restoration of Cultural Heritage, Elsevier, pp. 239–276, ISBN: 978-0-12-813910-3.

Tosik, R., 2005. Dyes color removal by ozone and hydrogen peroxide: Some aspects and problems Ozone-Sci. Eng. 27, 265.

Turovets, I., Maggen, N., Lewis, A., 1998. Cleaning of Daguerreotypes with an excimer laser. Stud. Conserv. 43, 89–100.

Vanraes, P., Nikiforov, A., Leys, C., 2016. Electrical discharge in water treatment technology for micropollutant decomposition, in Plasma Science and Technology - Progress in Physical States and Chemical Reactions, INTECH, ISBN: 978-953-51-2280-7.

Vašinová Galiová M., Havliš, J., Kanický, V., 2014. Laser Ablation Inductively Coupled Plasma Mass Spectrometry as a Tool in Biological Sciences, In: Havlíček, V., Spížek, J. (Eds.), Natural Products Analysis Instrumentation, Methods, and Applications, John Wiley & Sons, Inc., ISBN 978-1-118-46661-2.

Veprek, S., Patcheider, J., Elmer, J., 1985. Restoration and conservation of ancient artifacts: A New area of applications of plasma chemistry. Plasma Chem. Plasma Process. 5, 201–209.

Veprek, S., Eckmann, C., Elmer, J.T., 1988. Recent progress in the restoration of archaeological metallic artifacts by means of low-pressure plasma treatment. Plasma Chem. Plasma Process. 8, 445.

Wagner, H.-E., Brandenburg, R., Kozlov, K.V., Sonnenfeld, A., Michel, P., Behnke, J.F., 2003. The barrier discharge: Basic properties and applications to surface treatment. User Model User-Adap. Interac. 71 (3 SPEC.), 417–436.

Yializis, A., Pirzada, S., Decker, W., 1999. Steady-state glow discharge at atmospheric pressure. US Patent No. 6118218; issued Feb 1, 1999.

Zajíčková, L., Klíma, M., Janča, J., 1997. Temperature measurements of different materials in various plasma conditions. Zeitschrift für Schweizerische Archäelogie und Kunstgeschichte 54, 29–30.

Zhang, B., Chen, L., Lin L.X., Zhang, H., 2015. Understanding the multi-scale structure and functional properties of starch modulated by glow-plasma: A structure-functionality relationship. Food Hydrocoll. 50, 228.

4 Cleaning Processes in Plasma

The yield of the total plasma–chemical process is due to synergistic contribution of numerous different elementary reactions taking place simultaneously in the discharge system. The sequence of transformations of initial chemical substances and electric energy into products and thermal energy is usually referred to as the mechanism of the plasma–chemical process (Fridman, 2008). Since plasma consists of electrons, molecules or neutral gas atoms, positive ions, ultraviolet (UV) photons along with excited gas molecules and atoms, it carries a reasonably high amount of energy. And when all these molecules, ions and atoms come together and interact with a particular surface, plasma treatment is initiated. Plasma treatment upon any surface can be specified and precisely tuned by selecting the proper type of discharge, the geometry of electrodes, a gas mixture, pressure, output, etc.

From a practical point of view, 'plasma cleaning' is the removal of impurities and contaminants from surfaces through the use of an energetic plasma created from gaseous species. A plasma cleaning system allows the efficient cleaning of a surface without having a negative impact on other properties of the surface. Over the past few decades, the efficiency of plasma cleaning has been recognized, and used for a variety of industrial pre-processing cleaning of materials. Knowledge and experience from these applications can be successfully used in the protection of CH objects. Gases such as argon and oxygen, as well as mixtures such as air and hydrogen/nitrogen, are often used.

The plasma is created by using high-frequency voltages (typically kHz to >MHz) to ionize the low-pressure gas (typically around 1/1000 atmospheric pressure), although atmospheric pressure plasmas are now also common (Shun'ko and Belkin, 2007). Plasma cleaner (a device used for plasma cleaning) exposes the surface to a gas plasma discharge, gently and thoroughly scrubbing the surface, and/or exposing the surface to various ionized reactive species (reactive nitrogen and oxygen species) formed in the plasma discharge. Plasma cleaning can serve to get rid of non-visible oil films, microscopic rust, dust or other contaminants that typically form on surfaces as a result of handling, exposure or previous manufacturing or cleaning processes; additionally, plasma cleaning does not leave a surface residue. A plasma cleaner can treat a wide variety of materials, from plastics, natural polymer materials, metals, ceramics, stones, to objects and materials with complex surface geometries. Plasma cleaning is applied in the industry before the application of thin layers or before the application of adhesives to clean away loosely held contaminant residues and to activate the surface for increased bonding strength.

When preserving heritage objects, this will also be one of the main operations, at the beginning of the technological process, just after the operation of mechanical cleaning of the object from dust and weakly holding dirt.

Plasma discharge always contains a mixture of ionized/activated reactive species that include atoms, molecules, ions, electrons, free radicals, metastables, and photons in the short wave UV (vacuum UV, or VUV for short) range. This applies to both thermal (hot) plasma and non-thermal cold plasma. Such a mixture, which in the case of non-thermal plasma is incidentally around room temperature, then interacts with any surface material placed into the plasma discharge. The energy of plasma electrons and ions is sufficient to ionize neutral atoms, break molecules apart to form reactive radical species, generate excited states in atoms or molecules and locally heat the surface. Depending on the geometry of the electrode, type of the power supply, output, type of process gases and parameters, plasmas are capable of both mechanical work, through the ablative effect of the kinetic transfer of electrons and ions with the surface, and chemical work, through the interaction of reactive radical species with the surface.

The cleaning action of plasma can be described as plasma's stream of activated atoms and ions that behave like a molecular sandblast, which can break down organic contaminants (see Figure 4.1). These contaminants can be again vaporized during processing. Most of these by-products are small quantities of gases such as carbon dioxide and water vapor with trace amounts of carbon monoxide and other hydrocarbons. Whether or not organic removal is complete can be assessed with contact angle measurements or other techniques, such as FTIR spectroscopy measurements. When an organic contaminant is present, the contact angle of water with the device will be high. After the removal of the contaminant, the contact angle will be reduced to that characteristic of contact with the pure substrate. The UV energy is effective at breaking most of the organic chemical bonds (i.e. C–H, C–C, C = C, C–O, and C–N) of surface contaminants. The second mechanism of cleaning is accomplished by the oxygen species created in the plasma (O_2+, O_2-, O_3, O, O+, O–, ionized ozone and free electrons). These species react with the organic

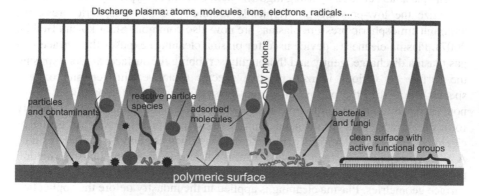

FIGURE 4.1 Schematic representation of the cleaning effects of corona plasma on the surface of polymeric substrates.

contaminants to form CO, CO_2, H_2O and low molecular weight hydrocarbons. The vapor pressure of these organic compounds allows them to escape the process. The resulting surface is significantly cleaner.

Plasma processing is not one process but a 'field of opportunities' that can be used to modify a surface through several mechanisms: ablation, activation, deposition, cross-linking and grafting. However, for cleaning purposes of cultural heritage objects and materials, sterilization, ablation, activation, crosslinking and etching are utilized.

4.1 Sterilization/Decontamination is an act or process, physical or chemical, that destroys or eliminates all forms of life, especially microorganisms. It has long been known that electric discharges and the plasma generated by them have microbicidal effects, i.e. they kill various microorganisms. Research into these microbicidal properties of nonthermal plasma at atmospheric pressure and the potential possibilities of their use in microbiology, medicine or the food industry is the subject of intensive research worldwide. Plasma sterilization treatment is gaining growing acceptance for disinfecting and sterilizing medical devices. Plasma treatment offers the potential for simultaneous cleaning and sterilization of medical instruments, but it is also suitable for sterilization of cultural heritage objects and materials that are often colonized by a number of various harmful microorganisms. It has been shown that many pathogens can be destroyed by employing nonequilibrium plasma discharges (Kylián et al., 2006), and the nature of plasma interactions with microorganisms or biomolecules has been extensively studied in the past few years. Plasma sterilization is particularly appropriate for medical or dental implants and thus also for objects and materials that are sensitive to the high temperature, chemical or irradiative environments associated with autoclaving, ethylene oxide (EtO) or gamma sterilization, respectively. Low-temperature plasma usually operating at room temperature or temperatures slightly higher doesn't cause thermal degradation of such material and offers multiple simultaneous effects helping them treat efficiently (Rahel and Tino, 2016; Tino and Šmatko, 2014).

Currently known and laboratory, clinically or industrially used methods of decontamination or sterilization are based on physical, chemical or physicochemical principles. None of the known methods can be used universally, due to their low efficiency, their disproportionate effect on the decontaminated object or surface or the relatively long time required to treat the surface. The use of low-temperature plasma can complement the range of decontamination methods currently used in conservation practice. Ideally, for some applications, nonthermal plasma becomes the method of choice.

Conventional sterilization techniques, such as those using autoclaves, ovens, and chemicals such as EtO, rely on irreversible metabolic inactivation or on the breakdown of vital structural components of the microorganism. Plasma sterilization operates differently because of its specific active agents, which are UV photons and radicals (atoms or assembly of atoms with unpaired electrons, therefore chemically reactive, for example, O and OH, respectively; Moisan, 2002). Nonthermal plasma generated at atmospheric pressure produces a mix of reactive molecules, charges, electric fields and radiation. The role of all these components has been widely studied (see, e.g. Laroussi and Leipold, 2004; Stoffels, 2006) and it was

noted that inactivation efficiency highly depends on the presence of charged species for room air conditions (Dobrynin et al., 2009; Fridman et al., 2007; Laroussi and Leipold, 2004; Stoffels, 2006). The quantitative representation of the individual components and thus the overall decontamination efficiency depends on the setting of the plasma discharge conditions. An advantage of the plasma method is the possibility, under appropriate conditions, of achieving such a process at relatively low temperatures (≤50 °C), preserving the integrity of polymer-based instruments, which cannot be subjected to autoclaves and ovens (Moisan, 2001a, 2001b).

Utilizing a plasma to achieve sterilization is a possible alternative to conventional sterilization means as far as sterilization of heat-sensitive materials and innocuity of sterilizing agents are concerned. The mechanisms responsible for microbial inactivation in cold atmospheric plasma have not been elucidated in detail yet. However, it is possible to describe the main processes that affect the efficacy of plasma sterilization effects. It must be pointed out that the inactivation mechanisms and their efficiency can vary between microorganisms, for example, bacterial spores are more resistant than bacteria, fungal spores are more resistant than conidiophores and these are more resistant than mycelium (Hertwig 2015a).

During the treatment, microorganisms are exposed to continuous bombardment with different reactive components of the generated plasma. Thereby, atomic and molecular radicals and excited molecules can cause an erosion of the microbial cell, atom by atom, through etching (Moisan 2001c). The reactive components will be adsorbed onto the microorganism surface, causing the formation of volatile compounds via chemical reactions and openings and lesions in the cell membrane. Consequently, Gram-negative bacteria are believed to be more easily inactivated by etching due to their thinner membrane structure compared with Gram-positive bacteria (Stoffels et al., 2008).

Bacterial and fungal spores can also be inactivated by etching caused by oxygen atoms and radicals (Park et al., 2004). Microbial support structures, such as biofilms, can also be degraded by the erosion of organic material due to the breakage of chemical bonds (Bourke et al., 2017). Different reactive species inside the cold atmospheric plasma, such as reactive nitrogen species (RNS) and reactive oxygen species (ROS), can also interact with various cellular macromolecules, such as membrane lipids, proteins and DNA. Oxidative DNA damage caused by ROS can lead to microbial inactivation (Li et al., 2013). Oxidative damage of membrane lipids affects their ability to regulate mass transport in and out of the cell (Laroussi and Leipold, 2004). Furthermore, the generated reactive species may also diffuse into the microbial cell, which can result in a decrease in intracellular pH. If an microorganism (MO) cell cannot maintain pH homeostasis, it will be inactivated (Booth, 1985; Padan and Schuldiner, 1987).

All active chemicals tend to attack the outer cell membrane of the MO, followed by DNA, as well as lipids and proteins themselves. Cell metabolism is progressively impaired. In terms of heat, long-term exposure in the plasma atmosphere leads to a smaller increase in sample temperature, which depends on the performance of the plasma apparatus in combination with the working gas (atmosphere). However, it does not have direct devitalizing effects, but it can dehydrate the sample and thus inactivate microorganisms by deteriorating conditions suitable for their life – higher

temperature and lower humidity. Subsequent repetitive pulses of the high electric field during plasma treatment can damage the cell wall membranes of the microorganisms and can thus effectively inactivate MO.

The cell membrane can also be damaged via electrostatic disruption due to the accumulation of charged particles on the microorganism surface (Laroussi, 2002). Such electrostatic forces caused by charge accumulation on an outer membrane surface can overcome the tensile strength of the membrane, resulting in its rupture (Mendis et al., 2000).

The effect of high power pulses depends on the intensity of el. field, duration and number of pulses. The critical intensity of the electric field required to inactivate MO depends on the type of biological cell, its diameter and growth status. Cell destruction occurs due to electromechanical stress on cell membranes. From the foregoing, the dominant factor in low-temperature atmospheric plasma in terms of decontamination effects on microorganisms is the presence of reactive particles and their ability to destroy or inactivate their organ structures.

A major issue of plasma sterilization is the respective roles of UV photons and reactive species such as atomic and molecular radicals. The UV photons are expected to be more strongly (if not totally) reabsorbed by the ambient gas at atmospheric pressure than at reduced pressure (≤ 10 torr). At reduced gas pressure (≤ 10 torr) and in mixtures containing oxygen, the UV photons dominate the inactivation process, with a significant contribution of oxygen atoms as an erosion agent (Moisan et al., 2002). This leads to consider two types of sterilizers: atmospheric- and reduced-pressure systems (Moisan et al., 2001a, 2001b). The respective roles of UV photons and radicals at reduced pressure are already well understood (Moisan et al., 2001a, 2001b, 2001c; Philip et al., 2001), which is not the case yet at atmospheric pressure (Laroussi, 1996).

UV photons emitted by cold atmospheric plasmas are able to induce the dimerization of thymine bases in bacterial DNA strands, which impedes the ability of bacteria to replicate (Laroussi, 2002). Furthermore, UV photons can also damage the DNA of bacterial spores (Setlow, 2007). Faster spore inactivation with increasing UV emission of the used cold atmospheric plasma has been also reported (Boudam et al., 2006; Reineke et al., 2015). Increasing UV emission causes an increase in DNA damage in spores (Hertwig et al., 2015b). Intrinsic photodesorption, an erosion of the cell, atom by atom, can be induced by UV photons due to the breakage of chemical bonds (Moisan et al., 2001).

A further mechanism of inactivation of bacterial spores is based on damage to the inner membrane and key germination proteins (Wang et al., 2016). The different spore properties, the outer spore coat, dipicolinic acid level inside the spore core as well as the DNA saturation with small acid soluble proteins, contribute to the resistance of Bacillus subtilis spores to different generated plasma components (Hertwig et al., 2017). However, identifying the main mechanism responsible for microbial inactivation will always be challenging, since the different interactions can occur simultaneously and also post mortem (Hertwig et al., 2018).

The humidity of the process gas also has an effect on inactivation by cold atmospheric plasma processes, whereby the specific impact is still part of ongoing research. The increased inactivation for *Geobacillus stearothermophilus* and

Bacillus atrophaeus spores with increasing process gas humidity was reported by Jeon et al. (2014) and Patil et al. (2014). They suggested that the effect was probably due to a higher generation of ROS, such as hydrogen peroxide and hydroxyl radicals. In a humid environment, reactive components of the cold atmospheric plasma process, such as ROS and RNS, are able to initiate various chain reactions. This can result in the generation of a larger diversity of reactive species (Surowsky et al., 2014).

4.2 Ablation is the removal of the surface by evaporation of surface material. At plasma modification of surfaces, three major effects are normally observed in the first case: functionalization, which can lead to covalent bonds suitable for attachment of other coatings; crosslinking, which can cohesively strengthen the topmost surface layer; and surface ablation, which can also be used for surface cleaning (Denes and Manolache, 2004; Grace and Gerenser, 2003). Plasma ablation involves the mechanical removal of surface contaminants by energetic electron and ion bombardment. Surface contamination layers (e.g. cutting oils, skin oils, mold releases, etc.) are typically comprised of weak C-H bonds. Ablation breaks down weak covalent bonds in polymeric contaminants through mechanical bombardment and subsequently surface contaminants, thus, undergo repetitive chain scission until their molecular weight is sufficiently low for them to boil away in the vacuum. Ablation affects only the contaminant layers and the outermost molecular layers of the substrate material. Argon is often used for ablation due to its high ablation efficiency and no chemical reactivity with the surface material.

4.3 Plasma Activation (sometimes also referred to as *plasma functionalization*) act as substituting atoms in the polymer molecule with chemical groups from plasma. Plasma functionalization also refers to the introduction of functional groups on the surface of exposed materials. It is widely used in industrial processes to prepare surfaces for bonding, gluing, coating and painting. Plasma surface activation involves the creation of surface chemical functional groups through the use of plasma gases at the atmospheric pressure – such as oxygen, hydrogen, nitrogen and ammonia – which dissociate and react with the surface. In the case of polymers (synthetic and natural ones), surface activation involves the replacement of surface polymer groups with chemical groups from the plasma gas. Plasma processing achieves this effect through a combination of ultrafine surface cleaning from organic contaminants, modification of the surface topography, reduction of metal oxides and deposition of functional chemical groups. The plasma breaks down weak surface bonds in the polymer and replaces them with highly reactive carbonyl, carboxyl and hydroxyl groups. Such activation alters the chemical activity and characteristics of the surface, such as wetting and adhesion, yielding greatly enhanced adhesive strength and permanency. Surface activation is the result of several processes:

- **Removal of weak boundary layers.** Plasma removes surface layers with the lowest molecular weight; at the same time, it oxidizes the uppermost atomic layer of the polymer.
- **Ultrafine cleaning.** Reactive chemical species efficiently oxidize organic

surface contaminants, converting them into carbon dioxide and water, which evaporate from the surface, leaving it in ultrafine clean state.

- **Modification of the surface topography.** Electric discharges having direct contact with the substrate erode the substrate surface on the micrometer scale. This creates microstructures that are filled by the adhesives due to the capillary action, improving the mechanical binding of the adhesives.

- **Crosslinking of surface molecules.** Oxygen radicals (and UV radiation, if present) help break up bonds and promote the three-dimensional cross bonding of molecules.

- **Reduction of metal oxides.** Plasma discharges, ignited in the forming gas, typically containing 5% of hydrogen and 95% of nitrogen, produce large quantities of reactive hydrogen species. By contact with oxidized metal surfaces, they react with metal oxides reducing them to metal atoms and water. This process is particularly efficient in electric arcs burning directly on the substrate surface. It leaves the surface clean from the oxides and the contaminants.

- **Deposition of functional chemical groups.** Short-lived chemical species, produced within the plasma volume, as well as the ions, produced within the thin layer, where the discharge contacts the surface, bombard the substrate initiating a number of chemical reactions. Reactions depositing functional chemical groups onto the substrate surface are in many cases the most important mechanism of plasma activation. In the case of plastics, usually having low surface energy, polar OH and ON groups significantly increase the surface energy, improving the surface wettability by the adhesives. In particular, this increases the strength of the dispersive adhesion. Moreover, by employing specialized working gases, which produce chemical species that can form strong chemical bonds with both the substrate surface and the adhesive, one can achieve very strong bonding between chemically dissimilar materials (Motrescu and Nagatsu, 2016).

4.4 Deposition in plasma involves the formation of a thin polymer coating at the substrate surface through polymerization of the process gas. The deposited thin coatings can possess various properties or physical characteristics, depending on the specific gas and process parameters selected. Such coatings exhibit a higher degree of crosslinking and much stronger adherence to the substrate in comparison to films derived from conventional polymerization.

4.5 Crosslinking is the setting up of chemical links between the molecular chains of polymers. Plasma processing with inert gases can be used to cross-link polymers and produce a stronger and harder substrate microsurface. Under certain circumstances, crosslinking through plasma treatment can also lend additional wear or chemical resistance to a material.

REFERENCES

Booth, I.R., 1985. Regulation of cytoplasmic pH in bacteria. Microbiol. Rev. 49 (4), 359–378.

Boudam, M.K., Moisan, M., Saoudi, B., Popovici, C., Gherardi, N., Massines, F., 2006. Bacterial spore inactivation by atmospheric-pressure plasmas in the presence or absence of UV photons as obtained with the same gas mixture. J. Phys. D: Appl. Phys. 39 (16), 3494–3507.

Bourke, P., Zuizina, D., Han, L., Cullen, P.J., Gilmore, B., 2017. Microbiological interactions with cold plasma. J. Appl. Microbiol. 123 (2), 308–324.

Denes, F.S., Manolache, S., 2004. Macromolecular plasma-chemistry: An emerging field of polymer science. Prog. Polym. Sci. 29, 815.

Dobrynin, D., Fridman, G., Friedman, G., Fridman, A., 2009. Physical and biological mechanisms of direct plasma interaction with living tissue. New J. Phys. 11, 115020.

Fridman, G., Brooks, A.D., Manjula, B., Fridman, A., Gutsol, A., Vasilets, V.N., Ayan, H., Friedman, G., 2007. Comparison of direct and indirect effects of non-thermal atmospheric pressure plasma on bacteria. Plasma Process. Polym. 4, 370–375.

Fridman, A., 2008. Plasma Chemistry. Cambridge University Press, Cambridge.

Grace, J.M., Gerenser, L.J., 2003. Plasma treatment of polymers. J. Dispersion Sci. Technol. 24, 305–341.

Hertwig, C., Reineke, K., Ehlbeck, J., Knorr, D., Schlüter, O., 2015a. Decontamination of whole black pepper using different cold atmospheric pressure plasma applications. Food Control 55, 221–229.

Hertwig, C., Steins, V., Reineke, K., Rademacher, A., Klocke, M., Rauh, C., et al., 2015b. Impact of surface structure and feed gas composition on Bacillus subtilis endospore inactivation during direct plasma treatment. Front. Microbiol. 6, 1–12.

Hertwig, C., Reineke, K., Rauh, C., Schlüter, O., 2017. Factors involved in Bacillus spore's resistance to cold atmospheric pressure plasma. Innov. Food Sci. Emerg. Technol. 43, 173–181.

Hertwig, C., Meneses, N., Mathys, A., 2018. Cold atmospheric pressure plasma and low energy electron beam as alternative nonthermal decontamination technologies for dry food surfaces: A review. Trend. Food Sci. Technol. 77, 131–142, ISSN 0924-2244, https://doi.org/10.1016/j.tifs.2018.05.011.

Jeon, J., Klaempfl, T.G., Zimmermann, J.L., Morfill, G.E., Shimizu, T., 2014. Sporicidal properties from surface micro-discharge plasma under different plasma conditions at different humidities. New J. Phys., 16, 1–14. 103007. doi:10.1088/1367-2630/16/10/103007.

Kylián, O., Hasiwa, M., Rossi, F., 2006. Plasma-based de-pyrogenization. Plasma Processes Polym. 3, 272–275. https://doi.org/10.1002/ppap.200500160.

Laroussi, M., 1996. Sterilization of contaminated matter with an atmospheric pressure plasma. IEEE Trans. Plasma Sci. 24(3), 1188–1191. doi:10.1109/27.533129.

Laroussi, M., 2002. Nonthermal decontamination of biological media by atmospheric-pressure plasmas: Review, analysis, and prospects. IEEE Trans. Plasma Sci. 30 (4), 1409–1415.

Laroussi, M., Leipold, F., 2004. Evaluation of the roles of reactive species, heat, and UV radiation in the inactivation of bacterial cells by air plasmas at atmospheric pressure. Int. J. Mass Spectrom. 233 (1–3), 81–86, doi:10.1016/j.ijms.2003.11.016. ISSN 1387-3806.

Li, J., Sakai, N., Watanabe, M., Hotta, E., Wachi, M., 2013. Study on plasma agent effect of a direct-current atmospheric pressure oxygen-plasma jet on inactivation of E. coli using bacterial mutants. IEEE Trans. Plasma Sci. 41 (4), 935–941.

Mendis, D.A., Rosenberg, M., Azam, F., 2000. A note on the possible electrostatic disruption of bacteria. IEEE Trans. Plasma Sci. 28 (4), 1304–1306.

Moisan, M., Barbeau, J., Pelletier, J., 2001a. Plasma sterilization - Methods and mechanisms [La stérilisation par plasma: méthodes etmécanismes]. Vide-Science Technique et Appl. 56 (299), 15–28.

Moisan, M., Barbeau, J., Moreau, S., Pelletier, J., Tabrizian, M., Yahia, L.H., 2001b. Low-temperature sterilization using gas plasmas: A review of the experiments and an analysis of the inactivation mechanisms. Int. J. Pharm. 226 (1–2), 1–21.

Moisan, M., Barbeau, J., Pelletier, J., Philip, N., Saoudi, B., 2001c. 13th Int. Coll. Plasma processes (SFV), antibes. Le vide: Sci. Tech. Appl. Numero special: Actes de Colloque 12–18 (Mai 2001).

Moisan, M., et al., 2002. Plasma sterilization. Methods and mechanisms. Pure Appl. Chem. 74 (3), 349–358.

Motrescu, I., Nagatsu, M., 2016. Nanocapillary atmospheric pressure plasma jet: A tool for ultrafine maskless surface modification at atmospheric pressure. ACS Appl. Mater. Interfaces 8 (19), 12528–12533. DOI:10.1021/acsami.6b02483.

Padan, E., Schuldiner, S., 1987. Intracellular pH and membrane potential as regulators in the prokaryotic cell. J. Membrane Biol. 198, 189–198.

Park, J.C., Park, B.J., Han, D.W., Lee, D.H., Lee, I.S., Hyun, S.O., Takatori, K., 2004. Sterilization using microwave-induced argon plasma at atmospheric pressure. J. Microbiol. Biotechnol. 14 (1), 188–192.

Patil, S., Moiseev, T., Misra, N.N., Cullen, P.J., Mosnier, J.P., Keener, K.M., et al., 2014. Influence of high voltage atmospheric cold plasma process parameters and role of relative humidity on inactivation of Bacillus atrophaeus spores inside a sealed package. J. Hosp. Infect. 88 (3), 162–169.

Philip, N., Saoudi, B., Barbeau, J., Moisan, M., Pelletier, J., 2001. 13th Int. Coll. Plasma processes (SFV), Antibes (2001). Vide-Science Technique et Applications Nume´ro spe´cial: Actes de Colloque 56, 245–247 (Mai 2001).

Raheľ, J., Tiňo, R., 2016. Wood surfaces: Plasma activation. In: Encyclopedia of Plasma Technology. 1st ed. CRC Press, Boca Raton, pp. 1541–1551, ISBN 978-1-4665-0059-4. https://doi.org/10.1081/E-EPLT-120049575.

Reineke, K., Langer, K., Hertwig, C., Ehlbeck, J., Schlüter, O., 2015. The impact of different process gas compositions on the inactivation effect of an atmospheric pressure plasma jet on Bacillus spores. Innov. Food Sci. Emerg. Technol. 30, 112–118.

Setlow, P., 2007. I will survive: DNA protection in bacterial spores. Trends Microbiol. 15 (4), 172–180.

Shun'ko, E.V., Belkin, V.V., 2007. Cleaning properties of atomic oxygen excited to metastable state 2s22p4(1S0). J. Appl. Phys. 102, 083304e1e14, https://doi.org/10.1063/1.2794857.

Stoffels, E., 2006. Gas plasmas in biology and medicine. J. Phys. D Appl. Phys. 39. doi:10.1088/0022-3727/39/16/E01.

Stoffels, E., Sakiyama, Y., Graves, D.B., 2008. Cold atmospheric plasma: Charged species and their interactions with cells and tissues. IEEE Trans. Plasma Sci. 36 (4), 1441–1457.

Surowsky, B., Schlüter, O., Knorr, D., 2014. Interactions of non-thermal atmospheric pressure plasma with solid and liquid food systems: A review. Food Eng. Rev. 7 (2), 82–108.

Tiňo, R., Šmatko, L., 2014. Modifying wood surfaces with diffuse coplanar surface barrier discharge plasma. Wood Fiber Sci.: J. Soc. Wood Sci. Technol. 46 (4), 1–6.

Wang, S., Doona, C., Setlow, P., Li, Y., 2016. Use of Raman spectroscopy and phase-contrast microscopy to characterize cold atmospheric plasma inactivation of individual bacterial spores. Appl. Environ. Microbiol. 82 (19), 5775–5784.

5 Plasma Cleaning of Inorganic Objects and Materials

5.1 REMOVAL OF CORROSION PRODUCT LAYERS FROM METALS

The metallic archeological objects are typically excavated in a state far away from the original one. Due to the long-term influence of the surrounding environment, various processes are running that in principle lead to the formation of more thermodynamic stable compounds compared to the original metal. This material degradation is known as corrosion and it is a very complex system of chemical and electrochemical reactions leading to the formation of oxides, nitrides, nitrates, chlorides, sulfates, etc., of the original material (Roudet, 1999, Varella, 2013). The real composition of these degraded (corrosion) products depends on many factors such as environment (the real composition of surrounding soil or water), humidity, presence of bacteria or animals, electric field, etc. Thus, each excavated metallic object contains its own set of corrosion products on its surface. Corrosion products of the most common materials are given in Tables 5.1 and 5.2.

Moreover, layers of corrosion products are also building up in the surrounding environment and, thus, the object surface also contains some materials from its surroundings such as sandy grains or rests of organic matters (Roudet, 1999, Varella, 2013). At the final state, these layers became dominant and no metallic core of the object is possible to observe. As the last step, the whole object is completely corroded and spread into the surrounding. Additionally, the corrosion product layers have a typically gradient character wherein the outer shells contain more in-crustations but the inner shells contain compounds more or less originated from the corrosion process of the bulk material (Roudet, 1999). The thickness of the surface layer depends on the material of which the object is made and on the technological history of the object (Belkind and Gershman, 2008). The layers of corrosion products also commonly contain some compounds that can accelerate original material degradation after its excavation. A typical example is the chlorine corrosion cycle in case of bronze (Scott, 1990, Scott, 1991). Thus, it is important, ideally immediately after the excavation, to remove these compounds and stop or at least significantly decelerate the material degradation process.

An additional problem is that the excavated object is difficult or even impossible to identify properly if corrosion layers are thick. A typical problem is to distinguish

TABLE 5.1

The main corrosion products of iron (Barthelmy, 2020, Fell and Williams, 2004, Réguer et al., 2007, Wang et al., 2008).

Name	Chemical formula	Crystal structure
Magnetite	Fe_3O_4	Cubic
Hematite	$g\text{-}Fe_2O_3$	Cubic
Geethite	$\alpha\text{-}FeOOH$	Orthorhombic
Akageneite	$\beta\text{-}FeOOH$	Tetragonal
Siderite	$FeCO_3$	Hexagonal
	$\beta\text{-}Fe_2(OH)_3Cl$	Orthorhombic
Rokuhnite	$FeCl_2 \cdot 2H_2O$	Monoclinic
	$FeCl_3 \cdot xH_2O$	Monoclinic
Greigite	Fe_3S_4	Cubic

between coins, buttons or studs. Thus, some technics for the removal of the corrosion layer from products are needed.

The conventional conservation treatment of metallic archaeological objects is based on both mechanical and chemical cleaning procedures.

The mechanical procedures are based on a global or selective application of high mechanical forces such as sanding (in current technologies based on dry ice pellets applications to avoid secondary contamination of the surface), drilling, application of small tools such as in dental medicine. These techniques are based on generally cheap equipment but the local treatment is very time-consuming and needs a lot of manpower. Therefore, there is a problem to use them in case of emergent conservation of numerous objects. Additionally, the object should not be extremely corroded because of its possible damage by the intense mechanical force application. Moreover, it is impossible to keep and observe any tiny surface detail.

The chemical procedure is generally known as desalination. The principle of them is the dissolution of corrosion products and corrosion accelerators in distilled water or in some special solutions such as LiOH. These procedures don't need huge manpower but the whole desalination takes typically a couple of months and, thus, a large storage area must be available. Furthermore, it is not fully clear whether there is potential interference among objects made of different materials if they are treated together.

Based on the description given above, the current situation in the classical conservation technologies is non-ideal and there are many limitations. The optimal technology for emergency conservation should be fast, be applicable for different objects together with less manpower and of course should be as cheap as possible. Besides this, special soft technologies can be developed for the tiny local treatment of selected objects.

TABLE 5.2

The main corrosion products of color metals (Barthelmy, 2020, Bastor et al., 2008, Campanella et al., 2009, Colomban et al., 2012, De la Fuente et al., 2007, Scott, 1990, Scott, 1991, Stofyn-Egli et al., 1998).

Name	Chemical formula	Colour
Antlerite	$Cu_3(SO_4)(OH)_4$	green, emerald, black
Atacamite	$Cu_2Cl(OH)_3$	green, yellow, green-yellow, black-green
Aubertite	$CuAl(SO_4)_2Cl \cdot 14(H_2O)$	blue, azure
Aurichalcite	$Zn_{3.75}Cu_{1.25}(CO_3)_2(OH)_6$	light green, blanked, green blue
Azurite	$Cu_3(CO_3)(OH)_2$	azure or various blue
Botallackite	$Cu_2Cl(OH)_3$	blue-green, green, light green
Brochantite	$Cu_4(SO_4)(OH)_6$	green, emerald, black
Buttgenbachite	$Cu_{19}Cl_4(NO_3)_2(OH)_{32} \cdot 2(H_2O)$	azure, blue
Cerussite	$Pb(CO_3)$	colorless, white, grey, blue, green
Cuprite	Cu_2O	brawn-red, violet-red, red, black
Gerhardite	$Cu_2(NO_3)(OH)_3$	green-blue
	$(2ZnCO_3 \cdot 3Zn(OH)_2)$	white
Chalcanthite	$Cu(SO_4) \cdot 5(H_2O)$	green, green-blue, light blue, dark blue
Chalcocite	Cu_2S	blue-black, grey, black, black-gay
Langite	$Cu_4(SO_4)(OH)_6 \cdot 2(H_2O)$	green-blue, bluish-green
Lead oxide	PbO	red, orange, yellow
Malachite	$Cu_2(CO_3) \cdot (OH)_2$	green, dark green, black-green
Nantokite	$CuCl$	colorless, white, grey, green
Paratacamite	$Cu_{1.5}Zn_{0.5}(OH)_3Cl$	green-black, dark green
Posnjakite	$Cu_4(SO_4)(OH)_6 \cdot (H_2O)$	blue, dark blue
Simonkolleite	$Zn_5(OH)_8Cl_2 \cdot H_2O$	colorless
Smithsonite	$ZnCO_3$	grey-white, dark grey, green, blue, yellow
Spangolite	$Cu_6Al(SO_4)Cl(OH)_{12} \cdot 3H_2O$	bluish-green, green, dark green, emerald
Spertiniite	$Cu(OH)_2$	blue, bluish-green
Tenorite	CuO	black, grey
Tin oxide	SnO	black
Zincite	ZnO	yellow, orange, dark yellow, dark red

Possible solutions can be based on non-equilibrium plasmas. We can distinguish two general concepts of devices applicable to the archaeological metallic object treatment. The first group is based on low-pressure plasmas that allow surface treatment of big objects or numerous objects simultaneously. The second one is atmospheric pressure operating systems that are generally applicable mainly for the local surface treatment. Each of these technologies has different advantages and disadvantages that are described in the following sections.

Effects of plasma action on the corrosion product layers are similar in both groups. The majority of archaeological objects are covered by corrosion products containing oxygen and/or chlorine-containing compounds. Both oxygen and chlorine are strongly electronegative and, thus, they effectively react with hydrogen that is an electropositive element. Their reactions can be schematically described as

$$AO + H \rightarrow A + OH$$

$$ACl + H \rightarrow A + HCl$$

In these reactions, AO and ACl mean any compound containing oxygen and chlorine atom, respectively. The procedure of plasma treatment can take a long time interrupted by soft mechanical cleaning and can be repeated multiple times, and, thus, there is a possibility of removal of oxygen and chlorine from the original corrosion product (Rašková et al., 2002, Veprek et al., 1988). Both reactions are exothermal (besides some activation energy) and, thus, corrosion products can be effectively destroyed in the atomic hydrogen environment. The OH radical can be further reduced by reaction with another hydrogen atom to water molecule; HCl is a stable specie. Both of them are volatile, i.e. they are presented in a gaseous state at low temperature and can be easily blown away from the surface vicinity.

Significantly less efficient is the removal of corrosion products containing sulfur without oxygen (sulfides) or nitrogen (amines), only. Sulfides can be reduced to volatile H_2S, but this reaction is not so effective and needs higher activation energy and two hydrogen atoms. NH_2 groups can be transformed by the reaction with atomic hydrogen to NH_3 which is volatile again.

Besides the neutral atomic hydrogen that is produced by plasma conditions by electron-initiated dissociation of normal hydrogen gas, other species also play an important role in plasma chemical treatment. As plasma is an ionized medium, it also contains significant concentration of ions (in case of cold plasmas about 1%), i.e. H^+ and H_2^+ species in case of pure hydrogen plasma. These particles also interact with the treated object and they can be also accelerated to the surface. Moreover, all presented species (besides elementary particles – electrons and protons) have internal excitation energies that help to decrease the energy barrier needed for the initialization of the reactions described above. All these particles arrive at the treated object surface together, so it is impossible to exactly detect what particles are the most efficient for the treatment.

Presence of organic materials in corrosion layer products is not so important because it is not too hard to remove them.

REFERENCES

Barthelmy, D., 2020. Mineral species containing Iron (Fe) [Online] http://webmineral.com/chem/Chem-Fe.shtml

Bastor, M.C., Mendonca, M.H., Neto, M.M.M., Rocha, M.M.G.S., Proenca, L., Fonseca, I.T.E., 2008. Corrosion of brass in natural and artificial seawater under anaerobic conditions. J. Appl. Electrochem. 38, 627–635.

Belkind, A., Gershman, S., Nov. 2008. Plasma cleaning of surfaces. Vacuum Technol. Coating, 46–57.

Campanella, L., Colacicchi, O., Alessandri, M., Ferretti, M., Plattner, S.H., 2009. The effect of tin on dezincification of archaeological copper alloys. Corrosion Sci. 51, 2183–2191.

Colomban, P., Tournie, A., Maucuer, M., Meynard, P., 2012. On-site Raman and XRF analysis of Japanese/Chinese bronze/brass patina - The search for specific Raman signatures. J. Raman Spectr. 43, 799–808.

Fell, V., Williams, J., 2004. Monitoring of archaeological and experimental iron at Fiskerton, England, Proceedings of Metal 2004: National Museum of Australia, Cambera, 17–27.

De la Fuente, D., Castano, J.G., Morcillo, M., 2007. Long-term atmospheric corrosion of zinc. Corrosion Sci. 49, 1420–1436.

Rašková, Z., Krčma, F., Klíma, M., Kousal, J., 2002. Characterization of plasmachemical treatment of archaeological artifacts. Czechoslovak J. Phys. 52 (E), 927–932.

Réguer, S., Dillmann, P., Mirambet, F., 2007. Buried iron archaeological artefacts: Corrosion mechanisms related to the presence of Cl-containing phases. Corrosion Sci. 47, 2726–2744.

Roudet, M., 1999. A la Recherche du Métal Perdu – Les Nouvelles Téchnologies dans la Restoration des Métaux Archéologiques, Musée Archéologique du Val d'Oise 1999, Éditions Errance, ISBN: 2-87772-167-1.

Scott, D.A., 1990. Bronze disease: A review of some chemical problems and the role of relative humidity. J. Am. Inst. Conserv. 29, 193–206.

Scott, D.A., 1991. Metallography and Microstructure of Ancient and Historic Metals, Getty Conservation Institute in Association with Archetype Books, Tien Wah Press, Ltd. Singapore, ISBN 0-89236-195-6.

Stofyn-Egli, P., Buckley, D.E., Clyburne, J.A.C., 1998. Corrosion of brass in a marine enviroment: Mineral product and their relationship to variable oxidation and reduction conditions. Appl. Geochem. 13, 643–650.

Varella, E.A., 2013. Conservation Science for the Cultural Heritage, Springer-Verlag, Berlin, ISBN 978-3-642-30984-7.

Veprek, S., Eckmann, C., Elmer, J.T., 1988. Recent progress in the restoration of archaeological metallic artifacts by means of low-pressure plasma treatment. Plasma Chem. Plasma Process. 8, 445.

Wang, Z., Xu, C., Dong, X., 2008. Localized corrosion and phase transformation of simulated archeological iron. Chin. J. Chem. Eng. 16, 299–305.

6 Cleaning of Organic Objects and Materials

Historical organic objects and materials are based, for the most part, on natural polymers. These are characterized by a complicated but regular supramolecular structure anchored in the morphological structure of the materials (e.g. from the glucopyranose unit of cellulose to plant fiber and paper substrate). Decontamination of organic surfaces such as wood, paper, leather and parchment, textiles or plastics is much more complicated because materials of these objects in principle are sensitive to both radiation and active particles formed by plasma. During the plasma treatment, a variety of active species generated by plasma reacts with the surface of the treated material. These species can, for example, introduce new functional groups and/or remove the contaminants from the surface (Roth, 2001). Broad research in this field is carried out mainly concerning medical applications where temperature-sensitive materials such as pulp are sterilized (Fridman and Fridman, 2013; Shintani and Sakudo, 2016). These systems are typically used in a global treatment regime. However, developed protocols are applicable and generally also accepted for new materials. The use of protocols for historical materials that are partially damaged (usually polymeric chains are shorted or partially oxidized) must be very carefully discussed because the potential damage of the object material by both radiation and active species is non-negligible.

Application of local treatment using plasma jets is made broadly for biomedical applications such as wound healing, plasma-based surgery, coagulation, etc. Their application is similar to the precedent cases, and limits for their use in microbiological decontamination of the historical object are also similar.

6.1 CLEANING OF PAPER

6.1.1 INTRODUCTION

Paper is an important part of the material nature of heritage. As a traditional information carrier, it is of great historical, cultural and communicative importance. This composite sheet material is characterized by a complex heterogeneous structure, formed by a network of fibers, which is reinforced and stabilized by interfibrillar hydrogen bonds. The paper fiber itself forms several structural levels, the basis of which is a cellulose macromolecule with a regular molecular and supramolecular arrangement. An important factor influencing the final properties of paper (including its durability) is the technology of pulp production and the used additives. The presence of other components of documents, books and artifacts, such as inks, pigments, binders, adhesives, waxseals, parchment and leather binding books and others, further complicates the choice of preservation methods. According to a number of scientific

publications, the protection of paper is given the greatest attention among various areas of preserved cultural heritage (Alexopoulou I., 2016), which is related to the complexity of the whole process of conservation of these objects. Conservation methods are the most serious factors of deterioration and degradation of paper artifacts; there are cleaning and microbiological decontamination, deacidification, consolidation and aqueous methods for the ink fixatives.

Paper cleaning is one of the basic conservation interventions. The aqueous, non-aqueous and mechanical surface treatment of paper substrate are long-held techniques in conservation practice. The twentieth century often involved the washing of degraded or discolored paper artifacts (after bathing, paper artifacts were often perceived to be whiter, stronger and healthier; Vitale, 1992). Wet cleaning is one of the most critical steps during conservation treatment, because of efficiency (penetration into the paper structure up to the level of cellulose) and environmental benefits. However, washing treatment usually involves a substantial impact on the original morphological structure of the paper and can be dangerous for water-sensitive inks and pigments (Zidan, 2017). Results of survey of cleaning methods of paper, used in conservation practice (Alexopoulou, 2016), indicate that mostly dry cleaning and wet cleaning with water (89%) is used; for wet cleaning in 53%, there are also used organic solvents to solubilize stains of adhesives on paper, and 24% of the participants use enzymes. Laser cleaning was not used. Concerning disinfection/sterilization methods, half of the survey participants (conservators) do not use any chemical or process. Considering that fumigation with ethylene oxide was the predominant sterilization method in the past (Hengemihle, 1995, Smith, 1986), there seems to be a trend in abandoning dangerous methods and adopting more benign ones (as Alexopoulou writes). Other methods such as gamma and UV radiation cannot be utilized for the disinfection of historical objects due to the significant decrease of the strength and change in the color of the paper (Gutarowska et al., 2016). These facts indicate the need for research and development of new, efficient, environmentally acceptable decontamination processes while being gentle on the treated object and human health.

6.1.2 PLASMA CLEANING OF PAPER

The main advantage of plasma in paper treatment is the inherently dry nature of the process and the possibility of combining different effects, such as removal of contamination, an increase in paper strength and the deposition of polymer films to prevent the paper object from environmental influences (Vohrer et al., 2001).

Due to the full range of organic low molecular and polymeric substances, paper carriers are easily infected by microorganisms, especially in areas with high relative humidity. Related to this is the priority interest in microbiological decontamination. However, in addition to disinfecting/sterilizing effects, plasma also affects the surface properties of cellulose-based materials. Ioanid et al. (2015) showed that a 6-min treatment of low-temperature plasma (LTP) in the nitrogen atmosphere is sufficient for book and paper document decontamination. The process did not change the pH of the material; however, plasma caused increased yellowness of paper. The effect of microbial decontamination was researched by LTP, generated by high-frequency multi-point corona discharge in a closed apparatus with positive disinfection efficiency on bacteria and fungus and having an insignificant effect on

the historical paper substrate (Gutarowska, 2016, Pietrzak, 2016). The main goal is to remove contamination by fibrous sponges in combination with increasing the strength of paper (Vohrer, 2001). This can be achieved by appropriately setting conditions that ensure the devitalization and subsequent removal of fibrous fungi and other microorganisms from the surface of the paper. Plasma was already studied for stabilization of documents containing iron-gall inks (Rehakova, 2008). The work was concentrated on the enhancement of strength and stability of historical paper documents treated in dielectric barrier discharge (DBD) at atmospheric pressure in combination with natural polymer chitosan and/or antioxidizing agents. LTP treatment can provide paper cleaning operations such as soil particle removal, greasy ablation, surface activation and microbiological decontamination. The effectiveness of the intervention and changes in the properties of the material depend on the type and conditions of the plasma discharge, and the type and surface properties of the treated paper. It has been shown that the microbiological decontamination is influenced by the material composition of the paper (kind of papermaking fiber, presence of lignin), its technological parameters (sizing and surface treatment) and the type of microorganisms (Gutarowska et al., 2016, Vizárová et al., 2017, Vizárová et al., 2018). Model papers inoculated with a suspension of the five most common genera of fibrous fungi (*Alternaria alternata, Aspergillus niger, Cladosporium herbarum Penicillium chrysogenum, Trichoderma viride*) (Sterflinger, 2010) were treated with Atmospheric discharge with runaway electrons (ADRE) plasma in different gas atmospheres, at different processing times and power settings. By monitoring their growth, it was found that the most resistant microorganism is *Penicillium chrysogenum*, which is the most common contaminant in the depositories of libraries and archives. Its growth is very pronounced especially on Whatman paper, which is made from pure cellulose. The decrease in the decontamination effect of plasma on filamentous fungi was manifested under the tested conditions in the order: *C. herbarum* > *T. viride* > *A. niger* > *P. chrysogenum* (Vizárová et al., 2018). The last-mentioned microorganism of this order, *Penicillium chrysogenum*, is, therefore, the most resistant filamentous fungi, to the action of sterilizing agents and technologies, and this must be taken into account when designing new technological procedures. It is also necessary to remember that it is also one of the most widespread filamentous fungi colonizing the environment of older archives, libraries and museum deposits. The efficiency of fungal decontamination by plasma under atmospheric conditions depends mainly on the type of particles generated in the plasma discharge (Vizarova, 2020). For decontamination (according to the available relevant literature sources, Laroussi, 2004; Stoffels, 2006), the most effective are hydroxyl, superoxide, peroxyl and hydroperoxyl radicals, which can chemically attack proteins in the cell wall of microorganisms, as well as enzymes found in their cytoplasm. Their amount depends on the type of atmosphere used and the presence of moisture is considered a positive factor, either in the atmosphere or in the bodies of exposed microorganisms. Moisture contributes to a significant increase in hydroxyls and improved decontamination efficiency. However, it is also necessary to take into account the degradation effects of reactive oxygen and nitrogen particles, which could potentially degrade the surface of the exposed material.

When looking for new methods of preservation, in addition to evaluating the effectiveness of the proposed processes (in this case plasma treatment), it is also necessary to always verify possible adverse effects on the material. Based on the study of changes occurring on the paper surface due to low-temperature atmospheric plasma using ATR-FTIR spectral analysis (Tiňo, 2017, Vizárová et al., 2018), it can be stated that there are no changes in the chemical structure of the material. However, the intensity of the absorption bands changes in the region of the carboxyl (1730 cm^{-1}) and carbonyl (1650 cm^{-1}) functional groups with the plasma treatment time and subsequently also depending on the aging time of the paper sample. The oxidation index (Lojewska, 2005) shows the degree of oxidative degradation due to the use of different atmospheres (oxygen, nitrogen, carbon dioxide, argon, and air). An important finding is the reversibility of changes in the value of the oxidation index of the order of tens of days after plasma treatment compared to the first day (depending on the type of paper). This can be explained by the initial plasma activation of the paper surface. Subsequently, after the initial reactions of the plasma-activated surface with the surrounding environment, a stabilization phase occurs and the changes expressed by the oxidation index are also less pronounced. The change in the value of the oxidation index toward the original value was also confirmed in a long-term experiment. This phenomenon was accompanied by a change in the pH value, which had the same trend.

A different plasma treatment mechanism is applied to remove dirt particles (dust, carbon black) from the surface of the paper (Vizárová, 2019). This was achieved while maintaining the same conditions (0.3 J.s^{-1}, nitrogen or argon, ADRE plasma), but by radically shortening the plasma modification time (tens of seconds). The adhesion of dirt particles to the surface had weakened, which can be attributed to the activation of the surfaces of all system components. What is important, effective removal was achieved without the need for mechanical contact with the treated surface.

6.2 CLEANING OF WOODEN OBJECTS

Objects of cultural heritage exhibit great variability of materials, not to mention that they are often heterogeneous systems, including wooden items. They consist of interacting components, which also has an impact on the procedures applied in the conservation and restoration of such objects.

Wood is considered to be one of the most common materials in heritage collections encountered all over the world. Due to its biodegradable nature, wood is exposed to a wide variety of biotic and abiotic agents, including fungi, insects, termites, moisture fluctuation or weathering (Kim, 2016). Wood is an extremely durable, renewable, complex, hierarchical material composed of various biomolecules (extractive) and biomacromolecules (polysaccharides, lignin). Their properties depend on various parameters such as botanical source, geographical origin, season, age of the wood, and may vary from one place to another in the forest (Nimz 1984). It has been used as a natural resource since prehistoric times, due to a wide range of applications, including dwellings, tools, weapons, transportation and decorative objects.

Wooden works of art typically include other materials as well, such as paint layers, which may be severely damaged even by deformations not sufficiently large to damage the wooden support. Conservation of wooden artifacts of cultural importance must, therefore, take into consideration not only average or typical values of the microclimatic environment in which they are conserved but also the history and the variations of such conditions, which can endanger the survival of unique masterpieces (Dionisi-Vici, 2004).

There is an extensive collection of wooden objects and structures of various kinds, depending on the type of environment and geographical origin in different states of decay in museums and research institutes around the world. The study of these archival sources is not only beneficial in the social sciences and humanities but also provides a wealth of information for the physical, material and engineering sciences on wood degradation processes over time (Altgen and Militz, 2016) as a function of species, pretreatment, geography and environmental factors (Guggemos and Horvath, 2005). Wood products that humanity forms since time immemorial are derived from strained and matured trees. The strain is obtained as a log that is later processed into lumber. Therefore, each wooden component, whether it is a veneer on top of a table or a leg of a chair, can be interpreted in terms of its original position in the tree. Many characteristics are common to all trees and can be talked about regardless of the specific type of wood.

CLEANING OF HISTORICAL WOOD

Cleaning is an important part of the process of preservation. It is necessary to understand the mechanism and potential impact of the cleaning technique or substance so that it can be used accurately. For example, if soot needs to be removed from an object, an approach that removes soot and nothing more should be chosen. Conservators have been criticized for over-cleaning the surfaces of paintings, and more recently for varnished wood surfaces.

Cleaning means the irreversible removal of material from an object and its consequences must be carefully considered. What is considered over-cleaning depends on fashion and varies from culture to culture. In the past, disputes over the cleaning of paintings led to the removal of varnishes from the surface. Also for wooden objects, the topic of the degree of deposit removal is topical (Brommelle and Smith, 1976; Jeffrey, 1999).

This question arises in part from a desire to preserve evidence of the passage of time. Also in cases where it is desirable to remove dirt from a porous surface without damaging the object being cleaned (see Figure 6.1). The success rate of cleaning should include not only how the object appears after cleaning, but also how the cleaning process affects the long-term protection of the object.

The ideal treatment should remove surface dirt and the original material should remain intact. However, it is rare for objects to be undamaged or in perfect condition.

The reasons that motivate the conservator to accept the risks and continue cleaning are often to increase the aesthetic properties of the object or to preserve the condition of the surface decoration. Deciding on the depth of cleaning is difficult. It is necessary to consider the aesthetics, evidence of use, and age that can lend the object and can be irreversibly altered by removing dirt and grime.

FIGURE 6.1 Stages of removal of unwanted material (impurities and degradation products). a) Surface with accumulated dirt. b) Unwanted material removed only from the surface. This degree of cleaning can be unsatisfactory if there is a significant contrast between the cleaned surface and the gaps loaded with dirt. c) Unwanted material removed from the surface and partially removed from the gaps. This degree of cleaning can be a surface that retains the patina of age or use. d) Almost all unwanted material has been removed, but as cleaning progresses, the substrate is more likely to be damaged or eroded. e) The surface was eroded in an effort to remove all traces of unwanted material. This type of damage is particularly likely when unwanted material and substrate share a sensitivity to cleaning, for example, removing paint from lacquered, Japanese or lacquered surfaces.

Deposit

A deposit is usually defined as an accumulated layer of surface impurities (dust, insect exudates, fibrous fungi, chemicals formed by reaction with oxygen, ozone, sulfur and nitrogen oxides, oxidation and degradation products of material, toxic residues from previous preservatives, pollutants from of Air).

Impurities are generally hygroscopic, often slightly acidic, and may be characterized by the source, size, chemical composition, or mechanism by which they adhere to the surface (Phenix and Burnstock, 1992).

The probability that dirt will be removed depends on the type and strength of adhesion between the dirt and the surface of the object. Impurities can adhere to the surface treatment mechanically by physical entrapment due to static electricity, hydrogen or dipole bonding or van der Waals forces. It is usually a combination of these forces that lead to the accumulation of impurities and their increase on the surface (Moncrieff, 1992).

Dirt can be removed from the surface if the attractive force between the cleaning system and the dirt exceeds the attractive force that adheres to the dirt surface. There are three general approaches to cleaning (in all cases, cleaning should be done by the simplest possible method).

- mechanical cleaning physically displaces dirt
- in a solvent or water with water, the impurities do not change in chemical form and are removed in solution
- in dry cleaning, the primary molecular bonds in the impurity itself are broken and converted to another form during removal

TRADITIONAL CLEANING METHODS

MECHANICAL CLEANING

Mechanical cleaning depends on the decomposition of the impurities, they do not require any toxic chemicals and there is a small risk that the removed impurities will get into the porous surface (Cooper, 1998).

Dust Removal

Dust is airborne particles that collect on the surface of an object and are not bound to a substrate or to each other. It can be removed with a dust cloth (lacquered tabletops), a soft natural bristle brush (inlaid or gilded surfaces), or a vacuum cleaner.

Cleavage

The cleavage can be used to remove brittle dirt, metal corrosion products or an undesirable coating from a substrate surface that is undamaged and relatively thick.

Cleavage uses a layer-breaking mechanism based on strong adhesive forces in the layers and weak adhesive forces between the layers. This technique avoids the risks associated with solvents.

Abrasion

Abrasive techniques are sometimes used to reduce the thickness of an unwanted layer, such as flat surface coatings, on corrosive products. Not recommended for decorative items.

Dry Cleaning

Used properly, dry cleaning methods are non-abrasive and rely on the adhesive properties of the dry cleaning material to trap dirt and remove it from the surface. These methods are suitable for porous surfaces.

Cleaning does not require abrasion, as these materials usually roll over the surface.

A typical example is the traditional removal of impurities with bread, but the residues promote the growth of mold. However, there are special products such as vinyl rubbers, smoke sponges, cleaning granules (Hackney, 1990).

CLEANING WITH SOLVENTS

There are several important factors that should be used when choosing a solvent or varnish. They include the solubility and compatibility parameters of the solvent and the impurity or varnish, the solubility parameters of the underlying decorative surface, the toxicity of the solvent, the dissolution rate of the impurity or varnish compared to the rate of penetration into the substrate.

We divide them into groups with the same chemical properties.

Chlorinated Hydrocarbons

The asymmetric addition of chlorine to the hydrocarbons increases the dipole bond, making them suitable for removing natural resins and coatings. However, these substances deplete the ozone layer and their use is therefore limited.

Alcohols

Alcohols contain an -OH group, a dipole that can form hydrogen bonds. Examples of alcohols used in furniture protection are ethanol, benzyl alcohol and 1-methoxypropan-2-ol.

Ethanol is a small linear molecule. It evaporates quickly and is a good solvent for natural resins and has a relatively fast swelling on them. It is more polar than larger and branched alcohols. Benzyl alcohol combines the properties of an aromatic and an alcoholic solvent. It is very effective on materials that combine aromatic and hydrogen bonds, for example, natural resins. It is not particularly selective for removing layers. If used either neat or as a large proportion in a solvent mixture, it damages the surfaces, so it is advisable to use it in small amounts to another solvent. 1-Methoxypropan-2-ol (also known as methylproxitol) is used as a diluent for many resins used in finishing and painting.

Aldehydes and Ketones

Aldehydes and ketones contain a carbonyl group, so they are dipole with the possibility of forming a hydrogen bond. They dissolve many natural and synthetic resins but do not dissolve greasy dirt well.

Ethers

Contain the group R-O-R, the structure is similar to water, but does not form hydrogen bonds. They are used on sensitive surfaces because their rapid evaporation limits the effect of their solubility.

Esters

Esters are derived from carboxylic acids. The general formula of esters is RCOOR1. Unpaired electron pairs on oxygens cause polarity but do not bind hydrogen bonds. Esters are very good solvents for nitrocellulose and some are good solvents for polyvinyl acetate adhesives.

Amines

Amines contain a nitrogen atom and have the general formula R-NH2. Depending on whether they are primary, secondary or tertiary, they form a hydrogen bond. They have the potential to saponify grease, oil and greasy materials.

CHEMICAL CLEANING

Cleaning to be used if previous procedures have not been sufficiently desirable to remove contamination. The problem, however, is to find a suitable reagent that would not cause damage to the monument. It involves the use of agents that act on molecular bonds, convert the deposit, or even varnishes, into another chemical form, thus removing them from the surface. Unlike solvent cleaning, the material is irreversibly converted. After using these reagents, the surface of the object must be rinsed with water.

Cleaning with Acids

Both organic and inorganic acids are used. They react with metals and corrosion products of metals. They are used as part of cleaning solutions; Ph buffers, chelating agents, and bile soaps. Although the wood is weakly acidic, the use of acid threatens its discoloration.

Cleaning with Alkalines

Alkaline solutions can cause alkaline hydrolysis of fats, as well as saponification of resins and waxes, as they contain ester bonds. A small amount of ammonium hydroxide solution is used to reduce the surface tension of the water; it can also neutralize possible weak acids formed. Sodium bicarbonate can be used to remove adhesives or as an ingredient in bleaching agents.

RECENT FINDINGS

One of the most encountered problems in the preservation of wood artifacts is represented by its biodegradation. Unger (Unger, 2012) reviewed the problems related to the historical use of inorganic (fluorides, fluorosilicates, metallic sulfates and chlorides, alkali arsenates or boron compounds) and organic biocides (chlorinated hydrocarbons, cyclodiene compounds, phenol derivatives, organometallic compounds or organophosphates), both on the artifacts themselves and to human health. The European standard EN 15003 proposes the hot air methodology to eliminate fungal and insect attacks. However, the method cannot be always applied (considering the state of degradation and the characteristics of the materials). With the understanding of those negative effects, the search for new biocides represented an important research area in the last decades. In 2011, Clausi et al. (2011) evaluated the antifungal effect (against white and brown rot fungi) of two widely used polymeric consolidants (Paraloid B72 and Regalrez 1126) applied on White poplar (Populus alba) and Norway spruce (Picea abies (L.) H. Karst). The authors observed that the application of individual consolidants led to different inhibition of the fungi (10% Paraloid being effective against white-rot fungus, while 5% Regalrez was effective against brown-rot fungus; the consolidant mixture inhibited both types of fungi). The results suggested that the combined application of the consolidants could slow the fungal growth in treated samples (behavior depended on wood species and treatment type); in the long term, no treatment was proven to be effective in completely inhibiting fungal growth. Stejskal et al. (2014) proposed the use of the fumigating agent hydrogen cyanide that proved to be effective against pinewood nematodes, Asian long-horned beetles and house long-horned beetles, important pests of the construction wood and historical buildings. The authors recorded a 100% mortality against the cerambycids (after 1-h exposure) and nematodes (after 18-h exposure), at a 20 g/m^3 concentration of fumigant agent. Although effective, the chemical compound was prohibited for use due to its high toxicity (together with another effective pesticide, methyl bromide; Querner et al. (2013). This led to the search for alternative chemical and non-chemical pesticidal agents (Fiarescu, Domi, and Fiarescu, 2020).

Recent advances in the conservation of wood artifacts were recently reviewed by Walsh-Korb and Averous (Walsh-Korb and Avérous, 2019) and by Fiarescu et al., (2020).

However, most of these techniques use only physical and chemical cleaning. The purpose of this chapter is to show the possibilities for cleaning with the use of low-temperature plasma. When searching for the available literature, it is impossible to find articles directly related to the cleaning of historical wood by the effect of LTP. Plasma modifications of wood are carried out primarily in order to activate the surface of the wood before the application of the surface finishes or before gluing. However, as already mentioned in Chapter 4.3, during the activation of the wood surface by plasma, there are, among other things, cleaning effects – removal of weakly bound surface layers, as well as ultrafine cleaning. At the same time, if the conditions for the formation of RNOS are met, there is also a deactivation of microorganisms colonizing the surface of the substrate, in our case wood, which subsequently acquires increased durability of the surface treatment and resistance to degradation after application of the surface coating. In addition, it is necessary to realize another important thing, namely that historical wooden objects, as well as today's objects, were often surface-treated with various varnishes, paints or other modifications. Thus, in the case of possible cleaning of such surfaces, the plasma does not come into contact with the wood surface, but reacts with impurities, dirt as well as with the surface layer of the coating and only to a minimal extent with the exposed wood surface in places where the coating has degraded or peeled. Under the PlasmArt project (see Chapter 7), the cleaning efficiency of LTP on shellac-treated wood was tested. When testing the cleaning effects of LTP, the procedure was to first test model samples of wood (oak) commonly represented in the collections of memory and fonds institutions surface-treated with shellac paint. This surface treatment has been widely used in the past and is present on a substantial part of collection items. Such model samples were exposed to LTP and the effects on shellac treatment were monitored. The experiment on model samples was performed with a piezoelectric plasma pen (see Chapter 3.5.4; at conditions: frequency 50 kHz, voltage maximum 20 kV, power consumption varied depending on the type of working gas: argon 10–12 W, air 36–41 W). In another experiment, a plasma-beam system was also tested, under the following conditions: distance of the nozzle from the surface of the treated wooden board 1.5 cm; working gases used: air and argon. Plasma processing times of up to 7 min are safe. Tests were also performed on a sample of a real, heavily soiled object (a board from a sewing machine with a deposit consisting of a mixture of dust, oil and microorganisms) in order to test the ability of plasma to clean heavily soiled wood surface, resp. facilitate its cleaning. It was found that the wood surface remained undamaged during the plasma treatment in the air atmosphere; the deposit was best removed in procedures where the surface was moistened before using the plasma. When argon was used as the working gas, the wood surface remained undamaged, the deposit was removed as well as in processes where the surface was mechanically cleaned with water or water with the addition of surfactants. This method is more suitable for heavily soiled surfaces. Based on the obtained results, it can be stated that low-temperature atmospheric plasma has the potential to clean the surface deposit of wooden objects of heritage

and has no adverse effects on the surface of shellac-treated material at exposure times of less than 5 min in air and 7 min in argon. In addition, plasma treatment helps to clean surfaces with varying degrees of contamination, in most cases without the need for organic solvents, using only water.

6.3 CLEANING OF PHOTOGRAPHS

6.3.1 INTRODUCTION

Photographs represent an important part of cultural heritage, which has a historical, aesthetic, informational and documentary role. Photograph is a complex multilayer object, composed of various materials (metals, paper, collodion, gelatin, albumen, protective varnish layers and colorants); identification of technique, material composition and degree of damage of photographs is a key element in cleaning and restoration.

Under the term photograph, we mean an image (slide, film or a photograph on paper) that is created by a photographic process, on film, paper, foil or another medium. Photography is one of the relatively young media, and its history began in 1826 when Joseph Nicéphore Niépce made the photography 'View from the Window' by heliography, the image was not created by silver reduction but by photopolymerization. The direct predecessor of today's photography based on silver halides is daguerreotype (Louis Jacques Mandé Daguerre, 1839), which was made directly on a metal substrate (silver-plated copper plate) and its image is made of amalgam (an alloy of mercury and silver). The first photograph on paper with the image based on reduced silver was created in 1841 by the calotype technique (talbotype, salted paper, William Henry Fox Talbot; Machatová, 2016).

Most of the photographs in museums, archives, libraries and private collections are albumen (Louis Désiré Blanquart-Evrard, 1847), collodion (Frederick Scott Archer, 1851) and especially gelatin photographs (Richard Leach Maddox, 1871), where on paper support, there is an image layer often separated from the paper by a barite layer (mainly in collodion and gelatin photographs). The materials of these mostly used historical photographs consist of a combination of inorganic substances (silver and baryte) and organic polymer materials (paper, albumen, collodion and gelatin; Machatová, 2016). Albumen consists of proteins, vitamins and minerals dispersed in the water milieu. The albumen print process was very popular in the period from 1850 to 1920 (Crawford, 1979; Vitale and Messier, 1994).

The collodion and gelatin silver prints have a layered structure, which consists of a silver image (Ag in gelatin or collodion), baryta layer and paper support (Lavedrine, 2009, Martins et al., 2012). The collodion is a solution of cellulose nitrate dissolved in a mixture of alcohol and ether. Collodion was employed in the photography process from 1850 onward, as a binder for photosensitive silver halide salts to glass and, later, to paper.

Gelatine is a protein of animal origin. Gelatin photography was the most commonly used binder photography in the 1890s and the whole twentieth century (Lavedrine, 2009).

At the end of the nineteenth and the beginning of the twentieth centuries, all three photographic techniques were used simultaneously. A survey of photographs

from the second half of the nineteenth and the beginning of the twentieth centuries in the Slovak National Museum at Bratislava Castle depository identified 56% of the photographs as gelatin, 29% albumin and 12% as collodion (Haberová et al., 2018; Haberová, 2020).

To obtain colors in the photography, a thin layer of dyes and pigments dispersed in the appropriate binder was often applied to the photograph (colored photograph), and protective varnishes were used to protect the photographs, especially from their mechanical damage; thus, photographs are complex multilayer materials, that are difficult to identify, clean and restore.

Although the first experiments with color photography based on silver halides began in the second half of the 19th century, color photography was not significantly established 100 years later. The image layer of color photography differs significantly from black and white because it does not contain silver (this plays a role only in creating the image, but then it is removed in the bleaching process) but dyes, so we will not deal with the color photography in this chapter.

Simultaneously with techniques based on the sensitivity of silver ions to light, non-silver photographic techniques were also developed, especially those based on the light sensitivity of iron ions (cyanotype, platinotype and argentotype). Cyanotypes, in which Prussian Blue forms the image, played an important role because this was used not only for photography but also for copying, and many books from the middle of the 19th century were illustrated by photographs made using the cyanotype technique. Three volumes from Anna Atkins's Photographs of British Algae: Cyanotype Impressions (1843–53) are the oldest examples of books illustrated with photograms (Stulik and Kaplan, 2013). The problem of cyanotype is its bleaching when photographs are exposed to light.

The discrimination of historical photographs is a very actual task (Lavedrine, 2009). In addition to visual and microscopic observation, Fourier transform infrared (FTIR) spectroscopy and a combination of near-infrared (NIR) spectroscopy with principal component analysis (PCA) are suitable for the identification of photographic techniques (Da Silva et al., 2010; Kozachuk et al., 2018; Martins et al., 2012; Marucci et al., 2014; Oravec et al., 2019).

The specific photographic technique requires different store conditions, restoration and conservation procedures, for example, the aqueous treatment is not suitable for the gelatin binder because of swelling. The structural and material identification is an essential and fundamental step to a critical stage to establish adequate procedures of restoration, preservation and serious damage prevention. It individuates the right way to preserve photographs to act as the better choice for appropriate conservation or preservation (Casoli and Fornaciari, 2014; Nieto-Villena et al., 2019).

6.3.2 Cleaning of Daguerreotypes by Plasma

The first experiment to treat photographs with plasma was done on daguerreotypes in 1981 by V. Daniels (Daniels, 1981). A significant part of these images has deteriorated; the main effect was tarnishing of the silver surface (Daniels, 1981). Tarnishing is caused by hydrogen sulfide from the air, and several methods have been devised for

its removal. Traditionally, two groups of silver cleaning methods – abrasive (unsuitable for the sensitive surface of a daguerreotype; Daniels, 1981), and chemical (use of potassium cyanide solution (Swan, 1975) or acid solutions of thiourea (Collingst and Young, 1976)) were used. Some photographs were colored, and a solution treatment can lead to a loss of the color, due to dissolution or to the mechanical action of the water dislodging particles from the surface (Daniels, 1981).

Using plasma treatment, many of the disadvantages of wet chemical methods are avoided (Daniels, 1981). Glow discharge in hydrogen gas (Daniels used a mixture of hydrogen and neon) can reduce silver tarnish back to silver. When a daguerreotype is made an electrode of such a system, reduction takes only a few minutes (Daniels, 1981). The silver object is used as one electrode of the plasma generator resulting in significant improvement of the reducing efficiency of the hydrogen plasma. This technique is a valuable addition to the existing methods and the obtained results. The method does not have a detrimental effect on the original silver coating. Mechanical damage related to abrasive and chemical methods had not been documented as well (Daniels, 1981).

Other alternative methods include low-pressure plasma and laser cleaning. However, their efficiency is limited (Grieten et al., 2017). The corrosion removal was accompanied by sputtering by the collision of ions against the original surface of the daguerreotype. The sputtering results in optical changes, including permanent matting effect (Daniels, 1981; Golovlev et al., 2000; Golovlev et al., 2003; Turovets et al., 1998). The use of non-thermal remote atmospheric plasma cleaning was introduced as a new method for corrosion removal (Boselli et al., 2016; Siliprandi 2007). Boselli (M. Boselli et al., 2016) used both a commercial plasma jet source (kINPen 09, Neoplas Tools GmbH) and a specially designed DBD plasma source operated within a controlled volume at atmospheric pressure. The argon–hydrogen gas mixture (hydrogen content: 35% vol.) was used to remove corrosion products, without immersion of the substrate in solvents or chemicals. The concept of the remote plasma treatment is that gas is channeled through the source and exits through a nozzle and indirectly treats the surface in the afterglow (Grieten et al., 2017). Treatment in the afterglow eliminates the reactive species such as ions, which are considered the main cause of the non-selective physical etching of the surface by low-pressure plasmas, from the interaction volume (Grieten et al., 2017). As there is no mechanical contact with the surface of the daguerreotype, the risk of mechanical damage is significantly reduced as well. Moreover, plasma cleaning is considered an eco-sustainable method, compared to conventional solvent-based conservation-restoration techniques. Grieten et al., 2017 at all evaluated the plasma cleaning at three different levels. They focused on the chemical and physical differences introduced by the plasma jet afterglow treatment. The selectivity of remote plasma treatment was proved, as only the oxidized species formed during the corrosion process have been transformed while the original surface remained unaffected. This resulted in a partial regeneration of the original image. The effects of plasma treatment are influenced by the exact chemical build-up of the daguerreotype, which depends on the exact technological procedure used by the author. A different approach may result in different types of corrosion products and influence the thickness of the corrosion layer as well. Atmospheric plasma treatment is a potential alternative for currently used cleaning techniques and that it is worth

further exploring. The long-term stability of daguerreotypes treated with a plasma afterglow was not studied, and this is a significant evaluation criterion for the conservation–restoration community. The corrosion process results in a displacement of atoms, and any kind of cleaning technique cannot recover the original position of these atoms. While some techniques can remove these displaced atoms, atmospheric plasma only changes the oxidation state of atoms by (partially) reducing corrosion products to their metallic state. The claims were supported by results from STEM, SEM, EELS, EDX and XAFS (Grieten et al., 2017).

6.3.3 MICROBIAL DECONTAMINATION OF ALBUMEN AND GELATIN PHOTOGRAPHY

The objects of cultural heritage on organic support are susceptible to attack by microorganisms. This problem has become a priority in the whole world since last year. Many specialists are trying to find the optimal methods for the conservation and preservation of cultural heritage objects. The virulency and long duration of attack by microorganisms, especially bacteria and fungi, cause significant degradations to the material support (Cappitelli et al., 2006; Ioanid et al., 2010).

The degradation phenomenon establishes an irreversible process of structural changes in the object (Laguardia et al., 2005). Photographs consist of paper support and image layer (silver halide in gelatin, albumen and collodion). Paper, gelatin, albumen and collodion are natural organic compounds, which are very sensitive to attack by microorganisms that cause chain degradation and, consequently, affect the image, resulting in discoloration of the affected area, and appearance of stains. Fungi can generate structural and color changes and deterioration of physicochemical properties of the support. Bacteria found in smaller amounts on cultural heritage objects can also produce serious deterioration. Cellulolytic bacteria decompose the cellulose, making it easily friable (Cappitelli and Sorlini, 2005; Ioanid et al., 2010). They can also cause serious risks for staff and visitors to museums, galleries and archives. High microbial contamination is mainly present in the surroundings (Skóra et al., 2015; Zielińska-Jankiewicz et al., 2008).

The following microorganisms were most often recorded in the photographs: *Penicillium, Aspergillus, Cladosporium, Alternaria Paecilomyces and Rhizopus* (Zielińska-Jankiewicz et al., 2008; Habalová et al., 2018; Kazánová, 2019; Ioanid et al., 2010). Genera *Penicillium, Aspergillus* and *Cladosporium* were identified and shown in the photograph in Figure 6.2 from Slovak National Archive in Bratislava (Kazánová, 2019).

Currently, mainly chemical methods (ethylene oxide sterilization and butanol vapor) or γ-radiation are used to disinfect contaminated material, some of which represent health risks (Tomšová and Ďurovič, 2017). The decontamination of photographs becomes difficult when wet and thermal treatments are applied to objects made of cellulose. γ-radiation, another method used in the decontamination of organic materials, induces the degradation of the support (Butterfield, 1987).

Currently, new decontamination achieved by high-frequency cold plasma is one of the new ways of treating cultural heritage materials (Dunca et al., 2005). This method is one of the physicochemical methods of sterilization. It is a non-invasive

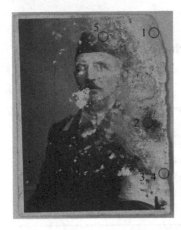

FIGURE 6.2 Historical photography. Individual sampling on photography: 1 – scalpel, 2 – swab, 3 – adhesive tape, 4 – adhesive tape, 5 – swab.

and ecological method that is very easy to apply for paper support objects (Habalová et al., 2018; Habalová et al., 2018; Ioanid et al., 2011).

The advantage of ADRE plasma is its ability to process larger areas at the same time, which makes it suitable for material sterilization. Its discharge has the potential to destroy viruses, bacteria and also fungi (Ioanid et al., 2010; Korachi and Aslan, 2013; Scholtz, 2015) and it is applicable also for coarse material treatment. Another benefit of this type of LTP is the activation and modification of materials surfaces, curing of deposited layers and formation of required layers on the material surface (hydrophobic, hydrophilic, antibacterial, etc.) (Zachariášová et al., 2019).

Habalová (2018) tested the disinfection methods of *butanol vapors* and treatment with *plasma* (Protens electrodynamic systems and technology, atmosphere nitrogen, air and carbon dioxide) on albumen photographs. The model systems of albumen photographs were pre-aged (80 °C, 50% RH) for 24 days before each treatment. After treatment, the stability of these samples was investigated after 24 days of additional accelerated wet aging (see Table 6.1). With all plasma types treatments, the color change (ΔE^*_{ab}) that occurred during accelerated aging after treatment was in all places of the photographic image comparable to samples that have been treated with butanol vapor or have not been treated at all. A slight increase of ΔE^*_{ab} values after plasma treatment was observed only in the brightest places (D_{min}) and the photographic image was not significantly negatively affected by any working gas used (Habalová et al., 2015; 2018).

Ioanid et al. (2010) tested the decontamination of historical photos on paper support with cold high-frequency plasma (temperature 35–40 °C, frequency 13.5 MHz, pressure 3.5×10^{-1}–7×10^{-1} mbar). After the treatment for 30 min, the total fungi decontamination occurred. The cleaning effect of plasma was confirmed by measuring color changes (Ioanid et al., 2010).

In our group, we tested the use of ADRE plasma for decontamination of black and white gelatin photography contaminated with the fibrous fungi *Cladosporium Herbarum*, and we found that in air and nitrogen atmosphere at power 2 W.cm^{-2}, time 15 min, the decontamination of the photography surface was successful. More details are in Case study 3: Decontamination of gelatin photography in this book (Chapter 8.3).

TABLE 6.1

The influence of plasma treatment on color changes (ΔE^*_{ab}) of albumen photography after wet aging (24 days, 80 °C, 50% RH) (Habalová et al., 2018).

Treatment	ΔE^*_{ab} on places with various density		
	D_{min}	D_{mid}	Dmax
no	3.4 ± 0.07	5.6 ± 0.08	2.2 ± 0.15
butanol	3.1 ± 0.09	4.7 ± 0.14	1.0 ± 0.14
plasma (air)	4.9 ± 0.07	3.2 ± 0.13	0.8 ± 0.09
plasma (CO_2)	5.2 ± 0.12	3.0 ± 0.12	0.4 ± 0.14
plasma (N_2)	4.0 ± 0.13	2.4 ± 0.11	1.5 ± 0.25

6.3.4 THE INFLUENCE OF PLASMA TREATMENT ON THE PROPERTIES OF PHOTOGRAPHY

Plasma treatment has great potential for the decontamination of surfaces. In order for the plasma to be used for this purpose, it is necessary to obtain sufficient evidence that the treatment does not damage the image and the photographic material (e.g. deterioration of the optical and mechanical properties). An important requirement when choosing a treatment of photograph is good optical stability, no fading or yellowing, which could impair the quality of the image (Tomšová and Ďurovič, 2017).

Hydrogen/argon plasma treatment (Ioanid et al., 2011) was used to enhance the readability of albumen and gelatin photographs. Treatment involving either physical and/or chemical etching, which did not cause significant physicochemical changes on the treated surface was used. Before and after plasma treatments, the photographs were analyzed by optical and atomic force microscopy, scanning electron microscopy with energy-dispersive X-ray microanalysis, FTIR, color, gloss and contact angle measurements (Ioanid et al., 2011). Increased contrast, which contributes to the improvement in the visibility of the image after plasma treatment was documented. After the plasma treatment, the FTIR spectroscopy confirmed the cross-linking of the gelatin and albumen film surfaces, especially through hydrogen bonds between amino groups. An increase of roughness and a decrease of gloss in the case of the gelatin-based photographic layer and a decrease of roughness, which leads to a slight increase of gloss in the albumen-based photographic layer was evidenced. The authors also claim that the cross-linking of the film surfaces, contributing to reinforcing the photograph surface against microclimate factors (temperature, humidity, light, and especially, polluting agents) is obtained (Ioanid et al., 2011).

The long-term stability of plasma-treated photographs is also a problem that needs further investigation. In this context, the question arises, whether plasma treatment does not start or accelerate degradation processes in photographs (paper

support or image layer), especially when they are exhibited for a long time at exhibitions, galleries or at home. The long-term stability before and after plasma treatment (ADRE plasma in air atmosphere, power 2 W.cm^{-2}, frequency 2000 Hz, the gas flow rate of 6 L.min^{-1}, time 10 min) and the degradation of black and white gelatin photography on two types of photographic paper Fomabrom (glossy and matt photographic paper with a barite layer), upon accelerated light aging using Q-SUN chamber, was investigated and the photoinduced changes were recorded by FTIR spectroscopy, densitometry and colorimetry (Zachariášová et al., 2019). The results obtained demonstrated that the plasma discharge had no significant destructive effect on the photographic image as the only negligible changes in the structure of the gelatin were detected due to plasma treatment. Consequently, this technique seems to be a perspective tool for microbial decontamination and cleaning of photographs (Zachariášová et al., 2019).

In addition to optical properties and image stability, the mechanical properties of photographs, especially force, and tensile stress, also play an important role. The effect of the low-temperature ADRE plasma (power 1 W.cm^{-2}, frequency 2000 Hz, atmosphere air, oxygen, nitrogen, the flow rate of 6 L.min^{-1}, time 10 and 40 min) on colored photography and its components, namely the black–white gelatin photography with a colored layer based on a red carminic dye was studied. Treatment of a black–white gelatin photograph with ADRE plasma in air and oxygen atmosphere showed no negative effect on the mechanical properties of black and white photography when treatment of samples in a nitrogen atmosphere caused a slight deterioration of mechanical properties compared to an untreated reference sample (see Figure 6.3). Plasma-treated samples were subjected to accelerated light aging in Q-sun chamber for 120 h (exposure dose 47.5 J.cm^{-2}). All plasma-treated samples had after light aging better mechanical properties than the sample that had not been plasma treated before aging (see Figure 6.3). The sample exposed to plasma in an oxygen atmosphere for 40 min at 1 W.cm^{-2} (exposure dose 2.4 kJ.cm^{-2}) and after that aged in a Q-SUN chamber (light aging) had the maximum force and tensile stress, approximately 15% higher than a sample untreated by plasma. SEM images also confirmed that the effect of plasma did not cause changes in the photographic image (Ďuricová, 2019; Haberová, 2020).

The effect of plasma on the color layer of colored photography was also studied. Although in most cases, the value of the color deviation is $\Delta E^*_{ab} \leq 4$ after the treatment of a sample with plasma; in the case of a colored layer using a gelatin binder, the color deviation ΔE^*_{ab} achieved higher values. Changes in FTIR spectra occurred on colored layers due to the plasma treatment, which indicates a possible degradation of binders. This confirms that the colored layer causes problems when treating colored photography with plasma, especially when the binder contains gelatin. On the contrary, the effect of ADRE plasma on a black and white layer is rather positive (Ďuricová, 2019; Haberová, 2020).

6.4 CLEANING OF TEXTILES

The effects of plasma on textile materials are known and have been described in several sources (Mather, 2009, Shishoo, 2007). Plasma technologies are used

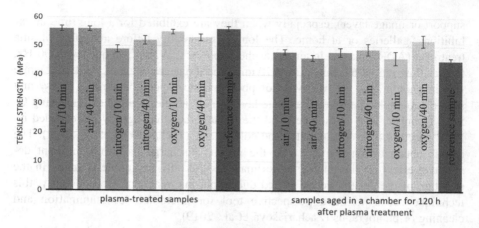

FIGURE 6.3 Effect of ADRE plasma (power $1 \, W.cm^{-2}$, time $10 \, min$ – *full columns* and $40 \, min$ – *patterned columns*, atmosphere air, oxygen, nitrogen) on the tensile strength of black–white gelatin photography. The reference sample was not plasma treated. The samples on the right were aged in Q-SUN chamber $120 \, h$ ($ED = 47.5 \, J.cm^{-2}$) after plasma treatment.

mainly in the processing of textiles and modification of textile properties. The nature of the modification of a textile surface is affected by the composition of the gas, the type of textile, the power and frequency of the electrical supply and the temperature and duration of the treatment. Several effects can be identified:

- etching or cleaning (the removal of tiny amounts of material from the surface); it is associated with changes in surface texture and wetting properties
- chemical modification caused by the introduction of particular chemical functional groups from plasma gas; these groups may improve wettability, biocompatibility and adhesion.

It is the change in the properties of historical textiles that is an undesirable side effect for which the use of this technology in the protection of cultural heritage is not very widespread. Several studies have shown successful use in cleaning historical textile surfaces from difficult-to-remove dirt. All these applications were carried out with vacuum plasma. Samples of 100% cotton, 100% wool and 100% silk soiled with soot from the simulated fire were cleaned (Rutledge et al., 2000a). The plasma treatment (by atomic oxygen) removed most of the soot from the surface and restored the color of wool and silk. A slight fading of the cotton was observed after exposure. If the treatment was too long, the cotton fabric degrades by thinning the cellulose fibers. By controlled treatment time, most soiling should be safely removed from these types of fabrics. The reaction of atomic oxygen converted the carbon to volatile species such as carbon monoxide.

The same method was used to investigate the possibility of removing defined contamination from gesso, paper and canvas (Miller-Rutledge et al., 2005). Most inks used (except the permanent marker) were removed from these materials in 5–12 min.

In the case of an Andy Warhol painting at the Carnegie Museum of Art, a lipstick imprint on the surface of 'Bathtub 1961' was unable to be removed by using solvents because it would allow the lipstick oils to soak into the surface leaving a pink smudge (Banks et al., 1999). Vacuum plasma treatment was performed by rastering the pencil beam over the smudge. The resulting cleaned area was free of red pigment and oils from the lipstick (it was lighter and more diffusely reflecting than the rest of the painting). This was due to the removal of some of the accumulated dirt on the surface as well as a thin layer of the paint binder. Figure 6.4 contains comparison photos of the Andy Warhol painting before and after treatment.

Practically any case using atmospheric plasma can be found in the literature. On the basis of general knowledge from plasma technologies used in textile treatment (Riccobono, 1973), it is possible to make a presumption of successful use of plasma in heritage protection in the removal of organic binders in the form of adhesives and unwanted (partially degraded) organic strengthening agents. According to Morent (2008) after 10 min of plasma treatment in O_2 plasma, 60% of the polymer (PVA in the form of a sizing agent) (Alexopoulou et al., 2005) is removed from the surface of the textile fibers.

Historical textiles often include metal threads. The cleaning of these parts of the textile is still not optimally solved. Often heavily corroded metal threads combined with a sensitive organic yarn are a material susceptible to damage by mechanical and chemical means. Plasma treatment is therefore a promising alternative for cleaning historical textiles containing metal threads. The most common corrosive product of silver-containing threads is silver sulfide. Since the end of the 70's of the twentieth century, studies were carried out on the effects of reducing low-pressure plasma. This type of plasma could be suitable for cleaning sulfide soiling but vacuum is a risk factor for sensitive animal fibers, especially silk (it could damage /dry the proteins).

It has been found that the treatment of plasma with atmospheric pressure with a cold beam could significantly reduce the sulfur content on flat lamellae or wires contaminated with silver sulfide. It has also been possible to reduce oxygen and chlorine compounds in some cases (Leissner et al., 2012). No damage to the base material was found (Reháková et al., 2018).

FIGURE 6.4 Andy Warhol 'Bathtub 1961' painting showing lipstick smudge before (left) and after (right) atomic oxygen treatment (Banks et al., 1999).

6.5 CLEANING OF PAINTINGS

In restoration practice, the most commonly used methods of cleaning the surfaces of works of art are methods using (organic) solvents. However, these methods have their limitations described in Part 2 (Cleaning in the preservation of cultural heritage).

Plasma began to be tested for such an application in more recent times. The first published works dealt with the removal of organic coatings from the surface of paintings (Banks and Rutledge, 1996) and cleaning of smoke-damaged paintings (Rutledge et al., 1999; Rutledge et al., 2000b). The same authors investigated the effect of plasma on varnished and unvarnished oil paintings, acrylic paints, watercolors and inks (Miller-Rutledge et al., 2005). Nevertheless, all these applications were carried out with vacuum plasma. Only a few cases using atmospheric plasma can be found in the literature. One of the first patented atmospheric plasma devices was tested in the removal of soot from canvas and marble (Banks, 1997). Later atmospheric plasma was used to improve the adhesion between polymer substrates and polymeric paints (Comiotto, 2009) or in the removal of soot and organic polymers (Pflugfelder et al., 2007). The work of (Voltolina et al., 2013) reports the results obtained in the frame of the EU project Plasma And Nano for New Age (PANNA) soft conservation; see Chapter 7), dealing with the assessment of the atmospheric plasma torch as a cleaning tool for the removal of alteration and

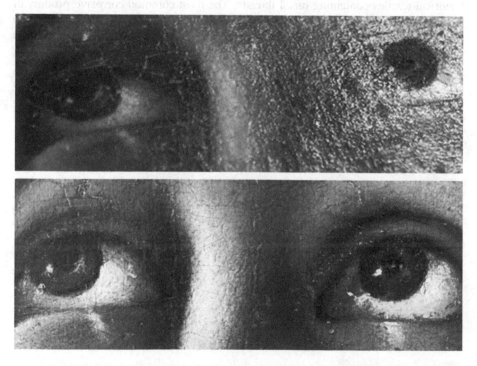

FIGURE 6.5 Above: selective cleaning of degraded paint using NTP. Below: state condition after restoration. Photo: D. Stojkovičová.

deterioration products on stone and wall painting surfaces. The removal of gypsum and soot as well as aged polymers and graffiti was tested on lab samples by different commercial plasma devices.

Among the positive features of plasma are the facts that the cleaning is contactless, precisely controlled due to the reduced diameter of the plasma plume, and confined to the very first layers of the surface. Therefore, it avoids undesired effects often encountered with traditional chemical cleaning, such as spreading or retention of solvents and undesired products inside the porous structure of the substrate.

The chemical effect of plasma is confined to the nanoscale. The interaction of plasma is strongly dependent on the nature of the treated material. Oxidative plasmas are effective in the degradation of organic molecules or macromolecules (surface varnishes and glazes) while inorganic structures, such as some pigments or sulfate groups in gypsum, are more stable and reluctant to chemically interact with plasma. The associated thermal effect is able to penetrate more in-depth but can be controlled by choosing the appropriate parameters (power, gas, distance, etc.). Nevertheless, in the choice of the right parameters, it has to be taken into account that the materials of paints (oil paint retouches) might degrade. These facts were used in the removal of aged discolored Damara varnishes in the restoration of oil painting 'Kajúca sa Mária Magdaléna' (The Repentant Maria Magdalena, unknown author), from the 19th century by plasma nozzle. This was preceded by an experiment on model samples of artificially aged paint of similar composition, by which suitable parameters of plasma treatment were selected. The partially degraded surface varnish was disrupted by plasma without damaging the colored layers (see Figure 6.5 top). There were oxidation changes confirmed by the FTIR method and a change in the surface structure. Then, the varnish could be removed by gentle mechanical and solvent removal (see Figure 6.5 bottom; Vizárová, 2019).

REFERENCES

Alexopoulou, A., Koutsouris, A., Konstantios, D., Mariolopoulou, P., Gerakari, K., Xatzistylianou, A., Psalti, E., 2005. Non-Destructive documentation of 12 post Byzantine icons of the Loverdo's collection. Proceedings of ART'05 8th International Conference on Non Destructive Investigations and Microanalysis for the Diagnostics and Conservation of the Cultural and Environmental Heritage, Lecce, 15-19 May. Univ. of Lecce Italian Society of Non Destructive Testing Monitoring DiagnosticsPubl., Italy.

Altgen, M., Militz, H., 2016. Photodegradation of thermally-modified Scots pine and Norway spruce investigated on thin micro-veneers. Eur. J. Wood Wood Prod. 74, 185–190.

Banks, B.A., 1997. Atmospheric pressure method and apparatus for removal of organic matter with atomic and ionic oxygen. US Patent 5,693,241, Dec. 2, 1997.

Banks, B.A., Rutledge, S.K., 1996. Process for non-contact removal of organic coatings from the surface of paintings. US Patent 5,560,781, Oct. 1, 1996.

Banks, B.A., Rutledge, S.K., Karla, M., Norris, M.J., Real, W., Haytas, C.A., 1999. Use of an Atmospheric Atomic Oxygen Beam for Restoration of Defaced Paintings, in Proceedings of the 12th Triennial Meeting of the International Committee for Conservation, ICOM, Lyon, France, 1999, pp. 271–275.

Boselli, M., Chiavari, C., Colombo, V., Gherardi, M., Martini, C., 2016. Atmospheric pressure non-equilibrium plasma cleaning of 19th-century daguerreotypes. Plasma Process. Polym. 14, p. 1600027.

Brommelle, N.S., Smith, P., 1976. The Conservation and Restoration of Pictorial Art, Butterworths, London.

Shishoo, R. (Ed.), 2007, Plasma Technologies for Textiles, Woodhead Publishing Ltd, Cambridge.

Butterfield, F.J., 1987. The potential long-term effects of gamma irradiation on paper. Stud. Conserv. 32,181–191.

Cappitelli, F., Sorlini, C., 2005. From papyrus to compact disc: the microbial deterioration of documentary heritage. Crit. Rev. Microbiol. 31, 1–10.

Cappitelli, F., Principi, P., Sorlini, C., 2006. Biodeterioration of modern materials in contemporary collections: can biotechnology help? Trends Biotechnol. 24, 350–354.

Casoli, A., Fornaciari, S., 2014. An analytical study on an early 20th-century Italian photographs collection by means of microscopic and spectroscopic techniques. Microchem. J. 116, 24–30.

Clausi, M., Crisci, G.M., La Russa, M.F., Malagodi, M., Palermo, A., Ruffolo, S.A., 2011. Protective action against fungal growth of two consolidating products applied to wood. J. Cult. Herit. 12, 28–33.

Collingst, J., Young, F.J., 1976. Improvements in some tests and techniques in photograph conservation. Stud. Conserv. 21, 79–84.

Comiotto, A., 2009. Fine-tuning atmospheric plasma to improve the coatability and bondability of plastics in modern and contemporary art and design. In: Proceedings of the Future Talks, München.

Cooper, M. et al., 1998. Laser Cleaning in Conservation: An Introduction. Butterworth-Heinemann, Oxford. ISBN 070531171.

Crawford, W., 1979. The Keepers of Light: A History and Working Guide to Early Photographic Processes, First ed., Morgan & Morgan, New York.

Da Silva, E., Robinson, M., Evans, C., Pejovic-Milic, A., Heyd, D.F., 2010. Monitoring the photographic process, degradation, and restoration of 21st-century daguerreotypes by wavelength-dispersive X-ray fluorescence spectrometry. J. Anal. Atom. Spec. 25, 54–661.

Daniels, V., 1981. Plasma reduction of silver tarnish on daguerreotypes. Stud. Conserv. 26, 45–49.

Dionisi-Vici, P., Mazzanti, P., Uzielli, L., Allegretti, O., 2004. Mechanical and dimensional behavior under asymmetrical moisture exchange in the hygroscopic field: Experimental tests on poplar boards, In: COST E15 Final Conference, Athens, pp. 219–224.

Dunca, S., Parpauta, D., Loanid, G., Ailiesei, O., Nimitan, E., Stefan, M., 2005. Utilizarea plasmei reci în combaterea deteriorării microbiene a unor suporturi organice (The use of cold plasma to fight microbial deterioration of some organic supports). Lucrarile celuide al X-lea Simpozion de Microbiologie si Biotehnologie, Corson, Iasi.

Ďuricová, B., 2019. Influence of low-temperature atmospheric plasma on layers in color photography, Diploma thesis. Bratislava (in slovak).

Fiarescu, C.R., Domi, M., Fiarescu, I., 2020. Selected aspects regarding the restoration/conservation of traditional wood and masonry building materials: A short overview of the last decade findings. Appl. Sci. 10 (3), 1164. https://doi.org/10.3390/app10031164.

Fridman, A., Fridman, G., 2013. Plasma Medicine. John Wiley & Sons, ISBN 978-0-470-68970-7.

Golovlev, V.V., Gresalfi, M.J., Miller, J.C., Romer, G., P. Messier, P., 2000. Laser characterization and cleaning of 19th-century daguerreotypes. J. Cult. Herit. 1, S139–S144.

Golovlev, V.V., Gresalfi, M.J., Miller, J.C., Anglos, D., Melesanaki, K., Zafiropulos, V., 2003. Laser characterization and cleaning of 19th-century daguerreotypes II. J. Cult. Herit. 4, 134s56–139ss56.

Grieten, E., Schalm, O., Tack, P., Bauters, P., 2017. Reclaiming the image of daguerreotypes: Characterization of the corroded surface before and after atmospheric plasma treatment. J. Cult. Herit. 28, 56–64.

Guggemos, A., Horvath, A., 2005. Comparison of Environmental Effects of Steel- and Concrete Framed Buildings. J. Infrastruct. Syst. 11, 93–101. doi:10.1061/(ASCE)1076-0342(2005)11:2(93).

Gutarowska, B., et al., 2016. A Modern Approach to Biodeterioration Assessment and the Disinfection of Historical Book Collections. Institute of Fermentation Technology and Microbiology, The Lodz University of Technology. Lodz, Poland ISBN 8363929018, 9788363929015.

Habalova, B., 2015. Study of albumen photographs structure degradation. Doctoral thesis. Bratislava (in slovak).

Habalová, B., Machatová, Z., Jančovičová, V., Maková, A., 2018. Study of albumen photographs degradation. In: Black and white image of the world. Issues in the conservation of photographs. 1. vyd. Toruň: Wydawnictwo Naukowe Uniwersytetu Mikolaja Kopernika, 47–66. ISBN 978-83-231-4034-4.

Haberová, K., 2020. The influence of discharge plasma treatment on the properties and stability of historical photographs. Doctoral thesis. Bratislava (in slovak).

Haberová, K., Machatová, Z., Luprichová, Z., Jančovičová, V., 2018. Survey of historical photographs in the paper depository of the Slovak National Museum at Bratislava Castle. In: CSTI 2018 Conservation Science, Technology and Industry. Book of Abstracts. Bratislava , pp. 270–278. ISBN 978-80-8060-435-6 (in slovak).

Hackney, S. 1990. The removal of dirt from Turner's unvarnished oil sketches. In: Dirt and pictures separated: papers given at a conference held jointly by UKIC and the Tate Gallery, pp. 35–39.

Hengemihle, F.H., Weberg, N., Shahani, C.J., 1995. Desorption of residual ethylene oxide from fumigated library materials. Preserv. Res. Test. Ser. Preservation Research and Testing Office November, Preservation Research and Testing Series No. 9502. Available on-line https://www.loc.gov/preservation/resources/rt/fume.pdf cited on May 10, 2020.

Ioanid, E.G., Frunză, V., Rusu, D., Vlad, A.M., Tanase, C., Dunca, S., 2015. Radiofrequency plasma discharge equipment for conservation treatments of paper supports. Int. J. Chem., Molecular, Nuclear, Mater. Metallurgical Eng. 9, 748–752.

Jeffrey, N.A., Dec. 10, 1999. Today's art lesson: Grime pays, The Wall Street J., W16.

Kazánová, K., 2019. Microbiological Contamination of Photographic Materials, Bachelor thesis. Bratislava (in slovak).

Kim, Y.S., Singh, A.P., 2016. Wood as cultural heritage material and its deterioration by biotic and abiotic agents. Secondary Xylem Biology. Origins, Functions, and Applications. In: Kim, Y.S., Funada, R., Singh, A.P. (Eds.), London, UK, Academic Press, pp. 233–257.

Korachi, M., Aslan, N., 2013. Microbial Pathogens and Strategies for Combating Them: Science, Technology and Education. In: Méndez-Vilas, A. (Ed.), Vol. 1, Formatex Research Center, Badajoz, Spain, pp. 453–459.

Kozachuk, M.S., Sham, T.K., Martin, R.R., Nelson, A.J., Coulthard, I., 2018. Exploringtarnished daguerrotypes with synchrotron light: XRF and m-XANES analysis. Herit. Sci. 6, 12–22.

Laguardia, L., Vassallo, E., Cappitelli, F., Mesto, E., Cremona, A., Sorlini, C., Bonizzoni, G., 2005. Investigation of the effects of plasma treatments on biodeteriorated ancient paper. Appl. Surf. Sci. 252 (4), 1159–1166.

Laroussi, M., Leipold, F., 2004. Evaluation of the roles of reactive species, heat, and UV radiation in the inactivation of bacterial cells by air plasmas at atmospheric pressure. Int. J. Mass. Spectrom. 233, 81–86.

Lavedrine, B., 2009. Photographs of the Past: Process and Preservation, First ed., Getty Conservation Institute, Los Angeles.

Leissner, J., Kilian, R., Vohrer, U., 2012. Das Forschungsprojekt Plasmatechnologie (Plasmatechnologie – eine innovative Technologie zur Konservierung und Restaurierung

von Kulturgutern und offentliche Praesentation der Forschungsallianz Kulturerbe, VII/ 2009-VIII/2012), Die Forschungsallianz Kulturerbe, Fraunhofern, 2012.

Ioanid, E.G., Rusu, D., Dunca, S., Tanase, C., 2010. High-frequency plasma in heritage photo decontamination. Ann. Microbiol. 60, 355–361.

Ioanid, E.G., Loanid, A., Rusu, D.E., Popescu, C.M., Stoica, I., 2011. Surface changes upon high-frequency plasma treatment of heritage photographs. J. Cult. Herit. 12, 296–317.

Lojewska, J., 2005. Cellulose oxidative and hydrolytic degradation: In situ FTIR approach, Polym. Degrad. Stab. 88, 512–520.

Machatová, Z., 2016. Study of Properties of Colour Structures in Hand-Coloured Photography. Doctoral thesis. Bratislava (in slovak).

Martins, A., Faffner, L.A., Fenech, A., McGlinchey, C., Strlič, M., 2012. Non-destructive dating of fiber-based gelatin silver prints using near-infrared spectroscopy and multivariate analysis. Anal. Bioanal. Chem. 402, 1459–1469.

Marucci, G., Monno, A., van der Werf, I.D., 2014. Non-invasive micro-Raman spectroscopy for investigation of historical silver salt gelatin photographs. Microchem. J. 117, 220–224.

Mather, R.R., 2009. Surface modification of textiles by plasma treatments, Surface Modification of Textiles, in Wei, Q. (Ed.), CRC Press, Boca Raton, Boston, New York, Washington, DC, pp. 296–319.

Miller-Rutledge, S.K., Banks, B.A., Waters, D.L., 2005. Atomic oxygen treatment and its effect on a variety of artist's media. NASA/TM—2005-213434.

Moncrieff, A., Graham, W., 1992. The Science for Conservators Series: Volume 2: Cleaning, Oxon, Routledge Publisher, p. 142s. ISBN 978-0415071659.

Morent, R., 2008. Non-thermal plasma treatment of textile. Surf. Coat. Tech. 202, 3427–3449.

Nieto-Villena, A., Martínez-Mendoza, J.R., Ramírez-Saito, M.Á., Arauz-Lara, J.L., de la Cruz-Mendoza,J.Á., Guerrero-Serrano, A.L., Ortega-Zarzosa, G., Solbes-García, A., 2019. Exploring confocal microscopy to analyze ancient photography, J. Cult. Herit. 36, 191–199.

Nimz, H.H., 1984. Wood-chemistry, ultrastructure, reactions. Holz als Roh-und Werkstoff 42, 314.

Oravec, M., Haberová, K., Jančovičová, V., Machatová, Z., Čeppan, M., Huck, C.W., 2019. Identification of the historic photographic print materials using portable NIR and PCA. Microchem. J. 150, 104202.

Pflugfelder, C., Mainusch, N., Hammer, I., Viol, W., 2007. Cleaning of wall paintings and architectural surfaces by plasma. Plasma Process. Polym. 4, 516–521.

Phenix, A., Burnstock, A. 1992. The removal of surface dirt on paintings with chelating agents. The Conserv. 16 (1), 28–38.

Pietrzak, K., Otlewska, A., Danielewicz, D., Dybka, K., Pangallo, D., Kraková, L., Puškárová, A., Bučková, M., Scholtz, V., Ďurovič, M., Surma-Ślusarska, B., Demnerová, K., 2016. Disinfection of archival documents using thyme essential oil, silver nanoparticles misting and low-temperature plasma. J. Cult. Herit. 24, 69–77.

Querner, P., Simon, S., Morelli, M., Fürenkranz, S., 2013. Insect pest management programs and results from their application in two large museum collections in Berlin and Vienna. Int. Biodeter. Biodegr. 84, 275–280.

Rehakova, M., Ceppan, M., Mikula, M., 2008. Study of stabilization of documents containing iron gall inks by treatment of atmospheric DBD N2 plasma. Chemicke Listy 102, 1061e1063.

Reháková, M., Vizárová, K., Klocklerová, P., Čížová, K., Stojkovičová, D., 2018. Possibility of cleaning textile heritage objects with low-temperature plasma, In: 5th International Congress on Chemistry for Cultural Heritage 2018, ChemCH2018, 3-7 July, 2018, Muzeul National al Literaturii Romane, Bucharest, pp. 221–222.

Riccobono, P.X., 1973. Plasma treatment of textiles, a novel approach to the environmental problems of desizing. Textile Chem. Color, 5 (11), 239–248.

Roth, J.R., 2001. Industrial Plasma Engineering, Vol. 2, Applications to Nonthermal Plasma Processing, Institute of Physics Pub.

Rutledge, S.K., Banks, B.A., Chichernea, V.A., 1999. Recovery of a Charred Painting Using Atomic Oxygen Treatment. In: Proceedings of the 12th Triennial Meeting of the International Committee for Conservation, ICOM, Lyon, France, 1999, pp. 330–335.

Rutledge, S.K., Banks, B.A., Chichernea, V.A., Haytas, C.A., 2000a. Cleaning of fire damaged watercolor and textiles using atomic oxygen, NASA/TM—2000-210335.

Rutledge, S.K., Banks, B.A., Forkapa, M., Stueber, T., Sechkar, E., Malinowsky, K., 2000b. Atomic oxygen treatment as a method of recovering smoke-damaged paintings. J. Am. Inst. Conserv. 39, 65–74.

Scholtz, V., Pazlarova, J., Souskova, H., Khun, J., Julak, J., 2015. Nonthermal plasma—A tool for decontamination and disinfection. Biotechnol. Adv. 33, 1108—1119.

Shintani, H., Sakudo, A., 2016. Gas Plasma Sterilization in Microbiology: Theory, Applications, Pitfalls and New Perspectives. Caister Academic Press, ISBN 978-1-910190-25-8.

Siliprandi, R.A., 2007. Atmospheric pressure plasmas for surface modifications. Universita Degli Studi di Milano-Bcocca.

Skóra, J., Gutarowska, B., Pielech-Przybylska, K., Stepień, L., Pietrzak, K., Piotrowska, M., Pietrowski, P., 2015. Assessment of microbiological contamination in the work environmments of museums, archives and libraries. Aerobiologia 31, 389–401.

Smith, D., 1986. Fumigation quandary: more overkill or common sense? The Paper Conserv. 10, 46–47. http://dx.doi.org/10.1080/03094227.1986.9638531.

Stejskal, V., Douda, O., Zouhar, M., Manasova, M., Dlouhy, M., Simbera, J., Aulicky, R., 2014. Wood penetration ability of hydrogen cyanide and its efficacy for fumigation of Anoplophora glabripennis, Hylotrupes bajulus (Coleoptera), and Bursaphelenchus xylophilus (Nematoda). Int. Biodeter. Biodegr. 86, 189–195.

Sterflinger, K., 2010. Fungi: Their Role in Deterioration of Cultural Heritage. Fungal Biol. Rev. 24 (1-2), 47e55. https://doi.org/10.1016/j.fbr.2010.03.003.

Stoffels, E., 2006. Gas plasmas in biology and medicine. J. Phys. D: Appl. Phys. 39 (16), 1–2. https://doi.org/10.1088/0022-3727/39/16/E01

Stulik, D.C. & Kaplan, A., 2013. The Atlas of Analytical Signatures of Photographic Processes. Cyanotype. J. Paul Getty Trust. ISBN number: 978-1-937433-08-6 (online resource) http://www.getty.edu/conservation/publications_resources/pdf_publications/pdf/atlas_cyanotype.pdf.

Swan, A., 1975. Conservation treatments for photographs. Image 21, 24–31.

Tiňo, R., Vizárová, K., Hajdu, F., Sep. 13-14, 2017. Cleaning of natural materials with atmospheric low temperature plasma, In: Emerging Technology and Innovation for Cultural Heritage (ETICH), 5th International Seminar and Workshop, Sibiu, September 12-14, 2017, Organic Artefacts From Research to Exhibition. Măgurele, Ilfov, Horia Hulubei National Institute of Physics and Nuclear Engineering, 2017, S. 21-22. ISBN 978-973-668-463-0.

Tomšová, K., Ďurovič, M., 2017. Influence of disinfection methods on the stability of black and white silver gelatin prints. J. Cult. Herit. 24, 78–85.

Turovets, I., Maggen, M., Lewis, A., 1998. Cleaning of daguerreotypes with an excimer laser. Stud. Conserv. 43, p. 12.

Unger, A., 2012. Decontamination and "deconsolidation" of historical wood preservatives and wood consolidants in cultural heritage. J. Cult. Herit. 13, S196–S202.

Vitale, T.J., 1992. Comparison between practitioner sensory evaluation and measured properties of historic papers before and after washing, In: AIC annual meeting, Buffalo, 1992. Abstract in preprints.

Vitale, T., Messier, P., 1994. Physical and mechanical properties of albumen photographs. J. Am. Inst. Conserv. 3, 279–299.

Vizárová, K., Tiňo, R., Kaliňáková, B., Šipošová, N., Špacírová, Z. Sep. 13-14, 2017 Microbiological decontamination of paper with ADRE low-temperature plasma, In: Emerging Technology and Innovation for Cultural Heritage (ETICH), 5th International Seminar and Workshop, Sibiu, September 12-14, 2017: Organic Artefacts From Research to Exhibition. Măgurele, Ilfov: Horia Hulubei National Institute of Physics and Nuclear Engineering, 2017, S. 25-26. ISBN 978-973-668-463-0.

Vizárová, K., Tiňo, R., Reháková, M., 2018a. Čistenie a sterilizácia nízkoteplotnou plazmou v procesoch konzervovania prírodných organických materiálov. Cleaning and sterilization by low-temperature plasma in the processes of preservation of natural organic materials. In Slovak. Bratislava, Slovenské národné múzeum.

Vizárová, K., Kaliňáková, B., Vajová, I., Tiňo, R., Hajdu, F., Špacírová, Z., Lalíková, N., 2018b. Microbial decontamination of paper with low- temperature atmospheric plasma. 5th International Congress on Chemistry for Cultural Heritage 2018, ChEMCH 2018, 3-7 July, 2018, Bucharest: Book of Abstracts. Bucuresti: Muzeul National al Literaturii Romane, 2018, s. 238-239. ISBN 978-973-167-463-6.

Vohrer, U., Trick, I., Bernhardt, J., Oehr, C., Brunner, H., 2001. Plasma treatment - An increasing technology for paper restoration. Surf. Coat. Tech. 142–144, 1069–1073.

Voltolina, S., Aibéo, C., Cavallin, T., Egel, E., Favaro, M., Kamenova, V., Nodari, L., Pavlov, A., Pavlova, I., Simon, S., Scopece, P., Falzacappa, E.V., Patelli, A., 2013. Assessment of atmospheric plasma torches for cleaning of architectural surfaces, Built Heritage 2013. Monitoring Conservation Management, 1051–1057.

Walsh-Korb, Z., Avérous, L. 2019. Recent developments in the conservation of materials properties of historical wood. Progr. Mater. Sci. 102, 167–221.

Zachariášová, B., Haberová, K., Oravec, M., Jančovičová, V., 2019. Plasma treatment of gelatin photography. Acta Chimica Slovaca 12 (1), 27–33.

Zidan, Y., El-Shafei, A., Noshy, W., Salim, E., 2017. A comparative study to evaluate conventional and nonconventional cleaning treatments of cellulosic paper supports. Mediterr. Archaeol. Archaeom. 17 (3), 337–353. DOI:10.5281/zenodo.1005538.

Zielińska-Jankiewicz, K., Kozajda, A., Piotrowska, M., Szadkowska-Stańczyk, I., 2008. Microbiological contamination with moulds in work environment in libraries and archive storage facilities. Ann. Agric. Environ. Med. 15, 71–78.

7 Overview of Related Research Projects

The issue of the use of plasma in the protection of objects and materials of heritage is not very widespread but nevertheless, several research projects have already been devoted to it. The aim of this chapter is to provide an overview of known projects, their starting points, goals, as well as the main findings that have been published.

European project **Durawood** (Development of a cost-effective, durable coating system with low-fungicide content for wood surfaces using plasma discharge – Research for SME program (FP7-SME-2008-1) under Grant agreement no. 232296, project acronym DURAWOOD, Dec. 2009 – Nov. 2011) was dedicated to the development of a tailored plasma-based system for treating wood surfaces in continuous conditions suitable for industrial wood manufacturing. The project was not directly focused on the preservation of wooden heritage objects, rather focused on the possibilities of protecting wooden facades (which are often located, e.g. in very valuable wooden churches in the Carpathian region) using low-temperature DCSBD plasma. Laboratory research conducted during the project showed that plasma can be used to modify wood surfaces in a fine-tuned and versatile way. Upon performing over 10,000 experiments by varying the parameters of the plasma (various atmospheres, powers, treatment times, gaps, etc.), the conditions to make the wood surface more hydrophilic or more hydrophobic were determined for different species at the laboratory scale. In addition, the effect of plasma was investigated by an atomic force microscope and infrared spectroscopy showing that a layer of a hundred nm was modified on the wood surface. The project delivered a versatile, adjustable, scalable prototype system allowing the continuous plasma treatment of flat wood panels as well as all the associated know-how in terms of conditions for the treatment of various wood species depending on the sought effect. The observed possibility to modify wood surfaces just by changing conditions during the plasma treatment without any necessity to add special chemicals, decontamination and activation of plasma-treated surfaces placed the basis for subsequent application of low-temperature plasma technology in the preservation of cultural heritage objects and materials made from natural polymers (wood, paper, textiles, etc.). Stemming from the mentioned ideas, it follows that the treatment of solid surfaces by plasma discharge is a new modern method having a great potential in solution of a number of issues daily faced by professionals working in the field of restoration and conservation.

European project **PANNA** (Plasma And Nano for New Age 'soft' conservation – European Community's Seventh Framework Programme (FP7/2007–2013) under Grant agreement no. 282998, project acronym PANNA, Nov. 2011–Oct. 2014) was aimed to develop a novel atmospheric plasma technique for inorganic surface cleaning and coating deposition as well as two innovative coatings: a self-diagnostic

protective coating and a coating provided with identification marker. The plasma technique was proposed for surface cleaning and coating removal as an alternative or complementary to the other non-contact techniques such as the laser technique. This technique is characterized by no thermal heating, selectivity, chemical reduction of oxides, applicability on all substrates and competitive costs. As a result of the project, the team produced a portable plasma jet prototype, allowing the removal of organic substances or corroded metal layers. The non-contact jet is considered to be environmentally friendly and causes no thermal, mechanical or chemical harm to artifacts. The same device can be used to deposit invisible identification markings and protective coatings. PANNA successfully patented and marketed this technology. The technology was applied and tested in particular on stone and metal materials as well as mural paintings that are cultural heritage objects.

International project: 'Modern approach for for biodeterioration assessment and disinfection of historical book collections', (Nov. 2015–Jul. 2016; funded by the International Visegrad Foundation). Beside the aim to identify microorganisms involved in the biodeterioration of historical archival objects, the focus of the study was to determine modern disinfection methods against antimicrobial activity. The antimicrobial effectiveness and influence of low-temperature plasma on paper properties of treated historical artifacts were tested. Comparison with other promising disinfecting methods showed the competitiveness of this technology in terms of observed parameters (Gutarowsk et al., 2016).

The Slovak national project PlasmArt (Conservation and Stabilization of Cultural Heritage Objects from Natural Organic Compounds by Low-temperature Plasma) explored the possibilities of using low-temperature atmospheric plasma as a promising technology for the conservation (removal of microbiological, mechanical and chemical impurities) of heritage objects, especially from natural organic materials. The efficiency of plasma treatments was tested on several materials (paper, parchment, colored layer on paper, traditional photographic materials, wood, organic layer on wood, textile materials, metal threads and adhesives). The project carried out a survey focused on the application of low-temperature atmospheric plasma (NTP) to natural organic materials – carriers of cultural heritage – with the potential of use for technological conservation processes. The effects of plasma generated by three types of devices (ADRE, Plasma beam and Plasma handgun) were investigated through mainly spectrophotometric, chromatographic and imaging methods and microbiological experiments. The results showed that for specific cases, with the correct setting of parameters (plasma discharge atmosphere, power and time), there is a positive effect in terms of selected conservation procedures (microflora devitalization, ablation and surface activation). Standard procedures for microbiological decontamination of paper carriers and gelatin photographs using low-temperature ADRE plasma, verified on model samples and real objects, were developed. In addition, processes have also been developed to remove mechanical impurities from paper and wood surfaces and to remove the surface layer of paint with a deposit of impurities from the color layer as well as to remove adhesive tapes from the paper. Positive results in terms of the effectiveness of conservation (devitalization microflora, ablation and surface activation), in

addition to streamlining the process (reduction of working time), elimination of environmental issues and impacts on professionals' health have been achieved. A methodology has been developed for evaluating and controlling microbiological contamination of objects of cultural heritage in printed lignocellulosic substrates, parchment and photographs as well as procedures of evaluation efficiency of plasma treatment on researched systems. The original functional model PlasmArt handgun, a device for physicochemical treatment of 2D, 3D objects by the action of atmospheric NTP, was constructed. The most recent results are published in Chapter 8, case studies CS1–CS5.

REFERENCES

DURAWOOD project, 2009–2011, Development of a cost-effective, durable coating system with low-fungicide content for wood surfaces using plasma discharge - Research for SME programme (FP7-SME-2008-1) under Grant agreement no. 232296, Available. Online https://cordis.europa.eu/project/id/232296/reporting (cited May 15, 2020).

Gutarowsk, B., 2016. *A modern approach to biodeterioration assessment and the disinfection of historical book collections*. Institute of Fermentation Technology and Microbiology. The Lodz University of Technology, Lodz, Poland. ISBN 8363929018, 9788363929015.

PANNA Project, 2011–2014, Plasma And Nano for New Age "soft" conservation - European Community's Seventh Framework Programme (FP7/2007-2013) under grant agreement n. 282998, Available Online https://cordis.europa.eu/article/id/92676 safer art-restoration-and-cleaning (cited May 15, 2020).

PlasmArt project, 2016–2019. (APVV-15-0460 SK) - Conservation and Stabilization of Cultural Heritage Objects from Natural Organic Compounds by Low-temperature Plasma Available Online https://www.researchgate.net/project/PlasmArt-APVV-15-0460-SK-Conservation-and-stabilisation-of-cultural-heritage-objects-from-natural-organic-compounds-by-low-temperature-plasma (cited May 15, 2020).

8 Case Studies

8.1 CS1: MICROBIOLOGICAL DECONTAMINATION OF THE PAPER SUBSTRATE USING LOW-TEMPERATURE ATMOSPHERIC DISCHARGE WITH RUNAWAY ELECTRONS (ADRE) PLASMA

As mentioned in Chapter 6.1, paper carriers, books, archival documents and other artifacts on the paper substrate are susceptible to microbiological contamination and biodeterioration. To investigate the possibility of using low-temperature atmospheric plasma for microbiological decontamination of paper artifacts, three types of model paper samples were tested. Whatman paper, which is composed of pure cellulose and two kinds of acids, and lignin-containing paper (samples N and G), which represents the largest part of paper carriers in memory institutions. These acid-sized papers with high lignin content are the most critical in terms of long-term stability. Model papers inoculated with a suspension of fibrous fungi of the five most common genera *(Alternaria alternata, Aspergillus niger, Cladosporium herbarum, Penicillium chrysogenum, Trichoderma viride*; Sterflinger, 2010) were treated with low-temperature ADRE plasma, operating at atmospheric pressure in different gas atmospheres, at different processing times and power settings (see Table 8.1).

Through monitoring their growth, it was found that the most resistant microorganism is Penicillium chrysogenum (Vizárová et al., 2020). These filamentous fungi belong to the most common contaminant in the depositories of libraries and archives. Their growth is very pronounced especially on Whatman paper, as illustrated in Figure 8.1.

The decontamination effect of ADRE plasma on filamentous fungi was manifested under the tested conditions in the order *C. herbarum > T. viride > A. niger > P. chrysogenum* (Vizárová et al., 2018). It was found that the disinfecting

TABLE 8.1

Plasma treatment conditions with low-temperature ADRE plasma

Time [min]	5; 10	5; 10; 15; 20; 30	5; 10; 15
Energy [J.s^{-1}]	1.24	0.6	0.3
Frequency [Hz]	2000	2000	2000
Gas-flow rate [L.min^{-1}]	6	6	6
Atmosphere	Air; O_2; N_2; CO_2	Air; O_2; N_2; CO_2	Air; O_2; N_2

Kind of paper	REF	5 min	10 min
W			
G			
N			

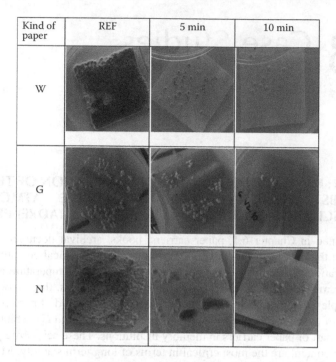

FIGURE 8.1 Decrease in *Penicillium chrysogenum* growth on the paper sample (W, G, N) after ADRE plasma treatment in air atmosphere at 5 and 10 min compared to the reference sample.

effect of ADRE plasma depends on the material composition of the paper (papermaking fibers), its technological parameters (sizing) and the type of filamentous fungi. The efficiency of fungal decontamination by plasma depends mainly on the type of particles generated in the plasma discharge (as is described in Chapter 6.1).

To determine the optimal conditions for plasma modification, which in this case represent a high efficiency of the protective intervention and minimal changes in the degradation of the treated material, various combinations of setting conditions have been designed and investigated; the effects of biological decontamination under less intense conditions of plasma treatment in ADRE plasma by reducing energy (from max. 1.24 J.s^{-1}, through values 0.6 J.s^{-1} to values 0.3 J.s^{-1}) and time (from 30 s to 5 min interval), intermittent mode (to avoid excessive thermal stress on materials during prolonged plasma exposure). The effect of output setting indicates the maximum efficiency at 0.6 J.s^{-1} (see Table 8.2).

It has been shown that for effects on *P. chrysogenum* conidia, a plasma exposure time to the contaminated paper of 10 min at 0.6 J.s^{-1} is sufficient. At 15 min of plasma modification, 100% (sterilization) efficiency was achieved on all model paper samples, and at 10 min, efficiency values were above 98%, regardless of the type of paper (see Table 8.3).

From the values of the number of raised colony-forming units after plasma treatment, the theoretical values of effective dose ED$_{90}$ was determined. It represents the time taken to reduce the original microorganism concentration by

TABLE 8.2

The impact of energy setting and kind of atmosphere (O_2, air) by ADRE plasma discharge on microbiological decontamination. P. chrysogenum viability was determined using colony forming units (the number of Colony forming units (CFU) in the untreated sample was considered as 100% viability and 0% efficiency) on the paper substrate (W and N)

Energy J.s^{-1}	Microbiological decontamination efficiency [%]			
	W		N	
	O_2	Air	O_2	Air
0.30	29.5	63.3	81.4	77.6
0.60	100.0	99.2	99.8	99.0
1.24	82.0	50.0	86.0	92.0

TABLE 8.3

Decontamination efficiency of plasma treatment on P. chrysogenum determined using colony forming units (the number of CFU in the untreated sample was considered as 100% viability and 0% efficiency) on the paper substrate

Plasma treatment conditions		Microbiological decontamination efficiency [%]		
Atmosphere	Time [min]	Kind of paper		
		W	G	N
O_2	5	99.7	99.7	99.2
	10	100.0	99.7	99.8
	15	100.0	100.0	100.0
N_2	5	99.4	99.5	80.8
	10	98.6	99.0	89.1
	15	99.9	99.9	96.8
air	5	98.0	96.2	97.8
	10	99.2	99.7	99.0
	15	100.0	100.0	100.0
CO_2	5	99.8	99.9	99.4
	10	99.8	100.0	99.9
	15	100.0	100.0	100.0
Ar	5	98.2	97.6	72.4
	10	98.2	97.7	86.1
	15	99.4	99.7	80.8

90%. For the air atmosphere, it was in the range of 1.8–3.4 min depending on the type of paper. The lowest time was recorded using a nitrogen atmosphere on W and G paper (0.1 min). For N paper, this time was up to 9 min, which is also confirmed by lower decontamination values when calculating CFU (Tiňo et al., 2018).

 The research results indicate the suitability of low-temperature atmospheric plasma as an effective technology for microbiological decontamination of paper information carriers. Based on the results of the study of oxidative changes occurring on the surface of paper due to plasma treatment, monitored by attenuated total reflection - Fourier transform infrared spectroscopy (ATR-FTIR) spectroscopy, it can be stated that there are no changes in the chemical structure of the material and the increase of oxidative degradation products is temporary (Tiňo et al., 2017, Vizárová et al., 2018). From the point of view of operational and economic reasons, it is possible to recommend an air atmosphere.

8.2 CS2: LOW-TEMPERATURE PLASMA CLEANING OF COLOR LAYER ON PAPER SUBSTRATE

Cleaning is one of the basic operations in restoring/preserving heritage objects. This operation is extremely delicate and always influences the originality of the historical work, especially in fine arts. In view of the current state of this issue, new methods and procedures are continually being sought as alternatives to the known techniques used in the art (Tiňo et al., 2019). In this study, the efficiency of removal of model dirt deposits by using low-temperature atmospheric ADRE plasma from color layer was studied. The experiment was realized on model samples, consisting of color layer on paper substrate (Akvarel Watercolor Maimeri Primary Blue – Cyan Pigment Phthalocyanine, binder gum arabic); two kinds of model soiling were created on the color surface: lampblack and vacuum cleaner dirt.

 The optical characteristics of the color layer were monitored in different plasma treatment modes.

 ADRE plasma treatment conditions: atmospheres N_2 and Ar/air; gas flow of 6 L.min^{-1}, exposure times of 5, 10, 15 min and 5–60 s; energy of the pulse Ep = 0.3 J/pulse, f = 2 kHz, interelectrode distance of 2.5 cm.

 Methods used for the evaluation of cleaning efficiency of watercolor model sample: optical microscopy, image analysis and adhesion of the dirt.

MODEL SOILING

Lampblack was used for model soiling, which is considered as one of the model dirt samples in this work. Lampblack is a model that represents dirt particles from soot, fires, etc. The procedure was as follows: each sample was applied with the same lampblack coat through a brush and a sieve from a height of 2 cm. Subsequently, excess lampblack coating was gently removed from the surface by tilting the sample and shaking. Only a small amount remained on the surface, which was then used to test the cleaning efficiency of the plasma action.

 The second method was the use of a vacuum cleaner dirt, the aim of which was to more realistically imitate real dirt in deposits. In the first step, the dirt from the vacuum

cleaner was sieved using a sieve first with a mesh size of 0.8 mm, to remove larger particles, and then a sieve with a mesh size of 0.18 mm. In this way, a fine powder of vacuum cleaner dirt was obtained. Subsequently, 1000 ml of water and 50 ml of sunflower oil were poured into the pot. Such an emulsion was brought to a boil. The sample was vaporized at a distance of 8 cm from the water surface for 15 s. A greasy coating formed on the surface of the sample, to which a fine fraction of vacuum cleaner dirt was evenly applied with a brush and sieve.

OPTICAL MICROSCOPY

A LEICA optical microscope, DM2700 LED, with a maximum magnification of 800x was used to observe the surface of the samples. The surface of the reference uncontaminated sample and samples that were soiled and subsequently modified with ADRE plasma were observed. Images were taken at 400x magnification (20x lens). The polarizer has been set to 45.

IMAGE ANALYSIS

Images were obtained from an optical microscope and ImageJ was used for evaluation. Using this software, the percentage coverage of the soiled area before and after plasma treatment under all plasma cleaning conditions was evaluated. In the ImageJ program, color images were first transposed to black and white (8 bit), then their brightness and contrast were adjusted, in order to best distinguish dirt particles and the substrate and subsequently, a dark background was set for better identification. In the last step, the particles on the surface were counted, their size distribution, as well as the percentage coverage of the area by dirt particles, was determined.

ADHESION TEST

2.5 × 2.5 cm samples were used to test the adhesion of dirt particles to the surface of watercolor samples. The test was performed on a reference sample with lampblack applied according to the procedure described in section Model Soiling, and subsequently, on samples modified with ADRE plasma under the above-mentioned conditions.

Adhesion was tested by means of adhesive tape; in particular, self-adhesive tabs with dimensions of the adhesive part of 2.5 × 2.5 cm were used. The tape was lightly pressed against the surface of the sample and passed four times using a roller weighing 339.97 g. An additional 200 g weight was attached to the roller. The total force acting on the sample was 5 N (roller + weight).

RESULTS

Model Soiling – Lampblack

Based on the results of preliminary experiments (biological decontamination), exposure times of 5, 10 and 15 min were chosen for plasma purification. Microscopic images were taken of each soiled sample before and after NTP application. The images were then

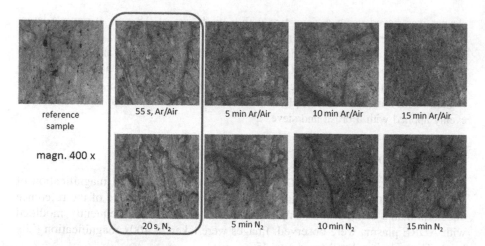

FIGURE 8.2 Microscopic changes in soiling of watercolored paper samples with lamp-black particles before and after plasma treatment; magnification 400.

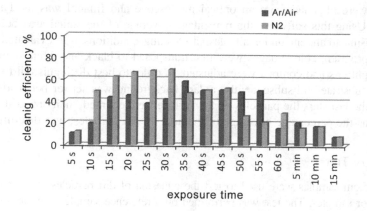

FIGURE 8.3 Optical microscopy, image analysis of lamp black pollution on paper substrate after plasma treatment (efficiency expressed as a percentage of the contaminated area of the substrate before and after plasma application).

subjected to image analysis, which counted the dirt particles on the model samples before and after the application of NTP. In addition, the adhesion of deposited dirt to the surface of model samples of paper covered with a layer of watercolor paint was tested. The images show that the effect of the action of plasma used in both atmospheres shows roughly uniform dispersion of particles of lampblack over the entire surface of the sample. By testing the change in adhesion of the deposit to the surface, it was found that the unmodified sample had less adhesion of the impurity to the surface than the plasma-modified samples. As a result, the plasma causes the dirt particles to charge and adhere more firmly to the sample surface. In addition, it was found that during 15 min of processing and subsequent implementation of the adhesion test, the surface is so active that it

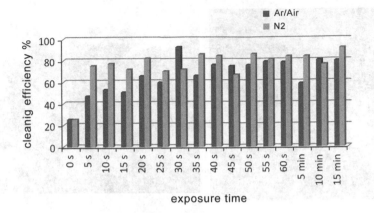

FIGURE 8.4 Test of adhesion of lamp black particles to the substrate (expressed as a percentage of the particles trapped on the test strip) as a function of plasma treatment time.

binds the adhesive from the test tape to itself. As a result, the selected plasma cleaning times are too long. Based on these findings, shorter plasma treatment times (5–60 s) were subsequently proposed.

In terms of the number of particles removed, the highest cleaning efficiency with ADRE plasma was achieved in an Ar/air atmosphere with an exposure time of 35 s, while when using an N_2 atmosphere, a time of 25 s was sufficient. In terms of the lampblack particles that stuck to adhesion tape, the highest cleaning efficiency was achieved in an Ar/air atmosphere with an exposure time of 30 s, while when using N_2 atmosphere, a time of 35 s was sufficient.

Similar behavior was recorded in the model soiled with vacuum cleaner particles representing real soiling conditions. Exposure times lasting 30–50 s are sufficient for the effective cleaning effect of plasma in either test atmospheres.

8.3 CS3: DECONTAMINATION OF GELATIN PHOTOGRAPHY

Because photographs are composed mainly of organic materials such as gelatin or cellulose, they represent a suitable culture medium for different fiber fungi as well as for many other microorganisms. Consequently, a great deal of historical photographs is damaged and devalued as these harmful processes may lead to their damage. In this case study, the possibility of using low-temperature ADRE plasma for decontamination of gelatin photographs was examined. Gelatin photographs on photographic paper FomaBrom N112 inoculated with the fibrous fungi *C. herbarum* were used as a model system (400 μl of inoculum at a concentration of 500 spores.μl⁻¹ was applied to a 6 × 6 cm photograph; see Figure 8.5). A photographic image with different densities was used for the experiment. We found that the density of the photographic image does not affect the growth of colonies on the surface of the photograph (Haberová, 2020).

The prepared samples of model photographs in plastic frames were treated with low-temperature ADRE plasma. Plasma treatment conditions were: power 1 or

FIGURE 8.5 Macroscopic image of a photograph with *C. Herbarum* (left) and microscopic image of a mycelium with accumulated silver (right; Haberová, 2020).

FIGURE 8.6 The plasma decontamination efficiency in air (*gray columns* a, b) and nitrogen (*dark columns* c, d) atmosphere at power 1 W.cm^{-2} (*full columns* a, c) and 2 W.cm^{-2} (*striped columns* b, d).

2 W.cm^{-2}; frequency 2000 Hz; atmosphere: air, nitrogen, oxygen; gas flow 6 l.s^{-1}; time: 1–40 min.

Figure 8.6 shows the graphical dependencies of plasma decontamination efficiency as the number of viable colonies as a function of plasma exposure time. In both types of the atmosphere (air and nitrogen), 100% inactivation of the spores was achieved after 15 min of plasma treatment independent of power, while after 10 min, the viability at power 2 W.cm^{-2} was less than 4. In preliminary experiments also, the oxygen atmosphere was used, but without positive results, so we did not work with this atmosphere further. From the measured results, plasma treatment in

an air atmosphere at 2 W.cm^{-2} seems to be the most promising, also from the point of economic reasons. The application of low-temperature ADRE plasma under the indicated conditions (power 2 W.cm^{-2}; atmosphere air, time 15 min) to real photographs confirmed its decontamination effect (Haberová, 2020).

8.4 CS4: IMAGE RECOVERY IN CYANOTYPE

Cyanotype is a photographic printing technique that produces cyan-blue prints, the image is formed by Prussian blue. A characteristic feature of cyanotype is its blue color due to the light sensitivity of ferric salts of some organic acids. A light treatment creates a redox reaction which results in a complex of intensely colored Prussian blue. The problem of cyanotype is its fading when photographs are exposed to light.

In our department, the samples were prepared based on a historical formula discovered by Sir J. Herschel in the year 1842 on Whatman paper with a surface pH of 5. Samples were subjected to light aging in a Q-sun chamber for three days. Light aging resulted in the fading of the samples, characterized by an increase in the coordinates L^* and b^* and a decrease of the coordinate a^*, making samples appear more green-blue (see Figure 8.7; Grešová, 2019).

Prussian blue shows a tendency to fade on the light. However, this is a reversible process, since it is sufficient enough if the air has access to the pigment, and oxygen can slowly re-oxidize Prussian white to blue again. The influence of temperature and low-temperature ADRE plasma on the reversion of blue color was studied. Since cyanotypes are blue, the most significant changes were observed in coordinate b^*, so we chose the recovery of coordinate b^* back to the original values for non-aged samples as the criterion for image recovery. Based on this criterion, the effect of temperature (laboratory, 40 °C, 65 °C and 100 °C) on the blue recovery of the cyanotype photographic image was studied. The recovery of the blue color (under the influence of heat) was monitored within one week after 24 h of exposure in the Q-SUN chamber. The development of the b^* coordinate during the observed recovery confirmed that the increased temperature does not have a positive effect on the recovery of the blue color, as the values of the b^* coordinate closest to the original (non-aged samples) were reached at laboratory temperature, which

FIGURE 8.7 Sample of cyanotype with different optical density ($D_0 = 0.1 - 2.1$) before aging (picture above) and after aging 72 h in the Q-SUN chamber (photo was taken 3 h after removal from the Q-SUN chamber – picture below; Grešová 2019).

corresponds with calculated ΔE^*_{ab} values; they were lowest in the case of image recovery at room temperature.

The impact of low-temperature ADRE plasma on the stability of the photographic image of prepared cyanotypes was also studied. Plasma treatment conditions were: power $2\,W.cm^{-2}$; frequency 2000 Hz; atmosphere: air, nitrogen; gas flow $6\,L.min^{-1}$; time: 10 min. At these conditions, no significant effect on the cyanotype image layer was found; however, there was a slight increase of C^*_{ab}, which can positively affect the quality of cyanotype.

In order to determine if the plasma would help to recovery the aged image, the samples were, 24 h after ageing in the Q-SUN chamber, treated with plasma in the atmosphere of nitrogen and air; in both cases, an exposure dose of $1.2\,kJ.cm^{-2}$ (10 min at $2\,W.cm^{-2}$) was used; as in the previous experiment, we found that the photographs were not damaged even at the indicated exposure dose. Colorimetric parameters (L^*, a^*, b^* coordinates) were measured five days after plasma treatment, during which the samples were stored in the dark. Again, we used the values of the b^* coordinate to evaluate the effect of plasma on the photographs (see Figure 8.8).

The effect of plasma on the prepared samples brought values of the coordinate b^* closer to the original ones (compared to an equally aged sample stored in the dark at room temperature without the effect of plasma), while the sample treated with plasma in an air atmosphere came closest to the original image (see Figure 8.8). From the above colorimetric measurements, it can be concluded that the plasma treatment of the light-aged cyanotype image layer helps to recover the

FIGURE 8.8 Dependence of b^* coordinate on optical density for non-aged sample (■, *dashed line*), sample exposed 24 h in the Q-SUN chamber, measured immediately after exposure (●), and samples measured five days after exposure in the Q-SUN chamber stored in the dark at room temperature without plasma treatment (▲), plasma-treated in an atmosphere of air (▶) and in an atmosphere of nitrogen (◀ ; Grešová, 2019).

image. The results obtained from colourimetric and densitometric measurements were also confirmed by FTIR spectra, specifically by changes in the absorbance of the band ν (CN groups) at 2071 cm^{-1}, which is typical for Prussian blue. The height of this band increases with the increasing value of the optical density of the image layer. It has been found that treating cyanotypes with plasma (mainly in the air atmosphere) has a positive outcome on image recovery. (Grešová, 2019).

8.5 CS5: CLEANING HISTORICAL TEXTILE WITH METAL THREADS BY PLASMA

INTRODUCTION

The main problems of historical textile cleaning arise from the fact that historical textiles are often objects of diverse material composition with complicated structure. They can contain fine materials sensitive to external conditions such as animal fibers and organic dyes and other materially different components, for example, metal threads, metal buttons and buckles. The choice of the appropriate cleaning method depends on the material composition, degree of damage and the type of contamination.

The plasma beam causes activation of the surface, including the established deposits – dirt and corrosion products. Plasma treatment focusing separately on certain parts of the object seems to be promising especially in removing contamination from metallic parts of historical textiles. Particular attention should be paid to the influence of plasma effect on the organic constituents – core of the threads. Therefore, this research was focused on the study of the effect of low temperature atmospheric plasma (LTAP) on metal threads, including silk fibers.

EXPERIMENTAL

Samples of textile adornment with metal threads (see Figure 8.9) coming from the nineteenth–twentieth century were examined. Material and structural analysis was performed using XRF, FTIR spectroscopy, scanning electron microscopy–energy dispersive X-ray spectroscopy (SEM-EDS) and optical microscopy. The metal threads contained mostly copper and the textile part was made of silk. First, the effect of plasma beam onto the surface of silk fabric was investigated. Atmospheric Pressure Plasma Beam (Diener Electronics GmbH + Co.) for treatment of planar and 3D objects with the following parameters was used: frequency 20 kHz, voltage 10 kV, power input 300 W and width of treated area up to max. 12 mm. Variables of the plasma treatment – type of gas, distance from the surface and time of application were optimized so as not to damage the silk fabric. The effects of plasma exposure were observed microscopically (MiScope, Zarbecco), by SEM (JEOL 7500F) and ATR-FTIR spectroscopy (Excalibur FTS3000MX, Digilab). Subsequently, a plasma experiment was performed on selected variable parameters on the surface of the metal parts (laces, bands). The aim was to remove corrosive products from the surface of metal parts without damaging the silk fibers.

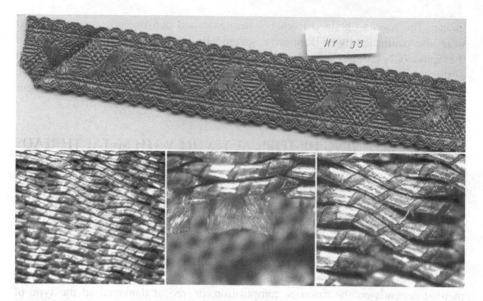

FIGURE 8.9 One of the investigated ribbons (turn of the nineteenth and twentieth century) containing a copper lamella and a silk core. Above: macro photography, below: photography taken by MiScope, magnification 40x (left) and 140x (middle and right). Photo: M. Reháková.

Effect of Plasma Treatment on Silk

Plasma treatment conditions that do not visually damage samples of silk fabric were defined: working gas N_2, O_2 – a minimum distance of plasma beam 30 mm, maximum application time 5 s; working gas Ar – minimum distance of plasma beam 5 mm, maximum application time 60 s (see Figure 8.10). ATR-FTIR spectroscopy has shown that any chemical damage of silk (fibroin) occurs at only conditions: *Ar, 10 mm, 30 s*. No hydrolysis of peptide bonds of fibroin occurs at these conditions (ratio of the absorption maxima of amide I/amide II did not decrease, Figure 8.11). Crystallinity index E (C-N) of fibroin – degree of crystallinity – proving the degradation of fibroin in its amorphous regions (ratio of the area of the peak at 1261 and 1230 cm^{-1} (Koperska et al., 2014)) did not increase under these conditions (see Figure 8.12).

Effect of Plasma Treatment on Copper Parts

The effects of plasma on the metal components cleaning of the threads were monitored after the separation of the metal strips (see Figure 8.13). Plasma pen Plastech 0 (Kamea, Slovakia) with working gases air, O_2, N_2 and Ar was used. Whereas a reducing plasma is recommended to remove corrosive products (metal oxides) from the surface of metals and alloys (Boselli, 2016, Miková, 2019), the laboratory reduction plasma equipment in VUT Brno was used, too.

Atmospheric plasma with O_2, N_2 and Ar was found to be effective in removing organic contaminants using a distance of 15 mm from the surface. It was checked by the FTIR method. Hydrogen plasma was more effective at removing corrosive products of metals. It was confirmed by microscopy and SEM (see Figure 8.14) and

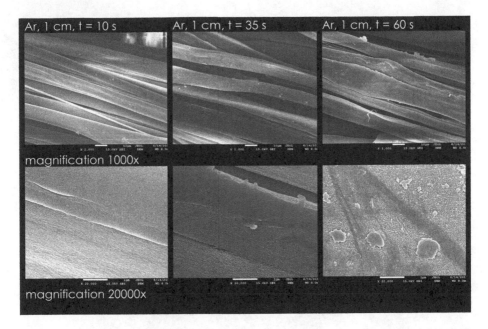

FIGURE 8.10 SEM images of plasma-treated silk fabric, working gas Ar, distance from the surface 10 mm, time of application 10–60 s.

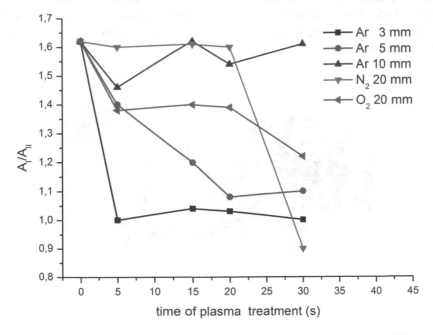

FIGURE 8.11 Index of *fibroin hydrolysis* dependence on plasma treatment conditions.

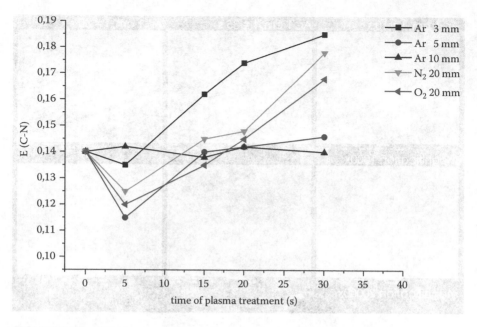

FIGURE 8.12 *Fibroin crystallinity index* dependence on plasma treatment conditions.

cyclic voltammetry (CV) measurements EmStat3 + (PalmSense, Netherlands; see Figure 8.15). Among other things, the FTIR spectra showed a decrease in the absorption bands belonging to carbonates (1570 cm^{-1}), which may have formed part of the corrosion products.

FIGURE 8.13 Metallic lamellae separated from silk core. Photo: M. Kováč.

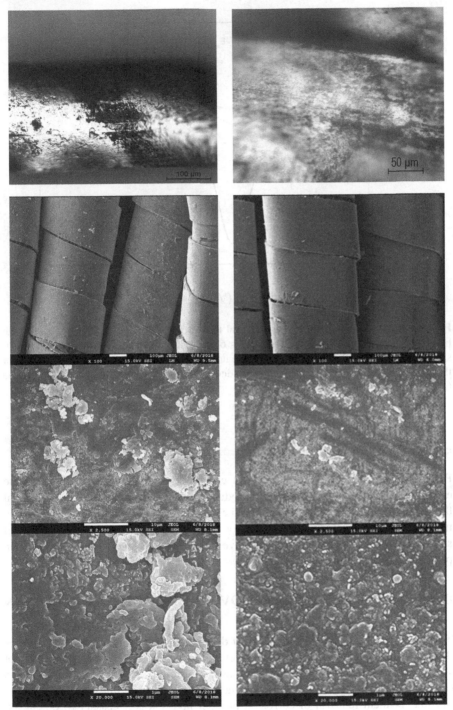

FIGURE 8.14 Surface of metal strips before (left) and after (right) plasma treatment (H₂, 15 mm, 180 s); the first line: optical microscopy in white light (M. Kováč), next: SEM at magnification 100x, 2500x, 20,000x. The images show a decrease of surface soiling and visual (color) changes in the places of the original contaminants.

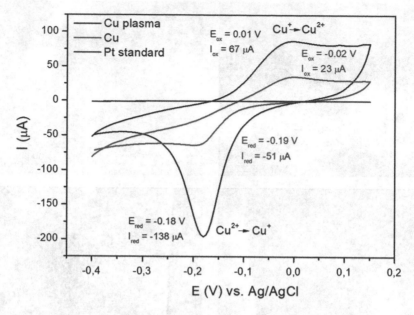

FIGURE 8.15 Voltammetry curves of metal threads before (red) and after treatment with hydrogen plasma (black). The current values of the plasma-treated metal thread were considerably higher than the current values of the untreated sample. This is due to the increase of the electroactive area of the metal threads due to the cleaning of the surface by plasma treatment.

SUMMARY

Plasma treatment conditions that do not cause chemical damage to silk could be effective in cleaning the corrosion products and surface organic dirt of metal threads. Working conditions depend on the composition and structure of the treated material and must be set individually for each object based on testing on model samples. Optimization of procedures have been proposed and further testing is in process.

8.6 CS6: LOW-PRESSURE REMOVAL OF MODEL CORROSION LAYERS FROM IRON

The material of each archaeologic object depends on its manufacturing procedures that are dependent on local sources as well as on a historical period. Thus, it is not so simple to find a related material among the current production. Moreover, each object has its own corrosion history. Due to these facts, a study focused on the plasma chemical removal of corrosion product layers was necessary to be carried out using model samples.

8.6.1 Preparation of Iron Model Samples

The cold-rolled non-alloy structural steel according to CSN 426315, quality 11321.21, was used for this study. To obtain full knowledge about this material, the standard metallographic study was carried out using the scanning electron microscope NEOPHOTO 21. The SEM image is shown in Figure 8.16.

The light parts in the image correspond to ferrite grains, perlite is in the dark parts. The glow discharge optical emission spectrometry was used for the exact elemental composition. The results are shown in Table 8.4.

The surface of the purchased material is protected against corrosion and also contains some residues of processing liquids. The samples (length of 10 and 50 mm) were cut from the rods (50×5 mm^2) and washed in a detergent solution (Star 50 P) to remove grease from the sample's surface. To obtain fresh bulk material, the grinding using sandy papers with grain sizes of 60 and 280 was done under water. After that, the samples were washed in ethanol of technical grade and dried by the airflow. Immediately after the washing, samples were put into desiccators to realize the corrosion process. Four sets of samples were prepared for this broad study.

FIGURE 8.16 Structure of original iron material.

TABLE 8.4
Elemental composition of used steel

Element	Fe	Mn	Si	C	Cu	Cr	Ni	Sn	Co	P	S
Content [%]	98.9	0.64	0.19	0.08	0.08	0.03	0.03	0.02	0.01	0.007	0.007

The first set was corroded in the HCl vapor for 5 weeks (based on preliminary tests, Sázavská, 2013). Samples of $10 \times 10 \times 5$ mm^3 were placed on the ceramic plate into the desiccator at the bottom of which a Petri dish with 20 ml of hydrochloric acid was put. The desiccator was kept in dark at laboratory temperature around 24 °C. After 5 weeks, samples were dried for 24 h in the vacuum dryer at 60 °C and kept with oxygen and moisture absorbers in special protecting bags made of aluminum barrier film (Long life for art, 2020) up to their plasma treatment. The corrosion layers contain two main compounds – rokuhnite (FeCl$_2$ · 2H$_2$O) and akageneite-M (FeOOH with chlorine atoms incorporated into the monoclinic crystal grid – see Figure 8.17) as it is shown in Figure 8.18. The sample surface is not smooth (see Figure 8.19). There are generally two main layers at the surface. The upper layer can be easily removed but the lower layer is very compact and its removal needs a very high mechanical force. Compositions of both layers are more or less the same.

The second set of samples was also corroded in the hydrochloric acid environment. As the corrosion of ancient objects is commonly taking place in the soil, this set of samples was prepared in the sandy environment. The samples of $50 \times 20 \times$

FIGURE 8.17 Akageneite structure. Big spheres are chlorine atoms, black spheres are iron atoms, bigger grey balls are oxygen atoms and smaller grey spheres are hydrogen atoms.

FIGURE 8.18 XRD spectrum of the HCl vapor corroded sample. All non-marked peaks correspond to rokuhnite.

FIGURE 8.19 SEM image of the HCl vapor corroded sample.

5 mm^3 were pre-prepared by the grinding as before. Samples were placed into the river sand and sprayed with hydrochloric acid. After that, they were placed into the desiccator with hydrochloric acid as the precedent set of samples. The corrosion process took 5 weeks again during which samples were covered by hard and compact incrusted corrosion products layers as it is shown in Figure 8.20.

FIGURE 8.20 Iron sample corroded in HCl vapor with sandy incrustation.

Therefore, the samples were dried again and packed according to the procedure described above. The incrusted layers were formed by sandy grains (that have not been modified by hydrochloric acid) glued by rokuhnite and $FeCl_2 \cdot 4H_2O$ was determined by XRD (see Figure 8.21).

The third set of samples was corroded in the nitric acid environment. The samples of $50 \times 20 \times 5$ mm^3 were pre-prepared by the grinding as before. The samples were placed onto the ceramic plate in the desiccator and sprayed with concentred nitric acid. The Petri dish with 20 ml of concentrated nitric acid was put at the bottom part of the desiccator. The corrosion process took 5 weeks again. The corrosion was weak, only because nitric acid passivates iron (Waseda and Suzuki, 2006). The corrosion layers were nearly homogeneous but thin as it is shown by the SEM image (see Figure 8.22). Their structure is based mainly on the thin grains; the compact layer was cracked. Due to this fact, the layer was not well adhered to the sample surface. The XRD analysis (see Figure 8.23) showed the presence of pure akageneite corrosion, only. This is because of the chain reactions

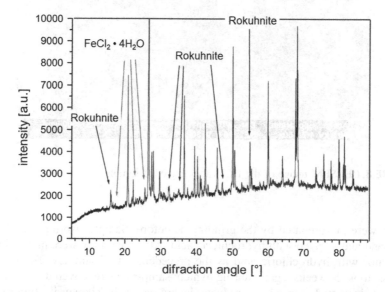

FIGURE 8.21 XRD spectrum of the HCl vapor corroded sample with sandy incrustation.

FIGURE 8.22 SEM image of the HNO$_3$ vapor corroded sample.

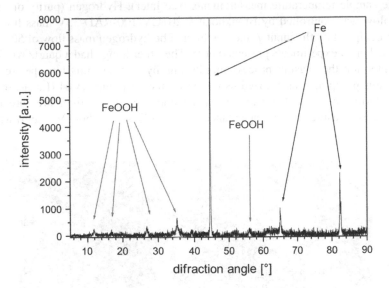

FIGURE 8.23 XRD spectrum of the HNO$_3$ vapor corroded sample.

$$Fe + 6HNO_3 \rightarrow Fe(NO_3)_3 + 3NO_2 + 3H_2O$$

$$Fe(NO_3)_3 + 3H_2O \rightarrow Fe(OH)_3 + 3HNO_3$$

Fe(OH)$_3$ is further oxidized to akageneite (FeOOH). After the corrosion procedure, the samples were dried again and packed according to the procedure described in the first set of samples.

The last set of samples was prepared in the sulfuric acid environment. The samples of $50 \times 20 \times 5$ mm^3 were pre-prepared by the grinding as before. The samples were placed onto the ceramic plate in the desiccator and sprayed with concentred sulfuric acid. The Petri dish with 20 ml of concentrated sulfuric acid was put at the bottom part of the desiccator. The corrosion process took 5 weeks again. The samples were covered by white corrosion formed by the compact multilayer of crystals (see Figure 8.24) that corresponds to szomolnokite ($FeSO_4 \cdot H_2O$) as was confirmed by XRD (see Figure 8.25). No other corrosion products were observed in this case. After the corrosion procedure, the samples were dried again and packed according to the procedure described in the first set of samples.

8.6.2 Experimental Setup and Conditions

The experimental apparatus for the plasma treatment was build up according to conclusions presented in Chapter 3.1 and Figure 3.2. The horizontal quartz reactor was 90 cm long with an inner diameter of 95 mm. It was mounted between two stainless steel flanges. In one of them, the pure hydrogen input was installed together with the airing valve and with throughput for a thermocouple that was used for the sample temperature measurements (see later). Hydrogen (purity of 99.9%) mass flow was controlled by Bronkhorst F-201CV-100-RAD-33V mass flow controller equipped by the input 7 microns filter. The hydrogen mass flow of 50 ml/min was used in all experiments presented here. The other flange had a quartz window at its center for the plasma process monitoring by optical emission spectroscopy. Apparatus pumping was realized using the rotary oil pump RV04 (Lavat) through the butterfly valve for the pumping speed and pressure setting. Pressure in the reactor was measured by the capacitance gauge CRT 90 (Leybold Vacuum) with the

FIGURE 8.24 SEM image of the H_2SO_4 vapor corroded sample.

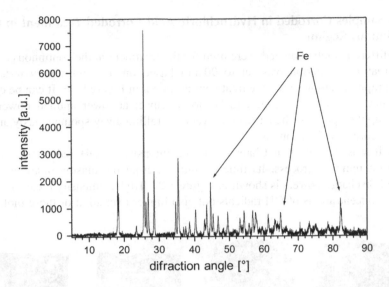

FIGURE 8.25 XRD spectrum of the H_2SO_4 vapor corroded sample. Other peaks correspond to szomolnokite (FeSO$_4$ · H$_2$O).

range up to 1333 Pa. Operating pressure was set in the interval of 150–200 Pa in all experiments.

The radiofrequency power supply Cesar 1310 (Advanced Energy, former Dressler) operating at 13.54 MHz was used for the plasma generation. The automatic matching network was used in the automatic (in the continuous plasma generation regime) or manual (in the pulsed regime) mode. The discharge was generated using a pair of outer copper electrodes placed at the top and the bottom of the reactor cylinder. The whole plasma part was in the Faraday cage made of a 1 cm steel mesh coated with zinc that was grounded.

The treated samples were put on the holder made from a pair of glass tubes (outer diameter of 10 mm) fixed in the reactor flanges. The sample position in the reactor was in its middle in all experiments.

The sample temperature during the plasma treatment was measured by a K-thermocouple placed inside the sample in a hole of 1 mm in diameter and 5 mm deep. The temperature was measured during the 5 s plasma off period each 5 min; 1 min interval was kept during the first 10 min of the process, to avoid electromagnetic induction on the wires that leads to the incorrect temperature measurement.

The reduction of the corrosion layers was continuously monitored by optical emission spectrometry according to the procedures described in Chapter 3.1.3. The compact optical spectrometer Ocean Optics HR4000 with the TCD1304AP detector and 2400 gr/mm grating covered the spectral interval of 250–349 nm. Integration time of 10 s with 6 spectra averaging was used for the acquisition. The multi-mode quartz optical fiber with the 600 microns diameter was used at the spectrometer input, the entrance slit was 5 microns wide.

8.6.3 Samples Corroded in Hydrochloric Acid Corroded Treatment in the Continuous Regime

Four different applied powers were used for the treatment in the continuous regime. The treatment duration was set to 90 min based on the preliminary tests. The photograph of samples after the treatment is shown in Figure 8.26. It can be clearly seen that corrosion layers start to be non-compact at lower applied powers. At higher applied powers, the corrosion layers are falling away spontaneously and the sample core is visible, only.

As it was described in Chapter 3.1, the intensity of OH radical reflects the corrosion removal process. Its time evolution during the plasma treatment at all applied discharge powers is shown in Figure 8.27. Higher intensity means not only higher concentrations of OH radicals but also higher excitation of these molecules

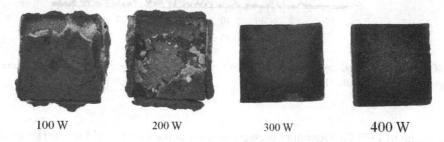

FIGURE 8.26 Photography of samples corroded in hydrochloric acid vapor and treated in the continuous regime at different applied power.

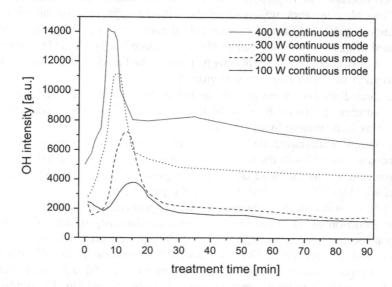

FIGURE 8.27 OH radical intensity as a monitoring parameter of the corrosion removal process of samples corroded in hydrochloric acid vapor and treated in the continuous regime at different applied power.

and thus integral intensity under the depicted curves is not directly proportional to the removed oxygen amount from the corrosion layers. But, of course, the relationship exists and the higher value means higher removal. It is well visible that maximum OH emission shifts to earlier times with the increase of applied power. This effect is not related to the temperature because the sample temperature is nearly the same at higher powers. Intensity increase is caused by the higher dissociation degree in the plasma; in other words, there is higher concentration of hydrogen atoms and ions at higher applied powers. After the maximum intensity, a slow decrease in intensity is observed because concentration of oxygen in the corrosion layers is decreasing.

The sample temperature increases for a long time and it starts to be nearly constant after about 30 min of the plasma operation (see Figure 8.28). The maximal temperatures observed at this experiment were not exceeding 200 °C, so the plasma chemical treatment was fully safe with respect to the potential initiation of metallographic changes even at the atomic scale.

The corrosion removal process efficiency was determined using the scanning electron microscopy with energy dispersion X-ray analysis (SEM-EDX). The area of $25 \times 25\ \mu m^2$ was used at each sample. Samples were cleaned just after the end of the plasma treatment with a dental brush to remove the rests of non-well attached material. The analysis did not proceed earlier than 2 h after the end of the plasma chemical treatment; thus, the secondary oxidation of the samples was not negligible. Results are shown in Figure 8.29. The decrease in oxygen content on the sample surface is similar at all applied powers because of the secondary oxidation. But the chlorine content is decreasing with the increase of applied power. This is related well to the higher concentration of hydrogen atoms and ions at higher powers that

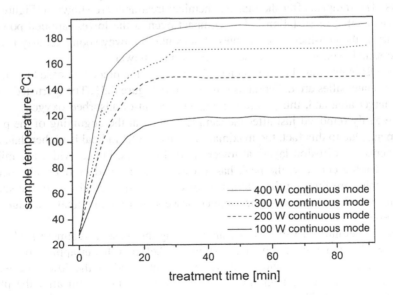

FIGURE 8.28 Samples temperature during the treatment in the continuous regime at different applied powers. Samples corroded in hydrochloric acid vapor.

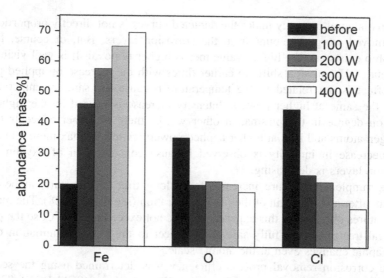

FIGURE 8.29 Surface abundance of the main elements before and after the treatment in the continuous regime at different applied power. Samples corroded in hydrochloric acid vapor.

are important for the chlorine removal. It is visible that the plasma treatment in one cycle is not sufficient for the full removal of all corrosion products as was described in Chapter 3.1.

The second set of experiments in the continuous mode was focused on the role of a sandy incrustation in the corrosion removal process. The treatment conditions and all procedures were the same as before to be able to fully compare the obtained results. The samples after the plasma chemical treatment are shown in Figure 8.30. It is visible that incrustation is less compact even at the lowest applied power. In contrary to the non-incrusted samples, it does not fall away spontaneously from the whole sample surface even at the highest applied power.

The OH intensities show the same behavior as in the precedent case but the peak maximal intensities are different as it is shown in Figure 8.31. The incrusted surface has a larger area and, thus, there is a higher amount of adsorbed oxygen on it that can be easily removed just after the sample heating at the beginning of the plasma treatment. Due to this fact, the maximal intensity of OH radical is higher than at the non-incrusted corrosion layers at lower applied powers, but its width is similar to before. On the contrary, the peak has a lower intensity and higher width because sandy grains are limiting the interaction of direct plasma species with the surface. The intensities are lower at higher applied powers after the maximal peak due to the same effect.

The temperature of samples measured during the plasma treatment is shown in Figure 8.32. Temperature behavior is similar to before at lower applied powers but its stabilization is faster and equilibrium is established at the lower value. The temperature peak at the beginning (at the time of about 10 min after the plasma switching on) is visible at the application of higher powers. After it, the temperature drops down and the temperature is significantly lower than in the case of non-

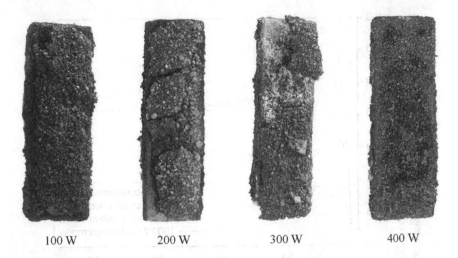

100 W 200 W 300 W 400 W

FIGURE 8.30 Photography of samples corroded in hydrochloric acid vapor with sandy incrustation and treated in the continuous regime at different applied power.

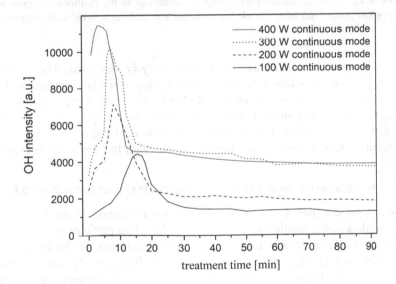

FIGURE 8.31 OH radical intensity as a monitoring parameter of the corrosion removal process of samples corroded in hydrochloric acid vapor with sandy incrustation treated in the continuous regime at different applied power.

incrusted samples. This observation reflects the fact that sandy grains are limiting the direct interaction of plasma species with the surface. Sand is nonthermally conductive and forms a thermal isolation layer at the surface that is generally a positive effect. Unfortunately, the same grains also decrease the plasma treatment efficiency as it was pointed above.

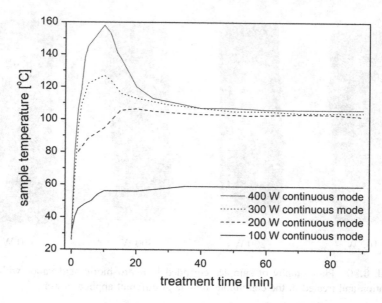

FIGURE 8.32 Samples temperature during the treatment in the continuous regime at different applied power. Samples corroded in hydrochloric acid vapor with sandy incrustation.

To confirm these results, the SEM-EDX analysis was used. The results are generally similar to before (see Figure 8.33); only there is significantly higher content of oxygen because it is presented also in the sandy grains (mainly silicon and aluminium oxides) and it is nearly impossible to distinguish its origin by the used method. The total content of elements was recalculated to have iron, oxygen and chlorine, only, to be able to relate the results with the non-incrusted samples.

8.6.4 HYDROCHLORIC ACID CORRODED SAMPLES TREATMENT IN THE PULSED REGIME

Application of the pulsed regime plasmas allows a decrease of the mean applied energy while keeping similar concentrations of the active particles as it was pointed in Chapter 3.1. This should lead to a significant decrease of the treated object temperature and to keep the corrosion removal efficiency. To verify these assumptions, the treatment of samples with the same corrosion history was carried out using different applied powers and duty cycles.

As an example, the set of samples treated at the power set to 200 W with duty cycles of 50%, 75% and in the continuous mode, i.e., duty cycle of 100%, is presented. The intensities of OH radical and temperature during the treatment are shown in Figures 8.34 and 8.35, respectively. The elementary composition of the treated samples is given in Figure 8.36.

The OH radical intensities show that lower mean applied power, i.e., lower duty cycle, has similar effect as the application of lower power in the continuous regime (compared with Figure 8.27) but the effect is much stronger. The corrosion removal is negligible at the lowest duty cycle.

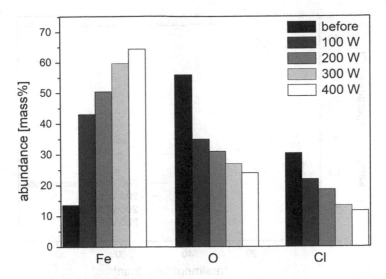

FIGURE 8.33 Surface abundance of the main elements before and after the treatment in the continuous regime at different applied power. Samples corroded in hydrochloric acid vapor with sandy incrustation.

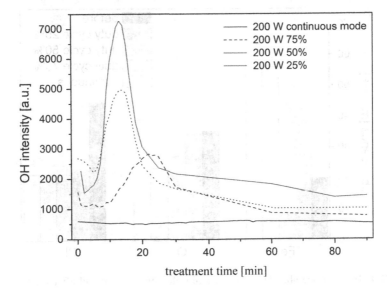

FIGURE 8.34 OH radical intensity during the pulse regime plasma treatment of samples corroded in hydrochloric acid vapor.

The sample temperatures show the same trend, too. The temperature at a lower duty cycle is low, and a stable temperature is reached in about 30 min at any conditions.

More interesting results of corrosion removal are shown in Figure 8.36. The removal of oxygen atoms is nearly negligible from the corrosion layer well related to a

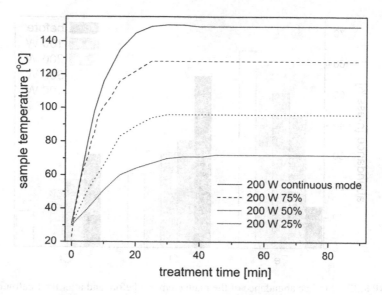

FIGURE 8.35 Sample temperature during the 200 W pulse regime plasma treatment of samples corroded in hydrochloric acid vapor.

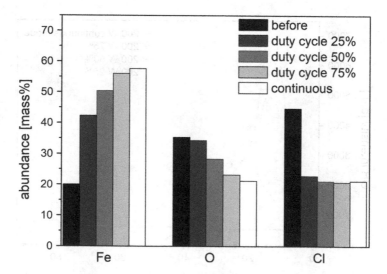

FIGURE 8.36 Surface abundance of the main elements before and after the treatment at 200 W using different duty cycles.

very low emission of OH radical at the lowest duty cycle. In another duty cycle, the relation between OH radical intensity and content of remaining oxygen in the corrosion layers is evident. The removal of chlorine has the same efficiency independently on the duty cycle (within the experimental error of about 5% of the measured value).

When we look at the same experiment carried out at 400 W (see Figures 8.37 and 8.38), the results are rather different. The OH emission shows some maximum even at

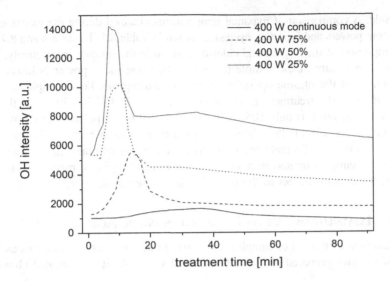

FIGURE 8.37 OH radical intensity during the 400 W pulse regime plasma treatment of samples corroded in hydrochloric acid vapor.

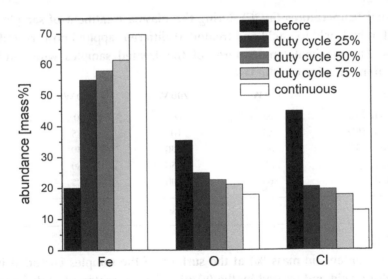

FIGURE 8.38 Surface abundance of the main elements before and after the treatment at 400 W using different duty cycles.

the lowest duty cycle. This fact indicates some removal of oxygen from the corrosion layers. Removal of oxygen as well as chlorine is proportional to the duty cycle, i.e., it is more efficient if higher energy is applied. The sample temperatures during the treatment are similar as shown for 200 W in Figure 8.35 and thus they are not presented here graphically. Based on these results, we can conclude that the highest removal is observed at the highest powers. However, we must also consider the sample heating that is not

negligible. A comparison of maximal temperatures obtained during the matrix experiment (four powers and four duty cycles) is shown in Table 8.5. Tables 8.6 and 8.7 show the comparison of the oxygen and chlorine content in the samples, respectively.

The temperature of the sample treated at the same mean power is lower if the treatment is in the plasma operating in the pulsed regime. For example, maximal temperature of the treatment at the mean power of 100 W is 130 °C in the continuous regime but it is only 105 °C in the treatment in the pulsed regime of 400 W with the duty cycle of 25%. Thus, the treatment at higher power in the pulsed regime is better to eliminate the heat stress. When we compare the surface composition of samples treated in pulsed and continuous regimes, results are more or less the same with respect to the corrosion layers removal.

8.6.5 TREATMENT OF SAMPLES CORRODED IN NITRIC ACID

The treatment of this set of samples was carried out at the same conditions as in the case of samples prepared in hydrochloric acid vapor. As it was pointed above, the

TABLE 8.5

Maximal temperatures (in °C) during the plasma treatment of samples corroded in hydrochloric acid and treated at different applied powers and duty cycles. The maximal temperatures of the treated samples with sandy incrustation are added in the last row

Regime	100 W	200 W	300 W	400 W
Duty cycle 25%	55	75	90	105
Duty cycle 50%	85	105	115	130
Duty cycle 75%	105	130	140	145
Continuous	130	150	180	190
Incrusted	60	100	125	155

TABLE 8.6

Oxygen content (in mass %) at the surface of the samples corroded in hydrochloric acid and treated by the 90 min plasma treatment at different applied powers and duty cycles

Regime	100 W	200 W	300 W	400 W
Before	35.3	35.3	35.3	35.3
Duty cycle 25%		34.3	21	24.8
Duty cycle 50%	23.1	28.4	21	22.6
Duty cycle 75%	22.8	23.2	21.7	21.1
Continuous	20.0	21.2	20.3	17.8

TABLE 8.7

Chlorine content (in mass %) at the surface of the samples corroded in hydrochloric acid and treated by the 90 min plasma treatment at different applied powers and duty cycles

Regime	100 W	200 W	300 W	400 W
Before	44.7	44.7	44.7	44.7
Duty cycle 25%		22.8	20.4	20.3
Duty cycle 50%	37.8	21.2	14.4	19.5
Duty cycle 75%	33.9	20.8	13.9	17.6
Continuous	23.4	21.2	14.6	12.6

corrosion layers are very uniform and stable. The results are presented as the representative selection at the highest applied power.

Comparison of OH radical intensities during the plasma treatment in the continuous mode is given in Figure 8.39. It is visible that the intensity increases with the increase of applied power. There is no clear sharp maximum as in the treatment of samples corroded in hydrochloric acid because the samples surface is very smooth and thus there is not so much amount of adsorbed air. The slow decrease in intensities corresponds to the oxygen removal from the corrosions layers. The uniformity of layers is kept after the treatment as it is documented by photographs in Figure 8.40 where there are no parts spontaneously falling away.

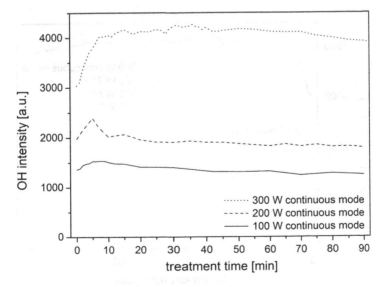

FIGURE 8.39 OH radical intensity as a monitoring parameter of the corrosion removal process of samples corroded in nitric acid environment and treated in the continuous regime at different applied power.

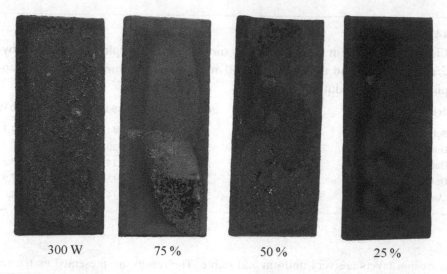

300 W 75 % 50 % 25 %

FIGURE 8.40 Photography of samples corroded in nitric acid environment and treated in the pulsed regime at different duty cycles.

The effect of the pulsed regime application is similar to before, as it is demonstrated in Figure 8.41. Due to the uniformity in corrosion layers and similarity of OH radical intensities at all used conditions, there are also no remarkable differences in the composition of corrosion layers (see Figure 8.42). The oxygen content is more or less constant. Note that the sample surface was cleaned after the plasma treatment by a dental brush; therefore, the reduced corrosion was removed by it and, thus, it was

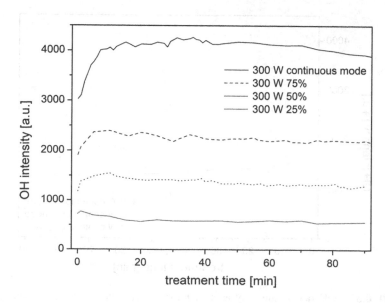

FIGURE 8.41 OH radical intensity during the 300 W pulse regime plasma treatment of samples corroded in nitric acid environment.

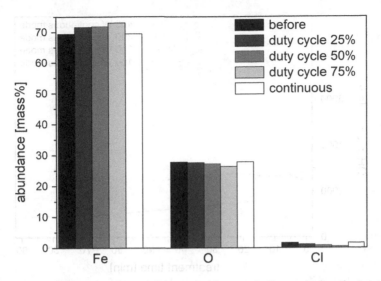

FIGURE 8.42 Surface abundance of the main elements before and after the treatment at 300 W using different duty cycles.

shown by the analysis that there is a deeper corrosion layer, only. Similar results were obtained also at the other applied powers. Temperature measurement showed the same behavior as in case of samples corroded in hydrochloric acid and the maximal temperatures during the treatment were also very similar.

8.6.6 TREATMENT OF SAMPLES CORRODED IN SULFURIC ACID

Also, this set of samples was treated at the same conditions as before. The general behavior of the OH radical intensities during the treatment is the same as before. Again, intensity increases with the increase of the applied power as it is demonstrated in Figure 8.43 for the continuous regime of the discharge. A broad maximum is visible at higher applied power that is related to the effective removal of corrosion products. This also corresponds to the pictures of the samples obtained after the plasma chemical treatment in the pulsed regime (see Figure 8.44). The corrosion layers spontaneously fall away at the highest duty cycle but not over the whole surface as it was in the case of hydrochloric acid corroded samples. The effect of the duty cycle is very similar as it is shown in Figure 8.45. The SEM-EDX analysis presented in Figure 8.46 shows a significant decrease of oxygen in the layers of the corrosion product and a smaller decrease of sulfur, too. As the corrosion layers are generally compact, the treatment time used for this study was not sufficient for the full removal. It can be also noted that based on Rašková et al., 2002, the plasma treatment starts to be inefficient when the OH radical intensity falls down to about 10% of the maximal value. However, that value was not achieved in these experiments. Similar results have been obtained also at the other experimental conditions, so they are not presented here. The maximal temperatures of samples during the treatment were similar to at the treatment of samples corroded in hydrochloric acid vapor.

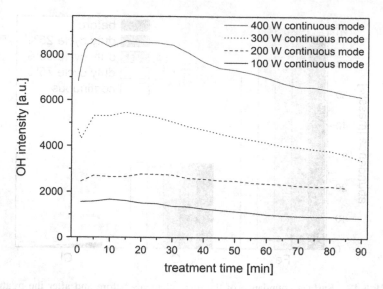

FIGURE 8.43 OH radical intensity as a monitoring parameter of the corrosion removal process of samples corroded in sulfuric acid environment and treated in the continuous regime at different applied power.

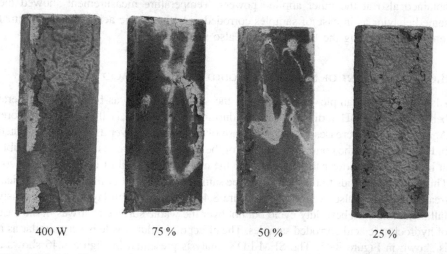

FIGURE 8.44 Photography of samples corroded in sulfuric acid environment and treated in the pulsed regime at different duty cycles.

8.6.7 APPLICATION OF BIAS VOLTAGE

The bias application was practically studied using the discharge configuration shown in Fig. 3.4-right (for other experimental device details, see the beginning of this chapter) using model iron samples ($50 \times 20 \times 1$ mm^3) corroded in hydrochloric acid environment. Plasma was generated in pure hydrogen at a flow rate of 50 Sccm at applied power of 300 W. The DC bias voltage was applied in both polarities. In

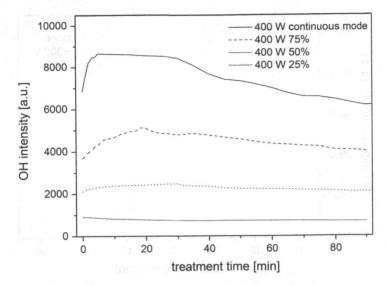

FIGURE 8.45 OH radical intensity during the 400 W pulse regime plasma treatment of samples corroded in sulfuric acid environment.

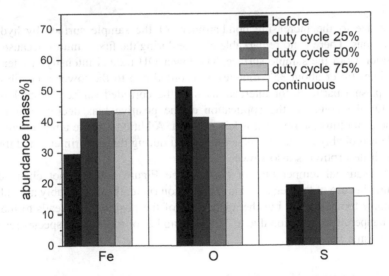

FIGURE 8.46 Surface abundance of the main elements before and after the treatment at 400 W using different duty cycles.

case of the positive bias application, hydrogen ions were repulsed from the sample surface. In case of the negative bias application, they were accelerated to the surface. Figure 8.47 shows the OH radical emission intensity during the first hour of the plasma treatment.

It is clearly visible that the application of negative voltage significantly increases the OH radical intensity especially at the time around 20 min at given conditions.

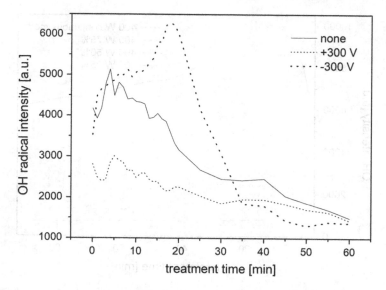

FIGURE 8.47 OH radical intensity during the plasma treatment at different bias application.

This is due to the increasing bombardment of the sample surface by hydrogen positive ions. There is no remarkable change during the first minutes because of air desorption from the sample surface. The lower OH radical intensity at later treatment times (after about 35th minute) is recorded due to the lower accessibility of active plasma particles for interactions with the corroded surface (a shielding effect). On the contrary, the application of the positive bias decreases ion bombardment and thus the removal is less efficient. Additionally, the temperature of the sample is probably lower (it was not measured during this experiment) and thus the initial air desorption is also slower.

The rotational temperature of plasma (see Figure 8.48) is not changed significantly in case of the negative bias application (note, this is probably not valid for the sample temperature), but the application of the positive bias leads to the rotational temperature elevation due to a higher number of ion-neutral species reactions in the plasma volume.

8.6.8 Treatment in Hydrogen–Argon Gaseous Mixtures

Also, this particular study was carried out using the experimental setup shown in Figure 3.2 in Chapter 3.1 and described in detail at the beginning of this chapter. The iron model samples of dimensions $50 \times 20 \times 1$ mm^3 were made from the same iron sheet as before. Samples were washed in the Star50 solution and in technical ethanol and dried at ambient air. Subsequently, they were corroded naturally in Technosoil (Soil texture: sandy loam (sand 2–0.05 mm, 66.4%; silt 0.05–0.002 mm, 22.2%; clay < 0.002 mm, 11.4%)) for 24 months at local climate (49°13'54.258"N, 16°34'40.393"E, Brno, Czech Republic).

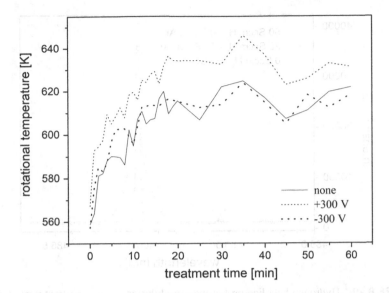

FIGURE 8.48 OH rotational temperature during the plasma treatment at different bias application.

The plasma treatment was carried out at 100 W, 200 W and 300 W applied powers in the continuous regime. Various hydrogen–argon mixtures keeping the same mixture mass flow rate of 50 Sccm for 3 h were used in this study. The plasma process was monitored by the Ocean Optics HR4000 spectrometer, and simultaneously, the atomic hydrogen beta line spectrum was recorded by the Jobin Yvon Triax 500 spectrometer. Here, the 3600 gr/mm grating was used to be able to observe the hydrogen line profile. The liquid nitrogen back-illuminated 1024 × 256 pixel detector was used as a detector. The sample temperature during the plasma treatment was measured by the Optocon thermometer probe mounted at the sample surface by a thin aluminum band. This device has measured temperature by changes of optical crystal frequency. The data transfer from the probe to the measuring unit is by the optical fiber, thus data are not distorted by the radiofrequency field creating the plasma.

The analyses of corrosion layers were examined by XRD spectrometry using PANAnalytical Empyrean SRD spectrometer with Pixel 3D detector immediately after the plasma treatment to avoid secondary oxidative processes. As the soil is in principle non-homogeneous, the surface layers of corrosion products with soil incrustations were removed from the sample by a dish sponge and homogenized by grinding in the agate vessel. The second sample was obtained from inner corrosion layers and the third one was obtained just at the sample metallic core surface.

The results presented here are from the series obtained at applied power of 300 W but similar data were obtained also at lower applied powers.

Figure 8.49 shows the atomic hydrogen beta line (at 486 nm) profile measured using three selected gaseous mixtures. It can be seen that the line intensity in pure hydrogen is much smaller than in the other cases. This reflects the fact that the

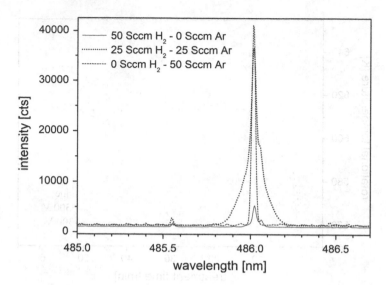

FIGURE 8.49 Hydrogen beta line profile measured during the plasma treatment at 300 W at the three selected hydrogen–argon gaseous mixture compositions.

dissociation degree of molecular hydrogen is significantly smaller. Also, the intensity of the secondary peak on the H-beta line right side is relatively high. This peak belongs to one of the rotational transitions of hydrogen molecule and thus reflects the excitation of the neutral molecular hydrogen molecule. In case of the hydrogen–argon mixture (50%:50%), the atomic hydrogen line has much higher intensity with respect to the molecular hydrogen rotational line that reflects a higher dissociation degree. Additionally, a much broader line profile is well visible, too. This line broadening is mainly due to the internal electric field in plasma that reflects the concentration of charged particle, i.e., the degree of plasma ionization (Xiong et al., 2012, Cvetanović et al., 2018). The presence of atomic hydrogen line also in pure argon plasma is due to the hydrogen coming from the corrosion product layers. In that case, the line is very narrow, so the dissociation degree is not so high and also there is no remarkable emission related to the molecular hydrogen.

The OH radical integral intensities are presented in Figure 8.50. The OH radical intensity as the monitoring parameter of the plasma treatment process shows the same shape during the time as it was described couple of times before. Interesting is that the OH radical intensity increases with the increase of argon concentration in the reactive mixture. This is related to the higher intensity of atomic hydrogen (see Figure 8.49) and thus it seems to be beneficial to use the argon rich gaseous mixtures. But the sample temperature also significantly increases with the increase of argon concentration as it is shown in Figure 8.51. This increase at given conditions is not critical for the treated iron but it must be carefully considered if metals with low melting temperature are presented in the object (like tin in bronze, see Chapter 3.1).

The XRD analyses show typical materials from the surrounding soil in all three selected layers. The presence of iron containing compounds is the most important

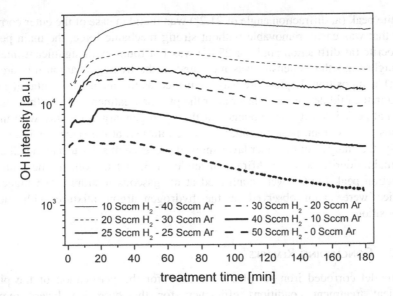

FIGURE 8.50 OH radical intensity as a monitoring parameter of the corrosion removal process carried out in different hydrogen–argon gaseous mixtures.

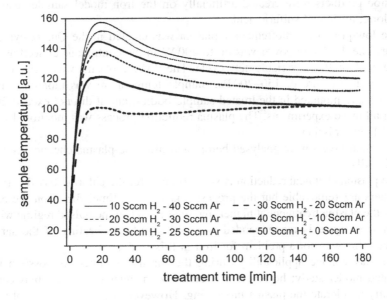

FIGURE 8.51 Sample temperature during the plasma treatment in different hydrogen–argon gaseous mixtures.

with respect to the iron corrosion products removal. The goethite (α-FeOOH), lepidocrite (γ-FeO(OH)) and siderite ($FeCO_3$) diffraction peaks were identified in the spectra together with iron in the inner sample. Their presence was dependent on the analysed layers as well as on the plasma treatment conditions. Only the main

goethite peak (at diffraction angle of 21.2°) was found in case of the outer corrosion layer that was easily removable without strong mechanic force, the main peak of lepidocrite (at diffraction angle of 27.8°) was not found with significant intensity. The highest goethite intensity was measured at the hydrogen–argon mixture with the 1:1 composition. Lepidocrite was confirmed as the main iron containing compound in the middle corrosion layer after the plasma treatment. Also at this case, the maximal peak intensity was obtained at the hydrogen–argon mixture with the 1:1 composition. A small peak for siderite was confirmed at the same conditions, too. Finally, the analysis of the inner layer showed presence of siderite and metallic iron. The main siderite peak (at diffraction angle of 32.0°) as well as the main iron diffraction peak (44.6°) were confirmed at all gaseous mixtures. The highest intensities were again observed at the hydrogen–argon mixture with the 1:1 composition.

8.6.9 Concluding Remarks

The model corroded iron samples were used for the verification of the plasma chemical treatment conditions efficiency for the corrosion layers removal. Archaeological objects made of iron are the most common artifacts, and the typical corrosion products on iron are akaganeite, rokuhnite and szomolnokite. These three corrosion products were created artificially on the iron model samples using hydrochloric, nitric and sulfuric acids.

The low-pressure radiofrequency plasma was created in the Quartz cylindrical reactor. The discharge power was up to 400 W in the continuous as well as in the pulsed mode with the variable duty cycle. The flowing plasma was created in pure hydrogen at pressure of 150–200 Pa. Sample temperature was monitored by the thermocouple mounted in the treated sample bodies, and it did not exceed 200 °C during all these experiments. The plasma reduction process was monitored via OH radical light emission.

Corrosion layers were analysed before and after the plasma chemical reduction by SEM-EDX.

The plasma chemical reduction is very efficient for the chlorine-based corrosion, the others are removable but the process takes longer time. Based on the experiments, the plasma treatment at higher maximal power in the pulsed regime with the shorter duty cycle is recommended to avoid significant heating of the samples; however, this was not a problem for iron in this study.

The bias voltage applicability during the plasma treatment is possible in the presented model study; however, in systems with inner electrodes, bias can significantly accelerate the plasma processing. However at any case, the real sample temperature must be carefully controlled.

Based on the gas composition study, we can conclude that the most effective corrosion layer removal process is if the hydrogen–argon mixture with the mass composition around 1:1 is used. The process is significantly faster than in the pure hydrogen and also temperature of the treated object is not so much elevated.

8.7 CS7: TREATMENT OF BRONZE CHISEL BY LOW-PRESSURE HYDROGEN–ARGON PLASMA

The bronze made wooden chisel (see Figure 8.52) discovered in the surrounding of the city Boskovice (Czech Republic, 49.4875122 N, 16.6599706E) without any relevant documentation was obtained from the collection of the Technical Museum in Brno. The chisel surface was covered by a thick layer of corrosion products with incrustations. Some parts were dark brown up to black, others were dark green. At some spots, green blisters were visible, too. The initial analysis by the hand XRF analyser confirmed that the chisel was made of bronze. The chisel was cut into four parts marked in Figure 8.52. The detailed analysis using SEM-EDX was employed for the reference part at ten different spots with the size of $25 \times 25 \ \mu m^2$. Element composition of the chisel surface is given in Table 8.8.

The plasma treatment was carried out using the experimental device described in Section 8.6. Each part of the chisel was treated for 90 min separately, part I once, part II twice, and part III thrice. The samples were not taken from the plasma device, and, thus, no intermediate cleaning between the plasma treatments was completed. The interruption between the plasma cycles was 2 h. The treatment proceeded in the pulsed regime with maximal power set to 300 W. Maximal allowed temperature was set to 120 °C to avoid tin evaporation during the plasma treatment (see Chapter 3.1). An example of the sample temperature and effective power during the plasma treatment is shown in Figure 8.53. The hydrogen (30 sccm) and argon (20 Sccm) gas mixture in the flowing regime was used as optimal (details see in Řádková et al., 2016).

The dependencies of OH radical spectrum intensity as the plasma process monitoring parameter are depicted in Figures 8.54–8.56 for each treated part

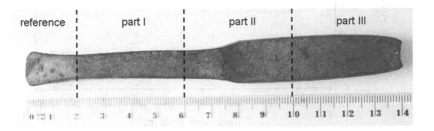

FIGURE 8.52 Bronze chisel used for this study with the marked parts.

TABLE 8.8
Element composition of the chisel surface

Element	Al	C	Ca	Cu	Fe	K	Mg	O	P	Si	Sn
Mass%	5.6	13.4	4.3	7.4	3.1	3.0	0.9	41.8	1.1	17.9	1.5

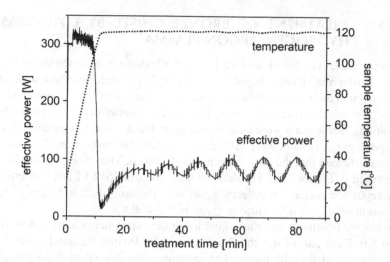

FIGURE 8.53 Temperature and effective applied power during the plasma treatment of Part I.

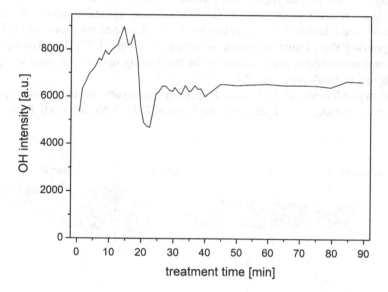

FIGURE 8.54 OH radical intensity as a plasma treatment process monitoring parameter during the treatment of part I.

separately. In all cases, the initial increase of OH intensity is visible and high emission (i.e., high OH production rate) is visible during the first 20 min of each treatment. This reflects an efficient removal of oxygen adsorbed at the surface and oxygen built in the corrosion layers. It must be noted that the effective power applied into the system significantly drops down after about 10 min from the beginning because the sample temperature is achieved close to the pre-set maximal

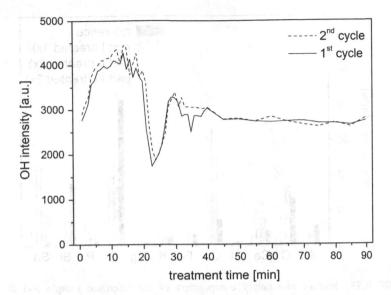

FIGURE 8.55 OH radical intensity as a plasma treatment process monitoring parameter during the treatment of part II.

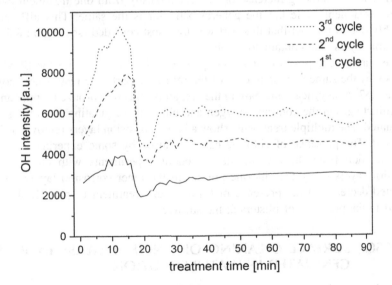

FIGURE 8.56 OH radical intensity as a plasma treatment process monitoring parameter during the treatment of part III.

allowed limit of 120 °C. A great difference among the treatment of different parts of the same object is remarkable. Although the OH intensity during the part I treatment has a high value, in the treatment of the part II, it reaches only about one-half of it, and both treatments of this part show more or less the same values. The treatment of

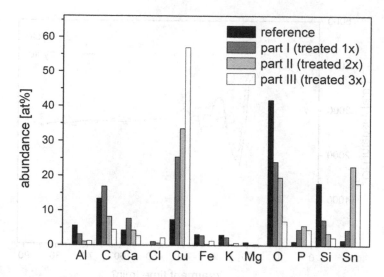

FIGURE 8.57 Surface elementary composition of the reference sample and the parts treated by the plasma.

part III shows a striking increase of the OH intensity from one treatment cycle to another treatment cycle but the general behavior is the same. This difference is probably due to the fact that this part was the most corroded (see Figure 8.52) and corrosion layers also contain some blisters.

The surface composition of all samples was determined using the SEM-EDX analysis by the same way as in case of the reference part. The results are shown in Figure 8.57. A significant increase in the elements related to bronze (copper and tin) is dominating. On the contrary, oxygen and elements originating from the soil are eliminated. The multiple treatments show a better corrosion layers removal as it was expected. The presence of chlorine can be caused by some experimental device contamination from the sets of the precedent experiments with chlorine-based corrosion layers or by the chlorine present in the inner corrosion layers. The unexpected decrease in the presence of tin after the treatment of part III should be related to the presence of blisters at the surface.

8.8 CS8: SURFACE CLEANING OF ANCIENT GLASS BY PLASMA GENERATED IN WATER SOLUTION

The application of plasma in combination with liquids for the surface cleaning of ancient glass is a new perspective direction in this material conservation/restoration. Currently, there are only a few studies available in this field (Hlochová et al., 2016). This study shows the first part of the results obtained by our research team using a specially designed electrode system for plasma generation in liquids (Krčma, 2015, Krčma, 2019).

The glass sample was discovered during the emergency excavation in the field of former Vlnena Company in Brno (Czech Republic, 49.18876 N, 16.61840E) in 2017. The whole artifact is shown in Figure 8.58.

FIGURE 8.58 Glass sample used for the presented study.

According to the excavation stratigraphy, this sample was made during the end of the eighteenth or the beginning of the nineteenth century. One-half of the sample was cut into six parts (each of them with an area of about 2 cm^2) that were used for the current study; the second half was kept for another experiment.

The plasma treatment was carried out according to the scheme shown in Figure 8.59. The specially designed handy movable electrode system (shown in Figure 8.60, practical realization is demonstrated in Figure 8.61) was immersed into the K$_2$CO$_3$ water solution in the glass vessel with dimensions 16 × 10 × 10.2 cm^3. The grounded polished stainless steel electrode was installed at the glass vessel wall. The ground from the specially designed laboratory power supply (Lifetech, 700 W) was connected through the capacitance $C = 961$ nF that was used together with the

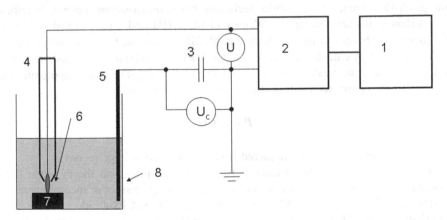

FIGURE 8.59 Scheme of the experimental setup. 1 – audio-frequency power supply, 2 – high voltage transformer, 3 – capacitor, 4 – movable high voltage electrode system (see Figs. 8.60 and 8.61), 5 – grounded stainless steel electrode, 6 – plasma, 7 – treated sample, 8 – glass vessel with water solution.

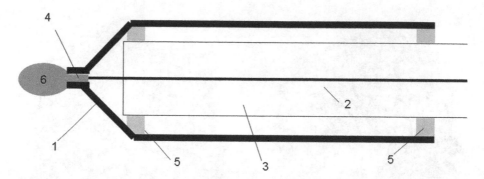

FIGURE 8.60 Scheme of the used electrode system and its realization. 1 – head of the electrode system with the pin-hole, 2 – tungsten wire (diameter of 0.5 mm), 3 – Quartz capillary, 4 – open space filled by liquid, 5 – silicone gland, 6 – plasma in the gaseous bubble.

FIGURE 8.61 Used electrode system (left) and generated plasma in water solution (right).

high voltage probe (Tektronix P6015A) for the measurement of energy dissipated into the electrode system. The evaluation technique based on Lissajous pictures described for dielectric barrier discharges (Wagner et al, 2003) and later adapted for high-frequency discharges in liquids (Krčma et al, 2015) was used for the energy calculation. The energy calculation is based on the chart of both high voltage and voltage at known ballast capacitance C as it is shown in Figure 8.62. The area is approximated by the parallelogram with area A. Energy P is calculated as

$$P = A \cdot f \cdot C$$

where f is frequency directly measured from the applied voltage record.

In order to check if the distance between the grounded and the movable high voltage electrode system influences the dissipated energy, the set of measurements at distances of 2.5, 7.5, 9, and 13 cm was carried out in NaCl solution with the conductivity of 205 µS/cm; the operating power supply frequency was (16780 ± 30) Hz. As the discharge character is random (see later), each experiment was repeated five times. The calculated energy was 24 W at all distances with the uncertainty around 1 W.

FIGURE 8.62 Chart for the dissipated energy calculation. Points represent the measured data.

The discharge itself is created in microbubbles according to the bubble theory of the discharge ignition (see Chapter 3.4). The bubbles are dynamic as it is demonstrated in Figure 8.63. These images were taken from the i-SPEED ultrafast camera movie (objective NIKON AD, AF MICRO NIKKOR 200 mm with aperture f/16). The system was illuminated by the high illuminance reflector with the lens of 15°. The acquisition rate was 10,000 frames per second, and single image exposure time was 0.01 ms. It is well visible from Figure 8.63 that the discharge is operating inside the bubble that propagates into the capillary as well as into the open solution. This ensures the direct contact of plasma with the treated surface. The bubble cavitation is a very fast process that leads to the generation of mechanic waves (for a better demonstration of shock waves, see Krčma et al., 2018).

The presented experiment shows the surface treatment dependence on the solution conductivity. The surface corrosion layers and other surface contamination should be mainly oxidized and consequently dissolved in the solution. The most common salt used for the solution conductivity adjustment is NaCl. But atomic chlorine that is produced by electrolysis at the anode is strongly oxidative and can damage the glass surface if the anode is close to the surface. Due to this fact, we chose less reactive inorganic salt K_2CO_3 for the solution conductivity adjustment. Moreover, this compound was frequently used during history as an additive in glass production (Eitel, 1975, Fanderlík, 1991). The solution conductivity was changed in an interval of 400–900 μS/cm. The discharge was operating at the fixed frequency of $(16{,}780 \pm 30)$ Hz, dissipated power was (23.0 ± 1.5) W. The area of approximately 10 mm in diameter was treated for 10 min. The high voltage electrode system was hand-moved about 1 mm above the surface to ensure good contact between the plasma and the sample surface.

FIGURE 8.63 Series of discharge images showing discharge bubble formation and propagation.

Surface analyses of samples were carried out using laser ablation inductively coupled plasma mass spectrometry (LA-ICP-MS). The excimer laser ablation system Analyte Exite + (Teledyne, Photon machine) with an ArF* excimer laser operating at 193 nm is equipped with a tunable two-volume ablation cell HelEx II enabling fast transport of an ablated material into the ionization source. Ablation was conducted in the He atmosphere, set to a constant flow of 0.8 L.min^{-1} in total. The carrier gas was mixed with Ar gas (1 L.min^{-1}) prior to the ICP source of a quadrupole ICP-MS Agilent 7900 (Agilent technologies). ICP ionization source was operating at RF power of 1550 W and argon flow of 15 L.min^{-1}. Optimization of LA-ICP-MS parameters was performed with the glass reference material NIST

SRM 612 with respect to the maximum signal sensitivity, and minimal doubly charged ions and oxides formation. The potential interferences were minimized via a collision cell (He 1 mL.min^{-1}).

Signal of isotopes of interest was investigated by line scanning (see Figure 8.64) using a laser beam spot diameter of 150 μm (square) within the sample area 150 × 150 μm^2 (variable related to the area of interest), approximately. The scan speed of 50 μm.s^{-1}, fluence of 3 J.cm^{-2} and frequency of 10 Hz were kept constant.

The NIST 612 and 610 standards were used for quantification. Preselected elements (see later in Table 8.9) were finally recalculated to their oxides and represent 99% of the whole sample, the rest 1% belongs to elements such as hydrogen, barium, cobalt, fluorine, and lanthanides.

Sample 1 was treated in the solution with initial conductivity of 400 μS/cm. Conductivity was increased to 405 μS/cm, only. The samples before and after the treatment are shown in Figure 8.65.

The surface cleaning was visible since the fifth minute, no remarkable changes were visible at the treatment beginning. The treatment was not so effective (see analyses in Table 8.9), this also reflects only a small increase in solution conductivity.

Sample 2 was treated in the solution with initial conductivity of 500 μS/cm. Conductivity was increased to 516 μS/cm after the treatment. The samples before and after the treatment are shown in Figure 8.66.

The surface cleaning was visible since the third minute. Two separate surface analyses were carried out. The first one was completed at the clean glass surface (analysis 2-g), the second one was done at the surface that was covered by a white layer after the treatment (analysis 2-w). The first analyzed part showed better cleaning than in the first sample. The second one showed a completely different surface composition and we suppose that this part of the sample was originally covered by some color décor.

FIGURE 8.64 Laser ablation scan over one of the analyzed samples. The distance between the neighbor lines is 15 μm (optical microscope LCD MIKRO 5MP, BRESSER).

TABLE 8.9
Surface composition of samples

				mass.%			
	$Li_2O \cdot 10^{-3}$	B_2O_3	$CO_2 \cdot 10^{-3}$	Na_2O	MgO	Al_2O_3	SiO_2
1	2.11	0.034	0.76	0.219	1.47	4.02	81.82
2-g	2.54	0.045	0.99	0.285	2.04	3.76	78.00
2-w	0.02	0.005	0.75	0.040	0.18	5.37	88.00
3	2.87	0.041	0.70	0.304	2.23	4.77	74.95
4	0.03	0.019	1.75	0.196	0.28	7.07	84.88
5	2.66	0.045	1.41	0.294	2.20	4.38	76.90
reference bulk	0.09	0.075	1.97	0.800	0.27	5.80	88.84

				mass.%			
	P_2O_5	SO_3	Cl	K_2O	$CaO \cdot 10^{-3}$	TiO_2	$Cr_2O_3 \cdot 10^{-3}$
1	0.86	0.31	0.029	9.23	1.13	0.272	3.65
2-g	0.98	0.43	0.016	12.49	1.43	0.178	1.62
2-w	0.08	0.23	0.061	4.37	0.18	0.154	2.01
3	0.92	0.65	0.034	13.96	1.51	0.131	1.52
4	0.10	1.03	0.068	3.90	0.78	0.186	2.74
5	0.89	0.36	0.033	12.93	1.50	0.176	1.63
reference bulk	0.18	0.58	0.037	1.01	0.21	0.213	4.03

				mass.%		
	MnO_2	FeO	$NiO \cdot 10^{-3}$	$CuO \cdot 10^{-2}$	ZnO	$MoO_3 \cdot 10^{-5}$
1	0.22	0.41	1.59	1.61	0.0800	7.51
2-g	0.29	0.43	1.76	1.18	0.0490	8.43
2-w	0.01	0.44	1.35	2.96	0.0264	1.82
3	0.31	0.63	3.72	2.65	0.0403	7.73
4	0.06	1.04	7.90	9.97	0.0589	3.66
5	0.30	0.43	1.68	1.05	0.0381	7.98
reference bulk	0.01	1.06	5.46	4.72	0.0741	5.41

Sample 3 was treated in the solution with initial conductivity of 600 μS/cm. Conductivity was increased to 635 μS/cm after the treatment. The samples before and after the treatment are shown in Figure 8.67.

The surface cleaning was visible since the fourth minute. Cleaning efficiency was well visible by the naked eye and this result was also confirmed by the elementary analysis (see Table 8.9). Solution after the treatment was also exposed to the additional discharge (using the same settings as during the treatment) and optical emission spectrum was collected (see later).

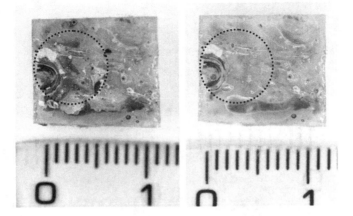

FIGURE 8.65 Glass sample treated in the solution with initial conductivity of 400 μS/cm. The treated area is marked by a circle.

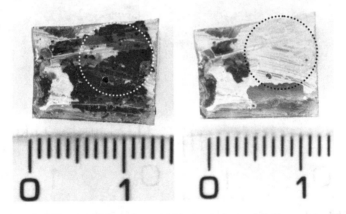

FIGURE 8.66 Glass sample treated in the solution with initial conductivity of 500 μS/cm. The treated area is marked by a circle.

Sample 4 was treated in the solution with initial conductivity of 800 μS/cm. Conductivity was increased to 839 μS/cm after the treatment. The samples before and after the treatment are shown in Figure 8.68.

The surface cleaning was visible after the first minute. The corrosion products were removed from the surface after the first minute of the treatment. This sample was rather inhomogeneous and thus the results of the surface analysis are significantly different from the others.

The last sample, sample 5, was treated in the solution with initial conductivity of 900 μS/cm. Conductivity was increased to 962 μS/cm after the treatment. The samples before and after the treatment are shown in Figure 8.69.

The surface cleaning was visible just after the beginning. The surface cleaning was generally good as it is visible from the picture as well as from the analysis.

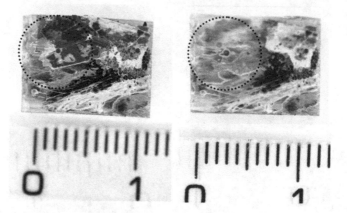

FIGURE 8.67 Glass sample treated in the solution with initial conductivity of 600 μS/cm. The treated area is marked by a circle.

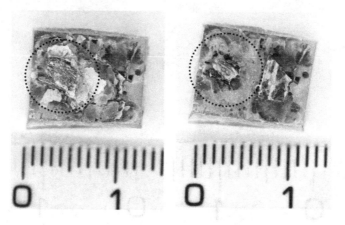

FIGURE 8.68 Glass sample treated in the solution with initial conductivity of 800 μS/cm. The treated area is marked by a circle.

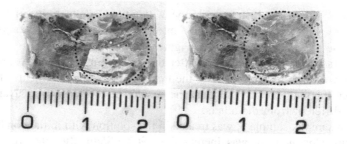

FIGURE 8.69 Glass sample treated in the solution with initial conductivity of 900 μS/cm. The treated area is marked by a circle.

The discharge in the solution with initial conductivity of 600 µS/cm was also studied by optical emission spectrometry. The emitted light was led to the multi-mode optical fiber using the quartz lens with a focal length of 100 mm, fiber input was at the focus, i.e., the whole discharge volume was analyzed. The other end of the fiber was mounted to the Jobin Yvon Triax 550 spectrometer with the liquid nitrogen cooled CCD detector (back-illuminated, 1026×256 pixels, UV enhanced). Emission spectra were recorded using the 1200 gr/mm ruled diffraction grating with the entrance slit of 0.03 mm and integration time of 30 s that ensured elimination of the discharge instabilities.

The spectra are shown in Figure 8.70. The characteristic of species for the discharges in water solutions such as molecular band of OH radical and hydrogen and oxygen atomic lines is well visible in both spectra. Also, the potassium lines are presented. The presence of sodium lines at 588 and 589 nm is probably due to the reactor contamination from another experiment where NaCl was used for the conductivity adjustment. The spectrum of the solution after the sample treatment also contains a few lines that are probably titanium. Comparing this result with the surface composition shown in Table 8.9, this is very probable because titanium was significantly removed from the sample surface. The presence of other atomic lines related to the surface contaminants was not detected at this pilot experiment. The full used solution examination will be performed by the ICP-OES technique that allows the determination of nearly all periodic table elements with the appropriate sensitivity.

Based on the experimental results, we can conclude that the application of the electrical discharge generated directly in the liquid can be a promising way for the surface cleaning of ancient glass. The equipment is not so complicated (and thus not so expensive, too) and good cleaning results can be achieved without any damage to the fragile ancient object. The surface analyses showed successful removal of elements presented at the surface from the surrounding environment and the increase of compounds related to the bulk material. The best results were achieved at solution conductivity in the range of 600–900 µS/cm. The treatment at lower conductivities is not so efficient because of lower plasma reactivity. On the

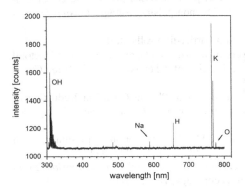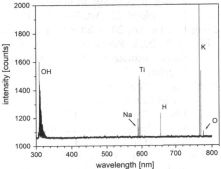

FIGURE 8.70 Optical emission spectra of the discharge in fresh (left) and used (right) solution with initial conductivity of 600 µS/cm.

contrary, higher solution conductivities can lead to stronger shock wave generation that can damage the treated object.

The separate studies are prepared for the application of other water solutions as well as the determination of effects of different applied powers and treatment times.

REFERENCES

Boselli, M., 2016. Atmospheric pressure non-equilibrium plasma cleaning of 19th century daguerreotypes. Diploma thesis, Department of Industrial Engineering, University of Bologna, Bologna, Italy.

Cvetanović, N., Galmiz, O., Synek, P., Zemánek, M., Brablec, A., Hoder, T., 2018. Electron density in surface barrier discharge emerging at argon/water interface: quantification for streamers and leaders. *Plasma Sources Sci. Technol.* 27, 025002.

Eitel, W., 1975. *Silicate Science*, Academic Press, New York, London, ISBN: 0-12-236306-X.

Fanderlík, I., 1991. *Silica Grall and its Application*, Elsevier, Amsterdam, New York, ISBN: 0-444-98755-X.

Grešová, D., 2019. Stability of photos taken by cyanotype technique. Diploma thesis. Slovak University of Technology, Bratislava (in Slovak).

Haberová, K., 2020. Influence of plasma on the stability of layers of historical photographs, Dissertation thesis. Slovak University of Technology, Bratislava (in Slovak).

Hlochová, L., Graham, W.G., Janová, D., and Krčma, F., 2016. Treatment of the Glass Archaeological Artefacts by Underwater Discharge, in International Symposium on High-Pressure Low-Temperature Plasma Chemistry (HAKONE XV) with joint COST TD1208 Workshop Non-Equilibrium Plasmas with Liquids for Water and Surface Treatments: Book of Contributed Papers, Masaryk University, Brno, pp. 392–395.

Koperska, M. A. et al., 2014. Degradation markers of fibroin in silk through infrared spectroscopy. *Polym. Degrad. Stab.* 105 (1), 185–196.

Krčma F., Jun. 10, 2015. Jet System for Plasma Generation in Liquids. Czech Republic patent CZ 305304 B6.

Krčma, F., 2019. Jet System for Plasma Generation in Liquids. EU patent, EP 3122161B1, 2019 Oct 23.

Krčma, F., Kozáková, Z., Vašíček, M., 2015. Generation of high frequency pin-hole discharge in water solutions. *Open Chem.* 13, 620–628.

Krčma, F., Kozáková, Z., Mazánková, V., Horák, J., Dostál, L., Obradovic, B, Nikiforov, A., Belmonte, T., 2018. Characterization of novel pin-hole based plasma source for generation of discharge in liquids supplied by DC non-pulsing voltage. *Plasma Sources Sci. Technol.* 27, Art. No. 065001.

Long Life for Art, 2020. https://llfa.eu/aluminium-barrier-film-rolls.html

Miková, P., 2019. Removal of corrosion layers of bronze by plasma technology. Doctoral thesis, Institute of Physical Chemistry, Faculty of Chemistry, VUT Brno, Czech Republic.

Řádková, L., Fojtíková, P., Přikryl, R., Krčma, F., 2016. Plasma Chemical Reduction of Model Corrosion Brass Layer Prepared in Soil, *European Physical Journal – Applied Physics* 75, Art. No. 24717.

Rašková, Z., Krčma, F., Klíma, M., Kousal, J., 2002. Characterization of plasmachemical treatment of archaeological artifacts. *Czech. J. Phys.* 52 (E), 927–932.

Sázavská, V., 2013. *Preparation and plasma chemical reduction of model corrosion layers on Iron*, PhD thesis, Brno University of Technology, Brno, Czechia.

Sterflinger, K., 2010. Fungi: Their role in deterioration of cultural heritage. *Fungal Biol. Rev.* 24 (1–2), 47e55. https://doi.org/10.1016/j.fbr.2010.03.003.

Tiňo, R., Vizárová, K., Hajdu, F., 2017. Cleaning of natural materials with atmospheric low temperature plasma. Emerging Technology and Innovation for Cultural Heritage (ETICH), 5th International Seminar and Workshop. 13–14 September 2017, Sibiu, September 12-14, 2017. Horia Hulubei National Institute of Physics and Nuclear Engineering, Măgurele, Ilfov, pp. 21--22. ISBN 978-973-668-463-0.

Tiňo, R., Vizárová, K., Reháková, M., 2018. Utilization of Low-Temperature Plasma in Preservation of Cultural Heritage. 5th International Congress on Chemistry for Cultural Heritage 2018, ChemCH2018, 3-7 July, Muzeul National al Literaturii Romane, Bucharest. Bucuresti, s. 108--109. ISBN 978-973-167-463-6.

Tiňo, R., Vizárová, K., Krčma, F. 2019. Nanotechnologies and nanomaterials for diagnostic, conservation and restoration of cultural heritage. In: Lazzara, G., Fakhrullin, R. (Eds.), *Chapter 11: Plasma Surface Cleaning of Cultural Heritage Objects*, pp. 239–275, eBook ISBN: 9780128139110, Paperback ISBN: 9780128139103, Imprint: Elsevier.

Vizárová, K., Kaliňáková, B., Tiňo, R., Vajová, I., Čížová, K. 2020. Microbial decontamination of lignocellulosic materials with low-temperature atmospheric plasmaISSN 1296-2074, https://doi.org/10.1016/j.culher.2020.09.016. Available on-line 5th November 2020 https://www.sciencedirect.com/science/article/pii/S1296207420304684.

Vizárová, K., Kaliňáková, B., Vajová, I., Tiňo, R., Hajdu, F., Špacírová, Z., Lalíková, N., 2018. Microbial decontamination of paper with low- temperature atmospheric plasma. In 5th International Congress on Chemistry for Cultural Heritage 2018, Book of Abstracts. Bucuresti: Muzeul National al Literaturii Romane, Bucharest, 2018, pp. 238–239. ISBN 978-973-167-463-6.973-668-463-0.

Wagner, H.E., Brandenburg, R., Kozlov, K.V., Sonnenfeld, A., Michel, P., and Behnke, J.F., 2003. The barrier discharge: basic properties and applications to surface treatment. *Vacuum* 71, 417–436.

Waseda, Y., Suzuki, S., 2006. *Advances in Materials Research: Characterization of Corrosion Products on Steel Surfaces*. Springer Berlin Heidelberg, New York, ISBN 3-3540-35177-9.

Xiong, Q., Nikiforov, A.Y., González, M.Á., Leys, C., Lu, X.P., 2012. Characterization of an atmospheric helium plasma jet by relative and absolute optical emission spectroscopy. *Plasma Sources Sci. Technol.* 22, 015011.

Subject Index

A

ablation, 9, 4, 25–26, 31, 39, 41, 44–45, 48, 61, 86, 136, 140
abrasion, 65, 71
absorbance, 99
absorption, 13, 62, 100–101, 103
accessibility, 36, 40, 133
accumulation, 47, 64, 67
acetate, 9, 66
acid, 13–14, 47, 64, 66–67, 71, 89, 96, 103, 105–106, 110, 112–123, 125–126, 130
 cyanide, 67, 71, 83
 dipicolinic, 47
 HCl, 13, 56, 103, 108–109
 HNO3, 110
action, 8, 10, 25, 34, 44, 49, 56, 61, 71, 80, 87, 92, 94
activation, 9, 32, 39–40, 45, 48–49, 51, 56, 61–62, 68, 73, 85–86, 99
 plasma functionalization, 48
active particles, 12, 16, 23, 59, 115
activity, 4–5, 8, 48, 86
adhesion, 4–6, 8, 40, 43, 48–49, 59–60, 62, 64–67, 73, 76–78, 86, 92–95
adsorption, 9, 38, 46, 114, 119, 131
ageing, 1, 3, 7, 62, 73–76, 79, 96–98
albumen, 60, 69–70, 72–74
alcohol, 6, 66, 69
 benzyl alcohol, 66
aldehydes, 66
algae, 70
alkaline, 8, 27, 31, 67
amide, 100
amines, 56, 66
ammonium, 48, 67
amphiphilic, 7
ancient, 7, 27–30, 39–41, 57, 81–82, 103, 132, 142
angle, 44, 74, 128
anode, 136
antibacterial, 73
arc, 23, 35, 37, 49
 cascading, 23
archival documents, 3, 82, 89
artifacts, 1, 3, 27, 39–41, 57, 59–60, 63, 67–68, 86, 89, 129
atmosphere, 3, 7, 11–14, 23–25, 28, 31, 33, 35–36, 43, 45–48, 55, 60–62, 68, 71–73, 75–78, 85–87, 89–92, 94, 96–100, 136

air, 3, 11–14, 19, 30–32, 35, 43, 46, 50, 62, 64, 67–70, 73–76, 81, 89–92, 94, 96–100, 103, 107, 119, 122, 124
 Argon Ar, 14, 23, 25, 38, 43, 48, 51, 62, 68–69, 74, 128, 131
 argon-hydrogen, 24–25, 71
 argon–oxygen, 24
 Helium He, 23, 35, 136, 145
 Neon Ne, 71
 Nitrogen N2, 3, 14, 18–20, 43, 46, 48–49, 56, 60–62, 64, 66, 73, 75–76, 91, 96–98, 124, 140
 Oxygen O2, 75, 96
 Ozone O3, 3, 32, 40, 44, 64–65
ATR-FTIR, 62, 91, 99–100
audio-frequency, 23, 137

B

beam, 26, 31, 67, 86, 99–100, 136
binder, 3–5, 49, 59, 69–70, 75, 67, 91
biocides, 67
 boron, 67
 phenol, 67
biodegradability, 7, 62, 67
biodeterioration, 10, 80–81, 86–87, 89
bio-films, 46
biomacromolecules, 45, 62
bleaching, 8, 57, 70
bleeding, 6
bombardment, 14, 46, 48, 122–123
bond, 6, 43–44, 46–49, 59, 64–67, 74, 100
 C–C, 44
 C-H, 44, 48
 C–O, 44
 covalent, 48
book, 3, 59–60, 70, 73, 86–87, 89
brush, 6, 18, 65, 92–93, 112, 119
bubble, 28–31
 cavitation, 135
butanol, 72–74

C

canvas, 4, 76, 78
capacitance, 16, 22, 32, 39, 107, 133
capacitor, 1, 16, 32
capillary, 7, 23, 25, 28, 49
carbon, 4, 27, 44, 49, 62, 73, 76

147

cathode, 4
cell, 40, 46–47, 61, 136
 metabolism, 46
cellulose, 9–10, 59–61, 69, 72, 76, 84, 89, 94
ceramic, 3, 11, 27, 29, 33, 43, 103, 105–106
CFU, 91–92
chamber, 11–15, 17–19, 75–76, 96–98
charge, 11, 45–47, 94, 128, 136
chemistry, 25, 29, 36–37, 41, 50, 82, 84
 analytical, 25, 80, 83
chisel, 131–132
chitosan, 61
chlorine, 26, 31, 36, 53, 55–57, 65, 67, 77, 103,
 107, 112, 114–115, 117, 121, 130, 132
clay, 6, 124
cleaner, 43, 45, 65, 91–94
cleaning, 1, 3, 5–11, 25–27, 29–30, 36–37, 40–41,
 43–45, 48, 51, 53–54, 56–57, 59–73,
 75–80, 82–86, 91–94, 99–100, 102,
 105, 131–132
 aqueous, 6–8, 10, 39, 60, 70
 over-cleaning, 63
cleavage, 65
coating, 9, 48–49, 65, 68, 71, 78, 85–87, 92–93
cold-plasma, 11–13, 33, 44, 46–48, 56, 72–73, 77
color, 5, 7, 9, 18, 26, 55, 60, 69–76, 82, 86, 91,
 103, 96–97, 104
 azure, 55
 black, 4, 27, 36, 40, 50, 55, 62, 70, 73, 75, 81,
 83, 93, 95, 105, 107, 131
 black-gay, 55
 black-green, 55
 black–white, 75–76
 blue, 37, 55, 70, 91, 96–97, 99
 blue-black, 55
 blue-green, 55
 bluish-green, 55
 brown-red, 55
 brown, 67, 131
 cyan, 91
 cyan-blue, 96
 green, 55, 131
 green-black, 55
 grey, 20, 55, 97, 107
 grey-white, 55
 lampblack, 91–95
 pink, 77
 pink smudge, 77
 red, 55, 75, 77, 105
 violet-red, 55
 watercolor, 78, 83, 91–94
 yellow, 55
 yellowing, 5, 74
 yellowness, 60
 ΔE, 73–75, 98
colorimetry, 75, 98–99

composite, 40, 59
compounds, 3, 7, 21–22, 27, 45–46, 53, 56, 67, 72,
 77, 86–87, 103, 128
concentration, 7, 14, 16, 23, 56, 67, 91, 95, 112,
 115, 128
conditions, 1, 7, 11, 16–17, 22–25, 27–28, 30–31,
 41, 46, 50, 56–67, 61–63, 68, 70, 85,
 89–90, 92–96, 98–2, 107, 112, 115,
 117, 119, 122, 128–129
conductivity, 15–16, 22, 28, 31, 14, 38–40, 42–44
configuration, 27–30, 32–33, 122
coplanar, 32, 39, 51
conservation, 1, 5–6, 9, 24, 27, 45, 54, 60, 62–63,
 68, 70–72, 78, 85–86, 132
conservator, 5, 60, 63
consolidants, 67, 83
contaminants, 1, 3, 9, 14, 43–45, 48–49, 59, 10, 4
contamination, 3–5, 15, 48, 54, 60–61, 66, 69, 72,
 76, 81, 83, 87, 89, 99, 132
controller, 13–14, 7
corrosion, 4, 7–8, 13–14, 18, 22–28, 53–56, 65,
 67, 71–72, 77, 86, 99, 101–103,
 105–106, 108–132
 Atacamite, 55
 Aubertite, 55
 Azurite, 55
 Botallackite, 55
 Buttgenbachite, 55
 Cerussite, 55
 Chalcanthite, 55
 Chalcocite, 55
 Gerhardite, 55
 Langite, 55
 Magnetite, 54
 Malachite, 55
 nitrides, 53
 Paratacamite, 55
 rust, 43
 Zincite, 55
cracking, 5, 7
crackling, 4
crater, 26, 31
crosslinking, 9, 45, 48–49, 74
crystallinity, 100, 102
curing, 73
current, 14, 28–30, 105, 132
 direct, 14, 16, 21, 27, 32–33, 46, 49–50,
 69, 114
cyclodiene, 67

D

damage, 3–4, 8–9, 13, 16, 21–24, 26, 31, 46–47,
 54, 59, 63–64, 66, 69–71, 74, 77, 95,
 99–100, 102
Damara, 79

darkening, 5
deacidification, 9, 60
deactivation, 68
decay, 4, 63
decomposition, 30, 41, 65
decontamination, 9, 27, 45–47, 59–61, 72–75,
 85–86, 89–97
deformation, 7, 63
degradation, 1, 3–5, 45, 53, 60–64, 67–68, 72,
 74–75, 79, 90–91, 100
deposit, 1, 3–5, 9, 21, 61, 63–64, 66, 68, 86,
 91–92, 94, 99
deposition, 15–16, 45, 48–49, 60, 85
desalination, 54
desorption, 18, 25, 81, 23–24
detergent, 7, 3
deterioration, 3–4, 9, 60, 72, 74–75, 79
devitalization, 61, 86
dirt, 3–8, 44, 62–66, 68, 76–77, 91–94, 99, 102
 stains, 4–5, 60, 72
discharge, 9, 12, 15–17, 23–25, 27–35, 43–46, 49,
 60–61, 71, 73, 75, 85–86, 89–91, 103,
 108, 111, 119, 122, 130, 134
 afterglow, 40, 71–72
 APGD, 35
 Atmospheric Discharge with Runaway
 Electrons ADRE, 33–34, 61–62, 73,
 75–76, 84, 86, 89–98
 barrier discharge, 15, 31–32, 36, 38–39, 41,
 51, 61
 Capacitively Coupled RF Discharge CCRF,
 15, 17
 corona, 31, 33, 38–40, 44, 60
 DBD, 15, 23, 25,
 31–32, 61, 71
 DCSBD, 32, 85
 dielectric, 15, 24, 29–33, 35–38, 61, 34
 narrow, 32, 28
 Nonthermal Plasma Jets NTPJ, 35
 piezoelectric, 33–34, 68
 pinhole, 28–29, 37
 post-discharge, 16, 23–24
discoloration, 60, 67, 72, 79
disinfection, 60, 73, 86
dissociation, 56, 12, 28
dissolution, 6–8, 31, 54, 65, 71
dose, 75, 90, 98
downstream, 23
drop, 3, 32, 114, 131
durability, 3, 59, 68
duration, 26, 47, 72,
 76, 110
dust, 3, 8, 43–44, 62,
 64–65, 68
dye, 5, 7–8, 37–40, 70, 75, 99
 carminic, 75

E

effect, 1, 5, 7, 13–14, 31, 44–48, 56, 60–62,
 66–71, 73, 75–79, 85–86, 89–90, 94,
 96–100, 112, 114–115, 119–120,
 123, 142
 antifungal, 67
 antimicrobial, 86
 negative effect, 14, 75
effectiveness, 24, 61–62, 86
efficiency, 7, 9, 18, 32, 43, 45–46, 48, 60–61, 68,
 71, 86–87, 90–92, 94–97, 112,
 114–115, 129
elastomers, 11
electric, 6, 11–12, 27–28, 32–33, 43, 45, 47, 49,
 53, 76, 128, 141
electrode, 13, 15–17, 23–24, 28–30, 32–33, 35,
 43–44, 71, 108, 130, 132
 electrodeless, 15, 17, 24
 needle, 30, 40
 parallel, 31–32
 pin, 28–29
 planar, 25, 28, 33, 35, 99
electrolysis, 14
electrolyte, 36
electromagnetic, 15, 21, 109
electromechanical stress, 47
electron, 11, 24, 33, 43–45, 48, 50, 56, 61, 66, 74,
 89, 99, 103, 112
 runaway, 33, 36, 39, 61, 89
elements, 3, 31, 114, 117, 119–120, 124, 126,
 131–132
elimination, 1, 9, 87
emission, 18–19, 21–22, 47, 103, 107, 109, 112,
 115, 117, 122, 128, 130–131
emulsion, 6, 8, 93
encrustation, 4, 27, 40
endospore, 50
energy, 7, 11–12, 14, 16–17, 25, 27, 31–33,
 43–44, 49, 56, 89–92, 107, 112, 115,
 117, 133–135
enzyme, 4, 8, 60–61
epoxide, 24
equilibrium, 4, 14
equipment, 22, 54, 81, 100, 142
erosion, 46–47
esters, 66–67
etching, 16, 45–46, 71, 74, 76
ethanol, 66, 3, 24
ether, 66, 69
ethylene, 45, 60, 72, 81
EtO ethylene oxide, 45
evaporation, 7, 21–22, 28, 48, 66, 131
excavation, 53, 32
excimer, 27, 40–41, 83, 136
excitation, 12, 14, 16, 56, 112, 128

exhaust, 14, 35
exposure, 7, 31–34, 43, 46, 48, 61–62, 67–70,
 75–76, 90, 92–94, 96–99, 135

F

fabric, 6, 76, 99–101
facades, 85
faraday cage, 8
fats, 4, 6, 8, 67
fibers, 5, 59, 76–77, 90, 99
fibroin, 10–2, 44
film, 4, 10, 31, 43, 49, 60, 69, 74, 103
flaking, 4
flat, 33, 65, 77, 85
flow, 13–14, 23–25, 27–31, 35, 75, 92, 96, 98,
 107, 122, 124
fluids, 9–10
fluorosilicates, 67
foil, 31, 69
frequency, 14, 16–17, 23–24, 29, 35, 68, 73,
 75–76, 89, 96, 98–99, 125,
 135–136, 138
fumigation, 60, 83
functionalization, 48
fungi, 3–4, 10, 60–62, 64, 67, 72–73, 83, 89–90,
 94–95, 145
 brown-rot, 67
 fibrous, 4, 61, 64, 73, 89, 95
 filamentous, 61, 89–90
 mycelium, 46, 96
 spore, 46–48, 95–96
 white-rot, 67

G

gamma, 45, 60, 80
gap, 31–33, 35, 64, 85
gas, 9, 11–14, 22–25, 28–30, 32, 35, 43–44,
 46–49, 56, 61, 68, 71, 73, 75–76, 79,
 89, 92, 96, 98–101, 130–131
 Co, 35, 37, 45, 55, 74, 89, 92, 99, 106, 141
gel, 6, 8–10
gelatin, 69–70, 72–76, 86, 94–95
generator, 15, 17, 33, 71
geometry, 33, 43–44
germination, 47
glass, 3, 11–13, 15–17, 22, 27, 29–30, 37, 69, 9,
 32–33, 36–38, 42–44
gloss, 74
glow, 35, 38, 40–41, 71, 103
glue, 4, 29–30, 105
graffiti, 79
grafting, 45
grease, 7, 66, 103
green-blue, 55, 96

green-yellow, 55
greigite, 54
grid, 3
groups, 5, 7, 48–49, 56, 59, 62, 65, 71, 74, 76, 79, 99
 carbonates, 11
 carbonyl, 48, 62, 66
 carboxyl, 48, 62, 66
 cyano, 44, 99–10, 102
 gum, 6, 91
 gypsum, 79

H

halides, 69–70
handgun, 86–87
hardness, 4
heat, 11, 14–15, 32, 44, 46, 50, 81, 97, 17
heat-sensitive materials, 12, 31–32, 35, 46
heliography, 69
heritage, 1, 3–5, 9, 11, 16, 23–24, 44–45, 59–60,
 62, 68–69, 72, 76–78, 85–87, 91
heritage collections, 62
heritage object, 5
high-current, 35
high-frequency, 12, 43, 60, 72–73, 134
high-pressure, 13–14, 37, 44
high-voltage, 16, 24, 32–33, 36
hollow tube, 35
homeostasis, 46
humidity, 3–4, 14, 47–48, 51, 53, 67, 60, 74
 RH, 73–74
hydrocarbons, 4, 44–45, 65, 67
hydrochloric acid, 13–14, 103, 105, 110, 112–122
hydrogels, 10
hydrogen–argon mixtures, 14, 24
hydrogen–argon plasma, 31
hydrogen bonds, 6, 59, 66, 74
hydrogen–oxygen mixture, 24
hydrolysis, 67, 100–101
hydroperoxyl radicals, 61
hydrophilicity, 5
hydrophobicity, 5, 7–9, 73, 85
hydroxyl groups, 48
hydroxyl radicals, 48

I

impact of a cleaning, 5
impurities, 1, 3–5, 7, 9, 43, 64–65, 68, 86
inactivation, 45–47, 50–51, 81, 96
 metabolic inactivation, 45
incrustation, 22, 109, 112, 115–117, 121
induction, 109
inductively coupled plasma, 136
infrared spectroscopy, 85, 91
inhibition of the fungi, 67

ink, 59–61, 76, 78, 82
inoculum, 61, 89, 95
inorganic materials, 3–4
insects, 3, 62, 64, 67, 82
insulation, 32
intensity, 18–20, 30, 47, 62, 111–116, 118–120,
 122–123, 125–129, 131, 133–134
interelectrode distance, 92
interelectrode gap, 35
interface, 7, 9, 40, 144
interfacial tension, 7
intracellular ph, 46, 51
ionization, 7, 14, 16, 25, 27, 35, 79, 128
ionized gas, 11–12, 35
ions, 11, 14–16, 23–24, 27, 31, 43–44, 48–49, 56,
 70–71, 112, 122–123
 anions, 7
 cations, 7
iron-gall inks, 61
irradiation, 3, 9, 40, 80

J

jet, 23–25, 28, 31, 35, 59, 71, 86
joule heating, 32

K

ketones, 66
kev energy, 33
K-thermocouple, 109

L

lacquered surfaces, 64
LA-ICP-MS, 36
laser, 6, 9–10, 25–27, 31, 36–37, 39–41, 60, 71,
 80, 83, 86, 136
layer, 3–6, 8, 18, 22, 26–28, 31, 33, 43, 48–49,
 53–54, 56, 63–66, 68–75, 77, 79, 86,
 91, 94, 98–99, 103, 105, 109, 111–112,
 114–115, 117–120, 126–132
 boundary, 48
 detachment, 4
leather, 3–4, 31, 59
lignin-containing paper, 89
lignocellulosic materials, 32
LiOH, 54
lipids, 46
liquid, 5, 14, 27–31, 103, 124, 132, 134
 bulk, 14, 22, 25, 27–28, 31, 53, 103
liquid-gas phase, 38
long-term exposure, 7, 46
low-pressure conditions, 23
low-temperature plasma, 1, 12, 31, 35, 37, 45, 60,
 68, 82, 84–87, 91

M

macromolecules, 1, 46, 59, 79
MALDI-ToF-MS, 37
marble, 78
marker, 76, 86
matt, 75
matting effect, 71
mechanical action, 6, 71
mechanical binding, 49
mechanical bombardment, 48
mechanical cleaning, 5, 44, 56, 64–65
mechanical contact, 62, 71
mechanical damage, 70–71
mechanical force, 18, 54, 103
mechanical impurities, 86
mechanical properties, 74–75, 84
mechanisms, 9, 24, 43–47, 49, 62–65
medical applications, 30, 59
medicine, 23, 27, 45, 54
membrane, 13, 46–47, 51
mesh, 16–17, 93, 8
metal, 3–6, 8–9, 11–12, 21–22, 26–27, 35, 43,
 48–49, 53, 55, 65, 67, 69, 77, 86,
 99–100, 102, 104–105, 128
 alloy, 22, 38, 67, 69, 100
 alumina, 29
 aluminium, 14, 103, 114, 125
 amalgam, 69
 brass, 26, 67, 145
 bronze, 14, 21, 53, 67, 128, 131–132
 cobalt, 219
 copper, 14, 26, 35, 38, 40, 67, 69, 99–100,
 108, 131
 Cu, 25, 55, 105–106, 132
 CuAl, 55
 CuCl, 55
 CuO, 55, 130
 Cuprite, 55
 Fe, 54, 56, 106, 132
 FeCl, 54, 103, 105
 FeCO, 54, 128
 FeO, 41
 FeOOH, 103, 106
 FeSO, 106, 111
 Hematite, 54
 iron, 19–21, 37, 39–40, 54, 56–67, 70, 82, 103,
 105–107, 109, 114, 122, 124,
 128–130, 145
 MgO, 130
 MnO, 130
 Pb, 20, 33, 55
 PbO, 55
 potassium, 31, 71, 140
 silver, 26–27, 69–72, 77, 96
 SnO, 55
 sodium, 31, 67, 40

steel, 13, 15, 17, 26, 81, 103, 106–108, 133,
 137, 145
tin, 14, 21, 55, 67, 128, 131–132
titanium, 140–141
TiO, 141
tungsten, 29–30, 137
zinc, 67, 108
Zn, 20, 55
ZnCO, 55
ZnO, 55, 132
Zr, 33
metallic, 7, 12, 15–17, 22–23, 25–26, 29, 53–55,
 67, 72, 99, 102, 127–128
metastables, 44
methane, 14
methods, 1, 3, 5–6, 8–10, 25, 37, 40–41, 45, 51,
 59–60, 62, 65, 70–73, 78, 83,
 86, 91–92
methyl bromide, 67
methylproxitol, 66
micelle, 7, 9
microanalysis, 74, 79
microbicidal, 45
microbiological, 3–4, 46–47, 59–61, 72, 75,
 86–87, 89, 91–92
microbubble, 28, 35
microclimate factors, 74
micro-discharge, 36, 50
microemulsions, 8–9
 oil-in-water, 9
microfilament, 32
microflora, 86
microorganism MO, 4, 45–47, 60–61, 68, 72, 86,
 89, 91, 95
 Alternaria alternata, 61, 72, 89
 Aspergillus niger, 61, 89
 Bacillus atrophaeus, 48, 51
 Bacillus subtilis, 47, 50
 bacteria, 40, 46–47, 53, 60, 72–73
 Gram-negative, 46
 Gram-positive, 46
 Cladosporium herbarum, 61, 73, 89
 colony forming units CFU, 91–92
 conidia, 90
 Geobacillus stearothermophilus, 47
 nematodes, 67
 Paecilomyces, 72
 Penicillium chrysogenum, 61, 72, 89–90
 Rhizopus, 72
 Trichoderma viride, 61, 89
micropollutant, 41
microscope, 3, 43, 70, 74, 85, 92–96, 99–100,
 103–104, 112, 131
microstructure, 49
mixture, 6, 11, 14, 23–25, 31, 43–44, 47, 66–69,
 71, 24, 28–31

mode, 22, 35, 90–91, 108–109, 112, 115, 118,
 121, 129
moisture, 7, 32, 61–62, 80, 103
molecule, 6–8, 11, 43–46, 48–49, 56, 66, 79,
 112, 128
monitoring, 13–14, 18, 61, 89, 107, 113, 116, 122,
 125, 128–129, 131, 133–134
MoO, 130
morphological structure, 59–60
mortality, 67
moulds, 48, 65, 84
multicomponent color layer, 5
multielectrode configuration, 30
multilayer, 33, 35, 69–70, 106
mutants, 50

N

nanocellulose, 6, 9
nanoparticles, 27, 31
nanosponges, 6
nanostructures, 27
natural materials, 4
natural polymers, 12, 59, 85
natural resins, 65–66
near-infrared spectroscopy, 82
nitrocellulose, 66
non-oxidizing, 27
non-polar, 7
nonthermal, 11, 33, 35, 44–45, 71
nozzle, 68, 71, 79

O

oil, 3, 6–8, 13, 43, 48, 66, 68, 77–79, 93, 107
optical emission, 18–19, 21–22, 103, 107, 109,
 139–140, 144–145
organic materials, 1, 4, 9, 31, 56, 72, 84, 86, 94
output, 35, 43–44, 90
overheating, 14
oxidation, 3–4, 11, 27, 62, 64, 72, 79, 112
oxides, 3, 48–49, 53, 64, 86, 100, 114, 136
oxygen radicals, 49

P

PACVD, 16
paint, 4–5, 7, 64, 68, 77–79, 86, 94
 acrylic, 78
 Akvarel, 91
 opacification, 5
paintings, 3–4, 8, 10, 63, 78–79, 82–83, 86
paper, 3–5, 9, 31–32, 59–62, 69, 72–76, 85–86,
 89–92, 94–96
 acid-sized, 89
paperboards, 32

papyrus, 80
paraloid, 67
parchment, 4, 9, 31, 59, 86–87
particle, 5, 8, 11–12, 16, 18, 23, 26–27, 47, 56, 59,
 61–62, 65, 71, 90, 92–95, 115,
 123, 128
patina, 64
peak, 100, 108, 111, 113–114, 128
pen, 29, 33–34, 68, 100
pH, 7–8, 46, 50–51, 60, 62, 67, 96
photodegradation, 79
photograph, 3, 69–77, 86–87, 94–98, 100,
 111–112, 115, 119, 123, 125
 argentotype, 70
 calotype, 69
 cyanotype, 70, 83, 96–99
 daguerreotypes, 24–26, 69–72
 platinotype, 70
photons, 11, 18, 30, 43–45, 47
photopolymerization, 69
physicochemical properties, 7, 72
pigment, 4–5, 9, 59–60, 70, 77, 79, 91, 97
plasma ablation, 48
plasma action, 56, 92
plasma activation, 48–49, 62
plasma afterglow, 72
plasma arc, 35
plasma atmosphere, 46
plasma beam, 86, 99–10
plasma cleaner, 43
plasma cleaning, 9, 11, 36, 43, 53, 67, 60, 71, 79,
 91, 93–94
plasma conditions, 17, 56
plasma deposition, 15
plasma discharge, 9, 33, 38, 43–46, 49, 61, 75, 81,
 85–87, 90–91
plasma etching, 16
plasma exposure, 32, 90, 96, 99
plasma generation, 28, 33, 107–108, 132
plasma handgun, 86
plasma ionization, 128
plasma jet, 23–25, 31, 35, 59, 71, 86
plasma-liquid, 27–28, 30, 36, 40
plasma modification, 48, 62, 90
plasma nozzle, 79
plasma pen, 33–34, 68, 10
plasma process, 13–14, 18, 48, 107, 124, 131
plasma purification, 93
plasma reactor, 13, 15, 22
plasma source, 23, 71
plasma sterilization, 45–47
plasma systems, 12, 16, 23, 25, 28, 31, 35
plasma torch, 78
plasma types, 35, 73
plastics, 11–12, 31, 43, 49, 59
polar character, 6

polarity, 5–6, 66
polar solvent, 7
pollutants, 3–4, 9, 27, 31, 64, 95
Polychromie, 4
polymer, 31, 40, 43, 48–50, 60–61, 69, 77–78
polymerization, 49
polymers, 8, 12, 31–32, 39, 48–50, 59, 78–79, 85
 chains, 49, 59
polysaccharides, 7, 62
polyvinyl acetate, 66
positive effect, 31, 86, 97, 114
positive ions, 16, 43, 122
preservation, 3, 7, 11, 59, 62–63, 67, 70, 72,
 78, 85
pressure, 11–14, 16, 23, 25, 28, 31, 33, 35, 43, 45,
 47–48, 55, 61, 71, 73, 77, 99, 107, 130
 atmospheric-pressure, 38, 50
principle, 5, 25, 45, 54
procedure, 5–6, 16, 18, 21–23, 54, 56, 61–62, 66,
 68, 70–71, 86–87, 91–93, 103,
 105–106, 109, 112
processing, 9, 11, 31, 45, 48–49, 61, 68, 76, 89,
 94, 103, 130
product layers, 18, 22, 27, 53, 56, 103, 128
protection, 1, 43, 60, 63, 66, 76–77, 85
proteins, 6–7, 46–47, 61, 69, 77
PTFE, 35
ptyaline, 8
pulp, 18, 59
pulse, 9, 25–27, 33, 37, 47, 92, 118, 120, 123, 126

Q

quartz, 13, 15, 25, 29, 107, 110, 130, 137, 140

R

radiation, 9, 15, 18, 45, 49, 59–60
 γ-radiation, 72
radical, 11, 18–20, 27, 30, 44–49, 56, 61,
 111–116, 118–120, 122–123, 125–131,
 133–134
 hydroxyl OH, 18–20, 30, 56, 111, 113–116,
 118–120, 122–123, 125–131
 peroxyl, 51
 superoxide, 51
radiofrequency RF, 12, 14–17, 21, 23–24, 29–30,
 107, 125, 130, 136
reaction, 3, 6, 8, 12, 14, 18, 21, 24, 27, 43, 46,
 48–49, 53, 56, 62, 64, 76, 96, 105, 124
reactor, 12–19, 22, 32–33, 107–109, 130, 140
 stainless steel, 13, 15, 17, 107, 133, 137
reagent, 66
recombination, 16, 21
recovery, 96–99

reduction, 24–25, 27, 48–49, 69, 71, 86–87, 100, 109, 130
regime, 12, 16–17, 19, 22, 59, 108, 110, 112–126, 130–131
reliefs, 33
removal, 1, 5–6, 9–10, 18, 23–27, 43–44, 48, 53–54, 56, 60–65, 68, 71, 76–79, 81, 86, 91, 97, 103, 111–113, 115–117, 119, 122–123, 125, 128–132
residue, 3, 8, 11, 43, 64–65, 103
resin, 4, 8, 65–67
resistance, 5, 22, 47, 49, 68
resistivity, 32
resonance, 32
restoration, 27, 62, 69–70, 78–79, 85, 132
retention of solvents, 79
risk, 7–9, 25, 31, 63, 65, 71–72, 77
R-O-R, 66
rotational temperature, 124, 127
roughness, 33, 74

S

salt, 4, 6–7, 31, 69, 96, 136
 AgCl, 105
 chloride, 4, 31, 53, 67
 NaCl, 135–136, 140
sand, 54, 105, 114, 124
saponification, 8, 66–67
scission, 48
secondary contamination, 54
secondary oxidation, 112
SEM, 72, 75, 99–101, 103–105, 108, 110–111
 SEM-EDS, 99
 SEM-EDX, 112, 114, 120, 130–131
shellac, 68–69
shock waves, 29–30
silica, 13, 144
silicon, 13, 29–30, 114
silk, 76–77, 99–102
smoke, 65, 78, 83
soap, 7, 67
soil, 5–9, 53, 61, 76–77, 91–94, 103–104, 124, 126, 128, 132
solubility, 6, 65–66
solution, 1, 7–9, 14, 27, 31, 33, 54–55, 64, 67, 69, 71, 85, 103, 124, 132–133, 135–143
solvent, 5–9, 11, 26, 60, 64–66, 69, 71, 77–79
 aromatic, 66
source, 23, 26, 35, 62, 64, 71
spark, 6, 24, 32
species, 9, 11, 13–14, 16–18, 23, 27, 30, 35, 43–44, 46–49, 56, 59, 63, 67, 71, 76, 85, 114, 124
 active species, 16–17, 23, 27, 30, 59
 nitric, 30, 105, 117, 122–123, 130

 nitrous, 30
 oxygen species, 43–44, 46
 plasma species, 18, 114
 RNOS, 68
 RNS, 46, 48
 ROS, 46, 48
spectra, 18, 75, 99, 101, 109, 128
spectrometer, 21, 109–110, 124, 126
spectrometry, 21–22, 25, 103, 109, 126
spectroscopy, 25, 44, 70, 74–75, 85, 91, 99–100, 107
spectrum, 18–20, 108–111, 124, 131
starch, 6, 41
sterilization, 9, 45–47, 60–61, 72–73, 90
substances, 1, 3, 6–7, 9, 43, 60, 65, 69, 86
substrate, 4–5, 9, 25–27, 44, 48–49, 59–61, 64–65, 68–69, 71, 79, 89, 91–93, 95
sugar, 6–7, 36
sulfur, 3, 40, 56, 64, 77, 106, 119–120, 125–126, 130
 sulfate, 4, 53, 67, 79
 sulfide, 26–27, 40, 56, 70, 77
supply, 14, 16–17, 24, 27–28, 32–33, 35, 44, 76, 107, 133, 135
surface ablation, 48
surface activation, 32, 48, 61, 86
surface analyses, 131
surface barrier, 32
surface bombardment, 14
surface cleaning, 6, 11, 25–26, 29, 48, 85–86, 133
surface composition, 117, 131
surface contaminants, 44, 48–49
surface deposit, 3, 68
surface dirt, 4, 63
surface energy, 49
surface geometry, 33
surface impurities, 3, 64
surface layer, 4–5, 8, 48, 53, 68, 86
surface oxidation, 11
surface pollution, 31
surface properties, 4, 12, 22, 60–61
surface structure, 79
surface temperature, 22–23
surface topography, 48–49
surface treatment, 9, 12, 15–16, 18, 23–30, 40–41, 55, 60–61, 64, 68
surfactant, 6–8, 68
suspension, 61, 89
swab, 73
swelling, 7–8, 66, 70

T

tape, 73, 86, 93–94
tarnish, 26, 70–71
technology, 5, 9, 21, 33, 54, 59, 73, 76, 85–86, 91

temperature, 3, 6–8, 11, 14, 16, 21–23, 25, 27, 31, 33, 35, 44–47, 56, 73–74, 76, 97–99, 103, 107, 109, 112–119, 123–125, 127–128, 130–131
 ambient, 11–12, 14, 30, 33, 35, 47, 124
termites, 62
textile, 3–5, 7, 10, 12, 39, 59, 75–77, 80, 82–83, 85–86, 99
thermal damage, 23, 31
thermal load, 35
thermal plasma, 11
thermal stress, 26, 30, 90
thermocouple, 22, 107, 130
topography, 48–49
torch, 25, 36, 38, 78, 84

U

ultrasound, 30–31
ultraviolet, 30, 43
 UV, 11, 40, 43–45, 47, 49–50, 60, 81
 VUV, 44
uniformity, 119
urine, 6

V

vacuum, 11–13, 15, 17, 30, 44, 48, 65, 76–78, 91–94, 103, 107
valve, 13–14, 107
vapor, 6, 44–45, 72–73, 103, 108–118, 120, 122
varnish, 4, 8, 63, 65–66, 68–70, 79
viability, 91–92, 96
vinyl acetate, 9
viruses, 73
vitamins, 69
volatile organic compounds, 3
 VOC, 3

voltage, 15–17, 23, 28, 30, 32–33, 35, 38, 51, 68, 99, 122, 130, 133
 bias voltage, 15–17, 122, 130
 DC, 14, 16, 29, 122
volume, 13–15, 25, 31–32, 35–36, 49, 71, 82, 124

W

wall, 4, 18, 22, 26, 31, 47, 61, 79, 81–82, 133
washing, 7, 60, 83, 103
water, 4, 6–8, 14, 27, 30–31, 44, 49, 53–54, 56, 60, 64, 66–69, 71, 93, 103, 132–133
wax, 3–4, 6, 8, 67
weathering, 62
wettability, 7, 39, 48–49, 76
Whatman, 61, 89, 96
wood, 3–4, 31–35, 59, 62–63, 67–68, 79, 86–87
 age, 62–64, 78, 85, 87
 picea abies, 67
 pinewood, 67
 poplar, 67, 80
 Populus, 67
 spruce, 36, 67, 79
 veneer, 32, 63
wool, 76
wound, 59
wound healing, 59
wrinkling, 7

X

XAFS, 72
X-ray, 74, 99, 112
XRD, 107–111, 127–128
XRF, 99, 131

Y

yield, 43